The LOS ANGELES SUGAR RING

INSIDE THE WORLD OF OLD MONEY, BOOTLEGGERS & GAMBLING BARONS

J. Michael Niotta, PhD
Foreword by Warren R. Hull

Published by The History Press
Charleston, SC
www.historypress.net

Copyright © 2017 by J. Michael Niotta, PhD
All rights reserved

Front cover, top: courtesy of Frannie LaRussa; *bottom*: Los Angeles Times Photographic Archive, Library Special Collections, Charles E. Young Research Library, UCLA.
Back cover, top: courtesy of Catlin Meininger; *center*: courtesy of George Niotta.

First published 2017

Manufactured in the United States

ISBN 9781625859976

Library of Congress Control Number: 2017945024

Notice: The information in this book is true and complete to the best of our knowledge. It is offered without guarantee on the part of the author or The History Press. The author and The History Press disclaim all liability in connection with the use of this book.

All rights reserved. No part of this book may be reproduced or transmitted in any form whatsoever without prior written permission from the publisher except in the case of brief quotations embodied in critical articles and reviews.

Dedicated to all the Georges I've (n)ever known.

Contents

Foreword, by Warren R. Hull — 7
Acknowledgements — 9
Introduction — 11

1. A Real Sugar Daddy — 15
2. Swimming in the Drought — 35
3. Frank Borgia and the Tax Man — 47
4. How We Got to Los Angeles — 62
5. Sweets and Incendiaries — 75
6. The El Rey Brewing Company — 78
7. The 1936 Multimillion-Dollar Lottery Ring — 96
8. A Riverside Accident — 109
9. A Gambling Parlor — 114
10. The Horses — 125
11. And Then Came War — 130
12. A Deli to Bring Them Together — 158

Bibliography — 163
Index — 173
About the Author — 175

FOREWORD

My interest in organized crime and, more specifically, Los Angeles organized crime, goes back to my youth. It was during visits to my great-aunt and great-uncle's home in Brea Hills, California, that I first learned of our family connection to people like Franklin Shaw, the onetime mayor of Los Angeles; Howard Hughes, aviator, movie producer and billionaire; and Jack Dragna, the leader of "organized crime" in the City of Angels. I would listen to the stories from "the good old days" shared between my "uncles"—Jimmy, Johnny and Joe (Jimmy Fratianno, Johnny Roselli and Joe Dippolito). As you can imagine, some incredible tales were told in Aunt Gaynell and Uncle Nick's kitchen, and I enjoyed listening to each and every one of them. Despite the reputation these men had as brutal and vicious gangsters, the stories I heard were never of murder and mayhem; rather, they were recollections of family and friends taking care of one another like family should.

During my twenty-five years as a researcher of organized crime in Southern California—and more specifically the city of Los Angeles—I have been extremely disappointed by the lack of quality nonfiction, true crime books dedicated to the City of Angels. Obviously, there are some incredible fictionalized stories about the seedier side—thank you, James Elroy—but to find a truly compelling nonfiction piece that takes place in Los Angeles is a bit more challenging. Don't get me wrong, John Buntin's *L.A. Noir: The Struggle for the Soul of America's Most Seductive City*, Bruce Henstell's *Sunshine & Wealth: Los Angeles in the Twenties and Thirties* and Kevin Starr's five-volume *History*

Foreword

of California: Americans and the California Dream are all excellent resources for those fascinated with the development of organized crime in LA from the 1920s to the 1950s. But none of these publications comes close to capturing the stories I heard as a kid—that is, until I read J. Michael Niotta's new book.

I come from a family that believes sharing family stories is more than a pleasant pastime and that stories with strong narratives build strong family bonds. I discovered this to be true when I wrote my first nonfiction book, *Family Secret*. While the story details how our family became involved in the murder of a famous mobster, what made writing the book so rewarding was the way the story drew people together. Not only did I hear from members of my family, many of whom I had never met, but I also heard from hundreds of my readers who became motivated to research their family stories after being inspired by reading one of mine. Niotta's book will have a similar impact.

Every metropolitan area has its share of historic corruption, and Los Angeles is no different. *The Los Angeles Sugar Ring* takes readers on a journey into the worlds of big-city politics, the socially affluent, vice, illegal gambling, police corruption and mobsters. Who doesn't like stories like these? Great books are those that take the reader on a compelling journey. Great books are the stories that allow you to flip from page to page, not only satisfied with what you've read but also wanting more. *The Sugar Ring* is a great book. It is gripping and will cause you to stay up until two o'clock in the morning just to find out what happens next.

Niotta is a gifted storyteller who captivated me from the start. He has a personal, well developed and descriptive writing style that makes for an enjoyable, smooth read. His knowledge of early Los Angeles history is second to none, and his family story is one of the most intriguing tales I have read in a very long time. J. Michael Niotta has done a masterful job on this, his first publication, and I am hopeful he will explore more of his family history and share those discoveries with the world.

Warren R. Hull
Producer/writer/independent film director

ACKNOWLEDGEMENTS

I would like to acknowledge the support, understanding and sacrifice of my wife, Jessy, and son, Dylan—putting together a book takes a lot from a young family. Thanks to all who've humored my less than conventional choices, with much appreciation to the Guarnieris and Niottas, plus the Amador, Cacioppo, LaRussa, Galardo, Dewey, Bovi, Rizzotto, Poli, Charfauros, Penkava, Glogovac and Dragna families. Special thanks to Big George for telling the tale that inspired it all; Frannie LaRussa, Anthony and Toni Amador and Catlin Meininger for their consistent willingness and wealth of stories; Gail Gray (RIP) for seeing the seed; Laurie Krill for spotting and fighting for a good story; Warren R. Hull for insight; the Rosie Network; Dr. Lawrence Murray; Mr. Christiaan Pasquale, my contemporary on many accounts; Andy Martello for graciously donating El Rey memorabilia; Bill Yenne for beer knowledge; Arlene Nunziati and the Order of Sons of Italy in America (OSIA); Arthur Nersesian and Dan Fante (RIP) for inadvertently nudging me from fiction to fact; Conquistadors C.C., Bill "WTF" Taylor and the once mighty motor pool, Brando Von Badsville, Richard "Dick" Williams, Nickie Bushor, Florence Quinn, Jerry Cacioppo, Luellen Smiley, John "Peebucks" Bonnel, Mike "Prestigious" Clem, Profs Kelly, Kantor and Tatum; Otto Dewey, Jay Mendoza, and all others who've helped on this journey. I wish to express immense gratitude to supporters of the book's image content: Anthony Amador, Frannie LaRussa, George and Jeanne Niotta, Catlin Meininger, Debra Turner, Monika Seitz Vega, Kari Orvik, Belgium Lion

Acknowledgements

Photography, J. Strauss of the *Great Falls Tribune*, Jason VanAntwerp, Mark Amador, Heather Bik, David Vazquez, the Vechil family, Jenessa Warren, Jessica Glogovac, Lori Orwig, Ronnie and Linda Galardo, Aaron Felt, Angie Sumrall, Sarah Sanger, Frankie Cascioppo, Matty the Jew, Leanne Babcock, Saralynn Sanfillipo, Janice Perine and the Vegas Niottas.

INTRODUCTION

"Hey, George," breathed through the receiver, "its Tommy. We got us a problem here. Guy says he doesn't wanna pay."
Tommy could hear the concern in the words that followed.
"You alright…they didn't hurt you any?"
"No. I'm good, thanks. But whaddaya want me to do?"
The silence on the line hung a moment, and then, in the bright tone that Tommy had come to know, Big George Niotta fired, "I'll handle it."
Thinking it settled, it surprised Tommy when his employer probed further.
"You sure they didn't try anything rough?"
"Naw, I'm fine, George. Really."
"Good! Get back to the route. I'll make a call. He's gonna lose his sugar!"
I can't help but concoct scenes like this. The story my eighty-one-year-old cousin George shared about our grandfather over coffee last spring piqued far too much interest. I'd made the drive out to San Dimas, off Route 66, to interview him about my great-grandfather Jack Dragna. By the end of our conversation, though, I'd learned a far sight more about another of my great-grandfathers—Big George Niotta. I'd long wondered about the crafty moves that played out during Prohibition—cops and robbers and such—and about the lives of those stuck in the blight of the Great Depression. Hearing my cousin's words that afternoon only pressed the curiosity harder. Born half a year after the repeal, George grew up on tales of an even older LA and of the exploits of Big George in the Southland.

Introduction

Despite such open dialogue about family history, it wasn't till the mid-1960s—and by mere chance—that the younger of the two Georges found out about our role in the sordid pastime of bootlegging. To pigeonhole Big George as a bootlegger, though, would be like saying Van Gogh painted houses. In line with other determined movers and shakers, he dabbled in an array of industries—some of them on the up and up and others worthy of the outlaw title. The climate out west stirred the ambitions of many opportunistic men—men who, although of common stock, raged against their cards, pushing for the top rung of LA's shadowy business world. In our grandfather's case, such bold moves allowed a poor, uneducated, illiterate immigrant to walk among the city's elite, to live kingly while most starved and—for a spell—to hold leverage over the Southland's top bootleggers—surprising moves for a husband and a father of eight. Far from surprising, Big George's daring maneuvers also teeter-tottered his family standing. He forever rode on the unforgiving cusp of success and alienation.

"Wishy-washy" about sums up California's approach to its vices. The legislators may have made the rules, but the rules definitely needed breaking. The state's viticulturists were but one of many factions aggressively opposed to Prohibition. Grape growers and vintners viewed the coming restriction as potential mass unemployment, and with good reason; the Golden State produced upward of 80 percent of America's wine! In fact, down south, the City of Angels even wore a more suiting title, "The City of Vines." Johnny Law and a horde of moral crusaders looked upon the bootlegger as just another gangster hood—and I'm sure a great number of them were. For some of California's "grape men," though, the title "Robin Hood" fit a far sight better. Negotiations bartered by "questionable men" facilitated shipments back east, keeping farmers from hocking their farms.

After the drought lifted, authorities fixed their sights on a new vice—gambling became the new booze to another prohibition. Yet that, too, proved indecisive. Angelenos of the twenties, thirties and on have always vigorously craved a good time, but perhaps just as strong was their proclivity for a region of touristy tranquility. We air our dirtiest laundry when others aren't looking. Call it a desire to live up to the name—a city of angels—or call it a thirst for a place that hid well its demons. This desire for an image of order kept dice, drinks and dancing to the back rooms and shadows. But LA's happening gaming vessels, speakeasies and bookie establishments represented far more than just fun. To the business-minded, it read like a powder keg of profits. Where demand breeds, someone will always appease and quench for a cut. Even though these wheeler-dealers rebelled—breaking

laws and committing moral crimes and sins—their deeds seldom lent an ill reputation. Successful operators enjoyed longstanding relationships with their communities and remained active within fraternal organizations. They profited mutually with politicians and select members of law enforcement while freely and zestfully rubbing elbows with old money and the Hollywood elite. Sometimes, they even secured city officials their respective seats. This is a story of culture, family and true crime in Los Angeles—early Southland style—where the defining lines of right and wrong blur. They were, after all, Angelenos, not angels.

1
A REAL SUGAR DADDY

*Sometimes the gangsters didn't wanna pay.
So I'd call your grandfather and he'd shut off the sugar.*
—*Tommy Boscio*

It all starts with the liquor industry, which is more than fitting. George Niotta got into the business knowing he was following in the footsteps of his grandfather, Big George, who had owned a brewery during Prohibition. Not long after the younger of the two Georges entered the trade, though, he discovered another of his grandfather's roles—bootlegger. Call it fate or call it chance, George stumbled on the information. Back in 1958, when he interviewed with industry heavy Simon Levi, he lacked the experience to land the job. Undeterred, he got his start another way, with the help of a man named Hy Hoffman. Hoffman, one of only two western states brokers for Fromm & Sichel, took a chance on young George, and the gamble paid off. By then, the distribution company had already drummed up quite a history. Fleeing Nazi Germany, fourth-generation winemaker Alfred Fromm partnered with another German vintner, Franz Sichel. The pair secured rights to Christian Brothers in 1938 and brokered their wines and brandies nationally, reaching forty-eight states. In the 1950s, they expanded by taking over the vineyards of California winemaker Paul Masson. Their efforts made household names out of each brand.

Working for Hoffman, George got situated in an office within the Young's Market Company, just one of the many outfits Hoffman distributed

beer, wine and liquor to in San Francisco and Los Angeles. George took to the trade swimmingly, as they say, and within a few months he found himself promoted to assistant western states manager, a title that came with a hefty responsibility. Beginning at the California-Mexico border, the region stretched all the way north to Washington State; heading east, it reached from the Pacific coast to the mountains of Colorado. If that weren't enough, George also served a as runner to the Stardust Hotel in Las Vegas. He didn't stick with Hoffman, though. A year and a half later, he interviewed elsewhere.

In 1960, George Niotta moved over to the Sterling Company, taking a job as a liquor and wine salesman. Like many others, the company fell under the ownership of Fromm & Sichel, so the leap didn't land him far. Although at this time one of the smallest distributors in Los Angeles, Sterling managed its affairs exceptionally well, a fact that did not go unnoticed. Not long after George joined the Sterling team, a much larger importer and wholesaler acquired the company, one that had previously turned George down—the Simon Levi Company.

Simon Levi left Bohemia for the United States in the early 1860s at the age of twelve. By his early twenties, he had opened a general merchandise store in Temecula, California, and before the coming of the 1900s, he formed the Simon Levi Company. Originally, the concern dealt exclusively in produce, but soon it expanded into wholesale grocery and liquor. More than sixty years later—right about the time George strolled onto the liquor peddling scene—the company Levi started had become one of the largest wine and alcohol distributors in the state. The public knew it as "The House of Scotch."

Though many employees found themselves out of work after the merger, George's track record and talents kept him gainfully employed. Back then, "a *good salesman* sold about $30,000 per month," he recalled. Although the standard had been set, George thought bigger—it was in his blood. "I was the first salesman that did a hundred thousand dollars of business in a month." If that weren't enough, George soon broke his own record, doing it back to back. For this feat, the company presented him with an engraved silver platter commemorating the achievement.

It was during his stint with Simon Levi, and during the mid-1960s, that George ran into a man who had worked for his grandfather decades earlier. "We'd get leads on new operations—bars or restaurants or liquor stores. I went out to one of those leads and I met a man who didn't speak English very good. He told me to come back the next day to meet his partner." After

doing just that, George learned something quite shocking.

George had just stepped into his thirties, and all the ambition in the world riled wildly within him. On the contrary, the gentleman standing before him looked closer to the end of his journey. "I gave him my business card," George conveyed plainly. The man read the name with a questioning tone. The response "You George's son?" soon followed. As simple as that sounds, for the Niottas, the question had always been loaded. Blame Italian tradition. To put it simply, back then more than a few men in the Niotta family responded to the name George. "No, I'm Michael's son," he corrected, explaining, "George is my grandfather." The man extended his hand, introducing himself as Tommy Boscio, then let on that he used to work for Big George. When George inquired in what capacity, Tommy nodded with a smile and gave a three-syllable answer. The response—"mechanic"—did little in helping pinpoint the specific company, though. The Niottas had started, purchased or backed so many endeavors over the years, and a mechanic could have worked at any number of them. Repeating Tommy's word silently, the image of a delivery truck flashed, and that was enough to send George's mind racing—"Pasta, cheese and olive oil!" Those were the items the family importing business in Boyle Heights specialized in—gems from the old country. It had been quite successful, too.

Back in the mid-1960s, when chance led George to Tommy, the intimate details about how the family lost the business were only scarcely known. As a boy, he'd heard vague tales of dubious circumstances—an act of betrayal. A few more decades would pass before he received a much fuller and bitter end of the story. The double-cross happened not long before George's birth, when Prohibition was still riding on its final embers.

"You worked on the delivery trucks?" George questioned, clarifying, "For the importing company?" The smile spreading over Tommy's face opened up to release a short laugh. And then, straight-faced, he revealed something even more confusing.

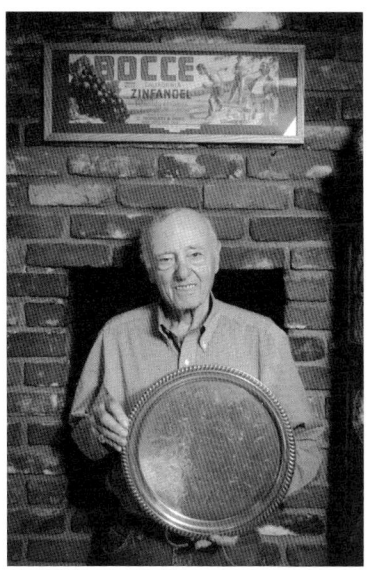

George Niotta and his "$100,000 back to back" Simon Levi silver platter, 2017. *Belgium Lion Photography*.

"No, no, no. I made the stills."

George's eyes widened. His ears peaked. None of his father's tales had ever mentioned this end of the business. Nodding quietly, he allowed the man to continue. On the books, Big George hired Tommy on to look after the delivery trucks for the Italian Wholesale Grocery Company, but in truth, his real duties involved the building and repair of unregistered liquor stills. Throughout the twenties and the early part of the thirties, the trade was not only illegal but also highly dangerous. That era had long since died, though, taking with it all former threat. Unafraid, Tommy spoke freely about his days working for Big George, and after confessing he tended to the family's private still, he divulged that his former employer also contracted him out to others. Apparently, Big George farmed the young man's services out to bootleggers who needed help getting situated or in keeping their operations going. Although already surprised, what came next threw George even further.

"Sometimes the gangsters didn't wanna pay. So I'd call your grandfather and he'd shut off the sugar. He wouldn't sell! Without the sugar…they decided to pay!" While bootleggers were busy with the day to day of manning their hidden caches, the Niottas served in another role, an integral one. Big George controlled the supply of raw materials—namely, sugar. While that might seem trivial, in the context it really meant something. "As good as gold" is a phrase that just about summed up the value of the sweet grainy stuff, both during Prohibition and throughout the length of the Great Depression. While sugar wasn't exactly scarce and wouldn't be heavily rationed until the coming of World War II, one couldn't make bootleg liquor without it, and the amounts required called for a wholesale distributor.

Legal and not, alcohol production has always been big business. If you weigh the effects of Prohibition, all it really did was switch hands as to who produced and who made the profits. "By 1927, an estimated 30,000 illegal liquor establishments, or speakeasies, had sprung up nationwide—twice the number of legal bars before the 'Noble Experiment' began." Speakeasies employed a long list of workers—bartenders and bouncers, dancers and entertainers, coat-check girls, cigarette girls, even hookers. Doormen and lookouts were also needed, plus clever deliverymen to bring the stuff in. If the place had gambling tables, that required even more staffing. More important than the fact that these secret nightclubs provided jobs is the timeline in which they did so. The stock market crash of 1929 left more than a few out of a job. Many lost everything they owned. The speakeasies continued to provide jobs, though, and this secured their popularity in the working world.

And for those who could actually afford the luxuries, they loved the clubs for another reason—the vices that couldn't be found anywhere else.

As is the case with any business, the setup can only work if customers make it through the door. For the speakeasy, liquor production and distribution became as necessary as the snow that skis rode on. In order to provide a finished product, though, certain ingredients had to be in the mix—namely exceedingly large quantities of yeast and sugar. High-grossing apparatuses, stills that could crank out as much as a thousand gallons of mash a day, went through hundreds and thousands of pounds of each. An order like that couldn't be picked up at the local market. As Julien Comte pointed out, "While neighborhood grocery stores provided yeast, sugar and malt to home manufacturers, commercial bootleggers received their supplies from" another source: wholesalers. This is "a point that historians too often overlook."

As difficult as it seemed, the game only got tougher. Prohibition set in nearly ten years before the market's crash, so any bootlegger who found it difficult to put his hands on sugar in that first decade was in for a major shock once the economy tanked. Based on Tommy Boscio's account, Big George Niotta had a leg up in the sugar department. Via importing ties he secured an ample and reliable supply, and through legitimate contacts he legally sold and transported. To move the product, he used company trucks or—when the order proved too large—freight. Tommy also relayed that Big George had a pretty good idea about how to exploit this access. Acting as gatekeeper to the sugar provided him leverage with what could easily be coined an unsavory lot. Bootleggers weren't exactly known for their polite manners or honest practices. As Tommy pointed out, "If the gangsters didn't wanna pay," all Big George had to do was threaten to shut them off. Without a pipeline, all liquor production stopped, and many more than just the bootlegger put stock in its manufacture. What Tommy failed to mention, though, was that bootleggers often stole rather than purchased the product. Big George was not immune.

> Santa Monica Evening Outlook, *July 20, 1925*
> *BURGLARS REMOVE SUGAR AND FOODS*
>
> *Los Angeles—burglars with a sweet tooth early today entered the Italian Wholesale Grocery store at 735 Kohler Street and drove away two trucks, one loaded with sugar and the other assorted provisions. The two were valued at $5,000. Detective Lieutenant T.B. Robinson recovered one of*

the trucks empty at Eighth and Central Avenue late today. No trace of the other has been found.

By today's standards, the $5,000 loss equates to more than $68,000. Still, the hit could have been worse—"The bandits failed in an attempt to open the safe of the grocery company." By 1925, the importing concern was either supplying sugar to bootleggers or being preyed upon by their kind. It's doubtful the robbery was an isolated incident, and it's likely the event occurred before Big George learned how to leverage his sugar. Considering the friends and connections he made in the second half of the decade, though, George probably didn't remain a victim much longer.

The business of bootlegging was never intended to be a one-time score. Profitable operations required consistency, reliability and a high level of trust. Naturally, a combination like that calls for an established relationship. Boosting someone's sugar was not the most ideal way of solidifying a lasting arrangement. Big George knew that heisting a truck or looting a warehouse was no mastermind operation. He'd suffered the hit but had also come to understand something far more important. If anyone expected to flourish in this special type of business, shipments had to reach their destinations, and they had to arrive consistently. Slaughtering the golden goose would only feed the hungry for so long, and those carrying the knives soon came to see the truth in the notion. Big George counted on the blessing of normalcy. Normalcy brought peace of mind and leveled out the anxiety. More important, without it, the uncertainty welcomed the devil. It made sense to get into bed with someone who could be trusted.

Mutual benefit isn't enough to entice, not when the risks involved threaten such a heavy loss. Suppliers refusing to work with bootleggers found themselves robbed by them. But even partnered up, wholesalers still had to worry about being hijacked by the competition. In addition to this, Prohibition's "dry" agents—"prohis"—loomed incessantly, and the penalties for supplying unregistered liquor stills became exceedingly steep, running into the thousands of dollars in fines and years behind bars. Knowing this, any deal negotiated also had to offer a measure of security. For this reason, provide-and-protect relationships began to form. But often these bonds extended further. Seeking partners who could be trusted without doubt, many involved in this inner circle dealt exclusively with those tied by blood or marriage. This could certainly be said of Big George's operation. His Los Angeles sugar ring involved the two Bruno brothers, who manned the stills out in the Mojave Desert, and the young

Cacioppo boys, who drove the product. Plus, marriage would eventually tie him to both John Cacioppo and Jack Dragna.

Although suppliers didn't technically fit the textbook definition of a bootlegger, the trade could not have existed without them. And because bootleggers became so dependent, the smart and ambitious suppliers learned to exploit the angle. All the way out in Pennsylvania, in the city of Pittsburgh, another crafty entrepreneur had come to the same conclusion as Big George. Hill District wholesaler Morris Curran realized "the profit that could be made from supplying bootleggers with stills, yeast, and sugar" and put together quite a fortune catering to Pittsburgh's void. But as Julien Comte highlighted, things turned out badly for Curran. Upon his demise, Sicilian baker Joseph Siragusa, a man known as "the Yeast Baron," took over his racket. When the pattern of violence continued and the game got bloody once more, Jack Palmere filled the baker's shoes. Clearly, Big George had stepped into a risky line.

Like any other businessman who'd made a huge investment, bootleggers longed to see returns, but many a pocket required appeasing in order for liquor to flow. The list of open palms expecting payment included the still builder, the supplier of the raw goods for production and the shipping company that safely and discreetly delivered. At the still site, a bootlegger employed a workforce that not only cranked out a finished product but also maintained equipment and guarded their interests. To avoid being discovered, bootleggers often set up operations in remote areas lacking electrical power. Desert, mountain and barn stills ran off generators, creating another expense. Not only do generators require maintenance, they also have to be fueled, making gasoline one more item to purchase and deliver. After being distilled, a process that rendered the booze safe to drink, the product needed transport. This required skilled drivers with enough nerve and know-how of the Southland's deserts to outrun police in a chase. They drove by night, at times guided only by the light of the moon—hence the term "moonshine." To service, repair, and sup up these hot-rod vehicles, trustworthy mechanics were added to the payroll, and for the bootleggers who owned clubs and gambling ships on the receiving end, another lengthy list of expenses waited.

All this bustle posed one very big problem—it brought a lot of extra parties into the fold. With an enterprise of such magnitude, it was virtually impossible for everyone to be married or related, which meant added eyes held vital information. Naturally, this brought on anxiety and begged for loose ends. For the investment to pay off, sites not only had to be supplied regularly and produce a viable product, they also had to remain hidden.

Keeping locations a secret from the competition and from the authorities proved a constant struggle—one more reason to associate with those who could be depended upon. Scaring suppliers and employees into silence by way of strong-arm tactics no doubt happened, and it always remained an option, but in the long run this seldom panned out. It's far too easy to leave an anonymous tip to the feds or to be bought by the competition. The smart and profitable play, and the play that Big George eventually slid into, involved simply paying these individuals for their vital services, and paying them well.

Riding the success of importing and various other endeavors, Big George, his wife, Phyllis, and their eight children fared well in Los Angeles. He'd arrived in LA from Louisiana but had originally come from Sicily—another factor that later worked in his favor. Although tied in with bootleg liquor, the family's importing concern did legitimately bring in cheese, olive oil and pasta from the old country. Bigger sellers, however, became sugar, yeast, redwood vats and metal cans—items sold to the owners and operators of unregistered liquor stills scattered all over LA, Orange County and the Inland Empire, an area fondly referred to by locals as the Southland. From what Tommy Boscio holds, Big George had a still of his own and employees on payroll, but his ambition didn't end with sugar and booze; he pushed into many industries.

"He had his fingers in a lot of big business," affirms George's grandson. "He was a hell of an entrepreneur, as we call them today." As Big George's focus strayed from importing, it gravitated toward an array of other opportunities, such as collecting properties. In 1929, a builder put up a four-story, thirty-one-unit apartment house in the famed Wilshire District. Located at 839 South St. Andrews Place—a short walk from Wilshire Boulevard—residents could boast a view of the Hollywoodland sign. Unfortunately, the market crashed not long after the building saw completion, and the dive in the economy caused the owner to part with his investment. By 1931, newspaper ads for the hotel boasted new management and a new name. Ads for single and double furnished rooms in the remodeled "La Niotta" ran in the *Los Angeles Times* for a decade. The family name has since been lifted, but the establishment still rents studios and singles under the allure of a historic setting, known now as the South Saint Andrews Apartments.

The La Niotta wasn't Big George's only rental. In 1933, he had a pair of frame and stucco properties built on the 300 block of North Martel, right around the corner from the Spanish Kitchen. George's oldest child, Celie, and her husband, John Cacioppo, moved into one home; he rented out the

INSIDE THE WORLD OF OLD MONEY, BOOTLEGGERS & GAMBLING BARONS

Left: Lobby of the former La Niotta Apartments, Los Angeles, 2017. *Photograph by author*.

Below: The Niotta home of the 1930s, Wilshire District, 2017. *Photograph by author*.

other. The bulk of the Niotta clan lived three miles up, off Olympic, in the famed Wilshire District. Their Spanish-style home at 1059 South Sierra Bonita sat a mere five-minute walk from Wilshire Green Park. The same year that construction on the rentals began, Big George ventured out to San Francisco to pick up even more real estate—a brewery. For six months prior to taking the helm, he'd handled distribution for the newly reopened plant, using his import fleet to make deliveries. And with all those trucks on hand, it just made sense to own a filling station. It had twelve pumps. Big George got into buying and racing horses, as well. The family visited racetracks up and down the coast regularly. Unafraid of the consequences, he invested in sprouting businesses, too, sometimes even taking them over. And almost religiously, Big George played the market. Despite the volatile and uncertain nature of the game, whenever he stepped into the stock exchange building, he managed to come out more than just unscathed.

Success in the market garnered popularity, and Big George drank it hungrily, basking in all the perks that came with being a winner. Regarding his grandfather in business, the younger George holds that "he took the chances" and wasn't afraid to get involved in start-ups. The Bohemian Distributing Company is one that comes to mind. "They were Italian owned, and they had Acme Beer with the bulldog. Grandpa lent them money to get going, and they turned into a huge liquor distributor." The venture must have taken place at the start of the 1920s. Beer historian Bill Yenne pointed out that Bohemian pushed Acme's "near beer" in the summer of 1921, after beverage salesman Frank Vitale partnered with J.S. Foto, a small retail beverage store owner. If Big George backed Vitale and Foto, then he played a major role in launching one of the state's largest distributers. The company had quite a run. By the 1930s, Bohemian branched out across California, and after securing the state's market, it expanded into surrounding territories and did it well—holding strong until 1993.

Although his willingness to jump fearlessly into an endeavor often paid off, in a large part, Big George made his way through the relationships he secured. By at least 1927, he'd become friends with Jack Dragna, a union that proved more than fruitful. Born in Sicily as Ignazio Dragna, "Jack" spent his first two decades of life heading back and forth between Italy and New York. Just prior to settling in America permanently, he served in the cavalry with the Italian army and invaded northern Africa during the Italo-Turkish War. Jack arrived in Los Angeles in late 1914 and spent roughly forty years there. Throughout the '20s, Jack engaged in various endeavors with prominent Sicilian rancher Joseph Ardizzone. Though many fortune

Inside the World of Old Money, Bootleggers & Gambling Barons

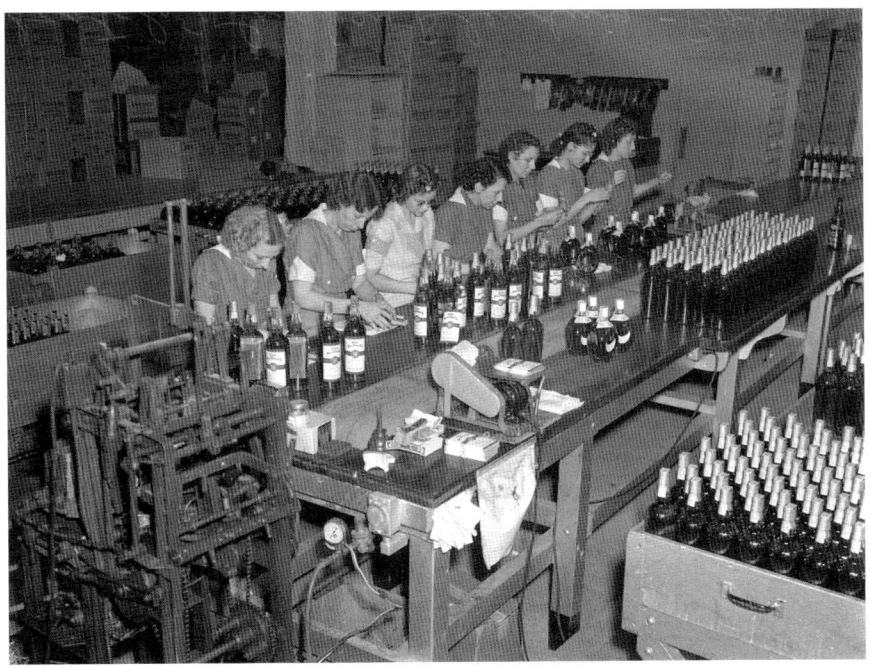

Women bottling at the Bohemian Distributing Company, circa 1940. *Los Angeles Times Photographic Archive, Library Special Collections, Charles E. Young Research Library, UCLA.*

hunters dabbled in the liquor and gambling trades, one of their biggest rivals was a politician. Charles H. Crawford and his associates—deemed the "Capitol Hill Gang"—boasted pull with LA mayor George E. Cryer. Connections such as this kept police interference to a minimum, allowing Crawford's gang to thrive. When Cryer decided to leave office in 1929, though, it cost Crawford much of his power and allowed former business partners and rivals to prosper—Jack Dragna included. But Jack was far more than a mere bootlegger or sportsman. Like Crawford, he got involved in politics.

In the mid-1920s, Jack served as a leading figure in Los Angeles's Italian Welfare League, an organization started with Joe Ardizzone. Though speculated by law enforcement to be a front for a "muscle" operation, the league came together to assist the Italian grape growers and vintners of California who'd been suffering from the restrictions of Prohibition. Jack's position in the organization soon pushed him into the role of a mediator, settling disputes among the business owners of LA's Italian colony, efforts that proffered the unofficial title "Mayor" of the "Italian ghettos."

Los Angeles Times, *December 16, 1929*
ITALIANS IN ANNUAL BANQUET
FIVE HUNDRED PARTICIPATE IN EVENT UNDER
AUSPICES OF ITALO-AMERICAN LEAGUE

Five hundred Los Angeles Italians met yesterday afternoon at their annual banquet of the Italo-American Welfare League in the Flower Auditorium to hear prominent men of their people and local government leaders tell them of the part they are playing in building a better city and nation. Dist.-Atty. [Buron] *Fitts expressed his pleasure in the way the local Italian organization makes itself felt in better law enforcement and commented on the valor and fighting spirit of the American-Italians during the World War.*

Cryer's replacement, Mayor Porter, addressed the attendees of the gala event that evening and gave praise to the city's Italian colony, offering "compliments on their art, music and literature, and the men they have produced who are prominent in the commercial and political life of Los Angeles." Honored guests included representatives from the Italian government—a count, a captain and a professor from the University of Florence. At the helm sat J.E. Ardizzone, chairman, with J.I. Dragna, vice-chairman.

Knowing Prohibition wouldn't last, Jack Dragna looked ahead. Like Big George Niotta, his focus refused to travel a straight line. Both men branched out, seeking to expand their interests. In 1928, Jack, along with partners Byrnes, Dougherty, Oswald and Bernson, purchased a football field–sized fishing barge. After investing an additional $20,000 to $60,000 into a remodel, adding a covered pavilion for dancing on the deck and gambling equipment for the guests, the *Monfalcone* was transformed from a hauling and fishing vessel into "the finest pleasure barge on the coast." The ship gained fame almost overnight. During the last breaths

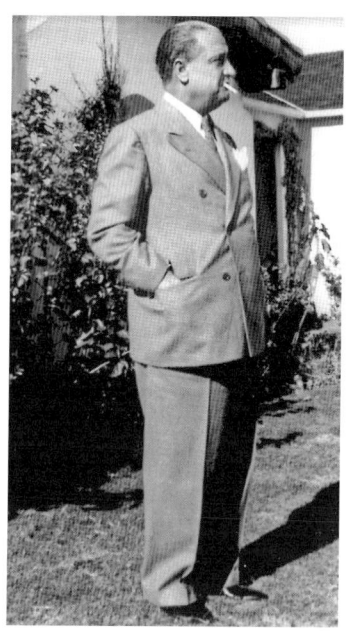

Jack Dragna, Leimert Park, 1940s.
Courtesy of Frannie LaRussa.

of the Roaring Twenties, the papers publicized the *Monfalcone*'s ongoing battles with Santa Monica and other coastal cities. While the citizens were certainly on board, officials did everything possible to prevent the ship's owners from operating a gambling den in the waters offshore. Even though the vessel anchored outside the state limit and beyond authorities' jurisdiction, under a hearty campaign led by the likes of DA Buron Fitts, headlines read, "Axe Squad to Smash L.A. Gaming Ship." The *Monfalcone* group fought with a rival faction too, the *Johanna Smith*—a predecessor docked three miles closer to shore. Both gaming vessels felt the wrath of city ordinances, which came one after the other, hampering business, in a war to keep patrons from getting out on the water for a good time.

After the *Monfalcone* burned to the waterline and the craze of its exploits died out, the papers once more referred to Jack Dragna as a "Civic Leader." And like his former business partner Joe Ardizzone, he became a prominent rancher. He partnered with his older brother, Tom, and the pair purchased five hundred acres of land out near Puente. There the family enjoyed relaxing getaways, rode horses, played cards, held parties and made a lot of wine.

> Los Angeles Times, *October 24, 1931*
> *WINERY FOUND IN HAYSTACKS*
>
> *The Dragna ranch, eight miles southeast of Puente, yesterday was raided by Federal agents, who report the seizure of 2,775 gallons of wine in barrels and vats, and the arrest of Tom Dragna on a charge of violating the national prohibition law. The agents reported the liquor concealed behind stacks of hay. Dragna was taken to the County Jail. He is said to have admitted ownership of the wine.*

While some argue that Jack held sway with Mayor Cryer, his biggest political in didn't come until later, after Ardizzone and Crawford had left the picture. Warren R. Hull and Michael Druxman contend that during his time with the league, Jack befriended Franklin Shaw. Seeing potential, Jack began to groom the man for office. Although bootlegging had just about seen its end, Jack's union with the new mayor propelled him in other endeavors, namely the large number of bookie and gambling establishments in motion all over the Southland. Not only did Mayor Shaw turn a blind eye to this activity—as Mayor Cryer had done for Charlie Crawford—he, along with the help of his brother, Joe Shaw, had rival clubs raided and sometimes

even shut down. This alliance provided Jack with a measure of security and reduced the level of competition. But having a connection in political office proved useful to Jack in other ways as well. Allegedly, Jack and Mayor Shaw had another racket going—securing construction contracts for a fee. A company bidding for a city or county project could be ensured the job over competitors if Jack liked them. Rather than bleeding these contractors greedily, he received a one-time commission for brokering the deal.

Crusaders like DA Earl Warren and, later, Police Chief William H. Parker made a lot of trouble for men like Jack, men with quiet arrangements all over town. But this was the way of the city. Illegal or not, citizens would forever crave vices like booze and gambling, and as long as that remained a truth, someone would be there to grant their wishes. Unlike operations on the other coast, the machinery out west moved without an excess of noise and violence. In Los Angeles—at least for a spell—illicit negotiations carried on quietly in the shadows. What displaced a lot of these long-standing arrangements were loud affiliates from out of town who'd come to LA for a piece of the action. Benjamin "Bugsy" Siegel needled into the Southland's rackets with an East Coast mentality, and he posed smugly for the cameras while doing it. Although his subordinate, Mickey Cohen, grew up locally in Boyle Heights, under Siegel's influence he, too, succumbed to the need for media attention. The gunfights and retaliation filtering into the streets of Southern California at the onset of the '40s and throughout the decade pulled the city's vice from the dark crevices and switched on one hell of a bright searchlight. Affected by all the change, many illegal operators skipped town for Las Vegas; the heat in LA was just too much to handle.

Come 1950, a witch hunt targeted the country's vice operators, one ethnically geared at Italians. During the televised Kefauver Hearings, the California Crime Commission held Jack Dragna in contempt for indicating he didn't know anything about the Mafia. Even though the investigations and proceedings were unable to prove the existence of this underworld society, the commission still saw fit to brand Jack the organization's West Coast representative. It even labeled him the "Head" of a "Los Angeles Crime Family." A more recent view on Dragna's role in Los Angeles, one expressed by LA crime expert Warren R. Hull, paints a contrary depiction. Jack Dragna's "reputation was one of being the leader of organized crime in Los Angeles, which is actually incorrect." Aiming to clear up this widely held misconception, Hull commented that Dragna was involved in "partnerships with a wide-range of politicians, police and other citizens—elected and non-elected—in a wide variety of

business opportunities." When a "change in the guard" in law enforcement occurred after the 1940s, however, Jack "fell out of allegiance" and "efforts to vilify him and deport him intensified." After the onset of these hearings, headlines referred to Jack Dragna as the "Al Capone of Los Angeles," and a campaign of harassment on Dragna's relatives began.

Negatives aside, Jack Dragna was exceedingly influential in the City of Angels, a man who made introductions, settled disputes, facilitated transactions and held sway for many decades. By at least the mid-1920s, he and Big George Niotta were more than just working together. George's daughter Celie, who dictated much of the family's history before her passing, indicated that "many Italians from Italy, who came to the U.S., wanted the rest of their family to join them for the baptism of their children." All but the two youngest Niotta children—Anne and Lucy—had been baptized. Big George's sister-in-law, Annie Siggia, had two little ones who needed baptizing as well, Don and Joey. Following suit were the Dragnas. "Jack and Frances Dragna had a son, Frank, and a daughter, Anna," and "mutual friends of the Dragna's—the Borgia's—had a daughter that had not yet been baptized—Rosalia."

At one and a half, Anna Dragna was the youngest of the bunch. Born in Los Angeles in 1926, this puts the timeline of the story at about late 1927. Celie would have been eighteen and newly married to John Cacioppo. Coincidentally, the Borgias asked the Dragnas to baptize their daughter Rosalia right when Big George asked Jack the same question. "The Dragna's also felt their children needed to be baptized." Jack had been holding off in the hopes that his sister would visit from Italy and be present for the occasion, but it was beginning to look like Josephine Dragna wouldn't be arriving anytime soon. Approached by Big George and Frank, Jack decided to make it happen. "You know, it is our custom to have a big celebration when our babies are baptized," Jack announced proudly. "Since we all seem to be baptizing each other's children, why don't we all get together, take the babies to church and baptize them at the same time?" Smiling, he added, "and have a grand celebration."

It's funny to think that even though the country was about to speed headfirst into the worst economic depression in the nation's history, George Niotta—a man with eight children to care for, with no formal education and who could neither read nor write—was doing better than just alright. He'd established a home for his family, made prominent and influential friends and even secured himself financially with a thriving importing business. Miraculously, Big George did even better trading stocks, making hundreds

of thousands. "My grandfather George did a lot of things," says the younger George, "but probably the bulk of his money was made in the market." Celie conveyed that her father grew exceedingly fond of the thrill of the game. As a result, she was tasked with driving him to the stock market nearly every day. Celie began her chauffeuring duties at the youthful age of fourteen, not long after George suffered a bad accident behind the wheel. Regarding her father, she contended that even though he couldn't read or write, he knew numbers very well. Adding to this, the younger George explained that his grandfather "could add, subtract and multiply faster" than he ever could with a calculator.

"He could read that board if you know what I mean. He knew the stock symbols. You don't have to be a genius and be able to read the name of the company if you know the stocks and what it stands for." When George says "for a man who can't read or write, that's something," he's certainly putting it lightly. The 1929 stock market crash decimated the country's wealthy. A lot of kings lost their castles, and yet, there sat George, perched high above the rubble ready to buy and sell, as if basking in economic immunity. But Big George wasn't just some fluke who rose from the ashes after the dust from '29 settled. He'd been up there shining with the big boys for quite a while. Setting him apart from the rest was his ability to prosper in a pinch. When most fizzled, he kept on burning brightly, as if some dazzling firework lighting the LA skyline—fitting for a man born on the Fourth of July.

Also in opposition to the ills of the time, and completed the same year the Depression struck, stood the Los Angeles Stock Exchange. The broad and majestic structure, not unlike the Roman Pantheon in its appearance, is likely where Celie drove her father every day. This landmark of perseverance seemed to match Niotta's will and drive. Neither saw fit to accept the defeated aura that plagued the country nor subscribed to a blackened mindset. The magic of George had been cast long before the economy nosedived, though. He and his wife, Phyllis, received plenty of attention throughout the 1920s—invites to black-tie events and dinner parties and requests from prominent figures with social standing, influence and, of course, lots of money.

Younger George recalls his father and grandfather's stories well. "The Niottas and the Foxes were quite close and had dinner together often." William Fox and his wife, Eve, settled in Los Angeles right about the same time as George and his. Although friendship blossomed in the 1920s, a newspaper headline and the story that followed suggest this relationship came to a close by the end of the decade. William Fox gained notoriety

Big George *(center, in white)* and dapper friends, early 1930s. *Courtesy of Catlin Meinenger.*

when he helped end a monopoly, making it possible for just about anyone to make a movie. He founded Fox Films in 1915 and, in the 1920s, opened a chain of theaters. At the height of his power, he even tried buying Metro-Goldwyn-Mayer (MGM). All this success ended abruptly and, toward the end, embarrassingly. The wreck that set it all in motion happened on the morning of July 17, 1929—"Film Magnate Is Badly Hurt in Auto Crash." A Rolls-Royce wreck left William Fox, "Pioneer of the Amusement World," critically injured and his chauffeur dead. The economy tanked shortly after, and although William Fox's body survived the car crash, his finances crumbled under the crashing market. When the film mogul fell into the arms of bankruptcy, Fox Films merged with Twentieth Century, spawning what is known today as 20th Century Fox.

Big George continued to play the stock market and to do exceptionally well. He also found success in several of his storefronts. Although he'd established himself in Boyle Heights, once the market crashed, the lifestyle he provided for his family jetted into something very different. George soared while others floundered, and the prosperity compelled him to move out of the old neighborhood. The family found itself on the edge of LA's glamorous Wilshire District, the house right there on the Miracle Mile among the city's upper crust. Just a short jaunt from Wilshire Boulevard, the spot swam in a sea of old money and the elite Hollywood caste.

"I was about two and a half when we lived there," figures George, known back then as "Little Georgie." Though quite young, he never forgot his corner neighbor. "Jimmy Durante would take his daily walk by the house." Since Georgie's mother, Rose, allowed him to play on the front lawn, he'd catch Durante on these morning strolls, and the kind man never failed to give the little boy his attention. "He would come by and give me shiny pennies." Later, George learned they'd been living in the presence of royalty. Just up

the street resided the famed socialite Wallis Simpson. Right about the time Jimmy Durante was handing over those shiny pennies to Georgie, the King of England was relinquishing his crown to his brother—humorously, another George. The royal family refused to accept the twice-divorced Simpson as King Edward VIII's bride and the next Queen of England. Learning this, he abdicated his throne, allowing King George VI to take over the country.

The year 1932 marked the second time the Olympic Games were held in America, and Los Angeles won the bidding far in advance.

> Oakland Tribune, *April 18, 1925*
> *LOS ANGELES TO GET 1932 OLYMPIC GAMES*
>
> *New York—Brigadier General Charles H. Sherill of New York, a member of the International Olympic Committee, told the Olympic Association this afternoon the committee had "definitely and decisively" decided to hold the 1928 games in Amsterdam, Holland, and the 1932 games in Los Angeles.*

By the time the games were set to be held, the climate of the country had shifted drastically. Despite the lavish state of a lucky few, the nation as a whole sat in shambles. But America wasn't riding out the Depression alone; few countries could afford to send a stable of athletes across the water, and some even bowed out completely, resulting in a minimal number of competitors. Italy's Olympians made the trip, and after receiving a gracious invitation, they visited the famed Wilshire District.

> *Italy's Contestants Guests at Luncheon*
>
> *The Italian Olympic team members will be the guests of George Neota, retired Los Angeles businessman, at a luncheon today at Neota's home. The majority of the Italian athletes are expected to be present.*

The LA games worked out well for both countries; the only team to take more medals than Italy was America.

Prosperity amid the chaos of the early 1930s caused Big George to stand out. To some, he appeared to be a rising star, a man to befriend and to keep tabs on. There is no doubt that his uncanny luck in the stock market had something to do with this, as did the success of his budding importing business. Lesser known were his smartly hidden bootlegging activities and the connections they'd fostered. But even with all the wealth and ties, Big

Inside the World of Old Money, Bootleggers & Gambling Barons

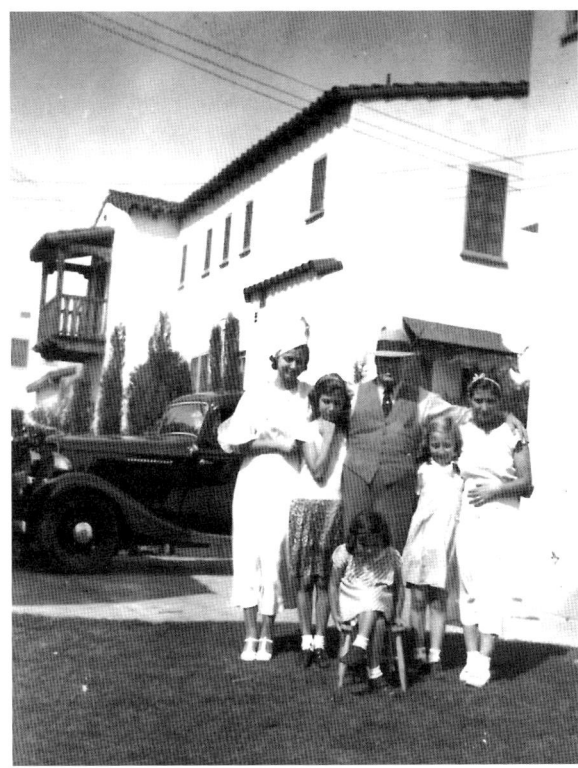

Left: Big George with daughters (*left to right*) Marion, Anne, Lucy and Josie, and granddaughter Lolly (*seated*) at their Wilshire District home, early 1930s. *Courtesy of George Niotta.*

Below: Michael Niotta and his hot rod, Boyle Heights, late 1920s. *Courtesy of George Niotta.*

George's grandson feels there was more to it. Perhaps this desire to be around George had something to do with the man himself. "He had a personality like a magnet!" George qualified the statement by adding that his grandfather "knew everyone in the city; all the big names—Sinatra, Spencer Tracy."

Big George's magnetism, paired with a freakish knack for numbers and an ability to make money in the stock market—and to do it well—made him a well-known member of the business community. To a degree, it even made him popular. George's off-the-wall antics and burning hot temper, on the other hand, sometimes stripped him of his social standing. Though content or even joyous in one moment, the next might deliver the wrath of the infamous Niotta temper—a trait that has yet to die out. At home with the family, the vibe teetered between boisterous and uneasy, riding the extremes. Even now, talk of Big George breaking plates of pasta over his sons' heads at the dinner table can sometimes still be heard. And yet, so can the tales of generosity, like the gifting of brand-new convertibles. But even that kindness has been tainted. On occasion, the younger George still relays the story about his grandfather getting so riled that he ice-picked all four whitewalls on his son's cherry convertible. Some call such behavior "crazy," some, "passion"; others make the excuse, "that's Italian."

2
SWIMMING IN THE DROUGHT

CALIFORNIA'S GRAPE MEN

Drinkers enjoyed their last legal swill in their favorite establishments on January 15, 1920. The drought kicked in the next morning. The "noble experiment," as it so inaccurately came to be called, attempted to reduce corruption, crime and taxes, and yet, just the opposite happened. In addition to being ineffective and exceedingly costly, Prohibition increased alcohol consumption, opened the door to harder drugs and gave rise to violence and corruption. It also kept the government from nearly a decade and a half of taxable income. Lesser known is the existence of a wartime prohibition that went into effect just prior. Amid the chaos of World War I, Congress sought to ration items used in the production of alcoholic beverages, arguing that items like grain would be better used as food for American soldiers. President Wilson stood behind the plan but actively sought its repeal once the war ended. Congress's dry lobbyists had other ideas, though, and remained adamant about keeping the United States alcohol free. Cleverly, they used their powers to circumvent the president's will. But the agenda did more than just overlook the wishes of the nation's leader; it pitted legislators against the grape growers of California.

A contender with France, Italy and Spain since the early 1900s, forty-five of California's fifty-two counties made wine, producing some fifty-two million gallons a year, or roughly "between 80 and 90 per cent" of the

entire country's stock. That's when Los Angeles wore the title "City of Vines." Extending the wartime prohibition past the battle's end threatened the livelihood of the industry, an industry composed largely of Italians. Everything the state's grape men had worked so hard to build could easily be torn down if the drought was allowed to persist. Economically, 1918 proved exceedingly bad for growers and vintners, and no one craved a repeat. "610 cars of grapes, of both wine and table varieties" left San Bernardino and Riverside vineyards via the Santa Fe Railroad. But these figures were substandard to what the Southland's grape men had come to count on. "Thousands of cars iced and pre-cooled at the Santa Fe plant" is more in line with what they were after, but industry heads foresaw no return to wealth without repeal. Accepting this as truth, the state—and the country—sat in anticipation, desperately hopeful for a decision in their favor.

> San Bernardino County Sun, *May 31, 1919*
> *GRAPE PRODUCERS SEEK QUICK WORD AS TO THIS COUNTY IF MEASURE REPEALED*
>
> *With a crop approximating 50,000 tons setting on the vines, and worth between $1,500,000 and $2,000,000 in non-prohibition times, grape men of San Bernardino county have turned their eyes toward Washington in an effort to hasten a decision, one way or another, by congress as to what it will do with President Wilson's request that wartime prohibition be repealed. The wine-grape men are facing a sea of uncertainties.*

"Prohibition or no Prohibition," warned the *San Bernardino Sun*, "a large quantity of wine grapes" will be "shipped east to the Italian centers" and "find their way into 'Moon-shine' wine." Pointing out the extent of this drive, the *Sun* insisted, "It would take an army…to prevent the making of wine by Italians in their homes after they bought the grapes." They had it right, too. By the end of the drought, 75 percent of California's grapes ended up in big cities like New York and Chicago. Faced with what they viewed as impending mass unemployment, the California Grape Protective Association—founded in 1908 by an Italian, Andrea Sbarboro—focused efforts on keeping the new law from becoming a reality. Despite the struggle, the Eighteenth Amendment passed, becoming the first to restrict rather than grant a freedom. The ill-prepared amendment lacked specifics, though, leaving some to wonder what constituted as an

California grapes heading back east, postcard, early 1920s. *Cardcow.com*.

alcoholic beverage and others questioning how the government intended to enforce the new legislation. These and other uncertainties served as catalysts for the National Prohibition Act, which arrived shortly after, and came to be called the Volstead Act.

Being an act rather than an amendment, the president finally had a say. Still against the idea, he vetoed. Despite opposition, the House and Senate passed the act, and as an added slap, they did it the very same day Wilson vetoed. Though approved, the amendment wasn't slated to go into effect for a full year, leaving drinkers plenty of time to stock up. For the grape men, the long stall meant the fight would continue. Despite the odds, they remained "determined to save their industry from the blight of Prohibition." In February, the grape men rallied for the new legislation to be revoked, and the assembly proved to be the "largest gathering of vineyardists" ever held. Naturally, all the noise stirred an ill response from "dry" factions.

> Oakland Tribune, *May 6, 1921*
> *BOOTLEGS WORK FOR REFERENDUM, SAYS DRY HEAD*
> *PETITION TO HOLD AN ELECTION ON WRIGHT LAW*
> *PAID FOR BY BOOZE, HE CLAIMS.*

San Francisco—the referendum petitions now being circulated for an election of the Wright dry law is an attempt on the part of bootleggers and blind pig operators to hold up State enforcement of prohibition, says Reverend Arthur H. Briggs, superintendent for Northern California of the California Anti-Saloon League. The referendum is to be circulated it was announced by the California Grape Protective Association. Concerning this, Briggs said: "What is the California Grape Protective Association? It would seem to be one of the many disguises used by the blind pigger, who is the only being in California who would have any interest in appealing the Wright law to the people."

Taking it fast from political to personal, this zealous anti-alcohol head also commented, "Bootleggers and blind piggers are the lowest and meanest sort of criminals. Ninety per cent of them are foreigners. This fact causes shame to hosts of law-abiding American citizens who were born in other lands." Here the "dry" way of thought speaks for itself, backed by a religious, moral and, at times, even ethnocentric agenda. Perhaps just as bad, the message gives no regard to economic ramifications, namely the impact Prohibition was having on what could easily be coined one of the state's most promising and profitable industries. Despite an excess of worry and toil on the part of the grape men, though, once "the manufacture, transportation, import, export, or sale of alcoholic beverages" officially became illegal, matters panned out very differently than they had expected. A couple of clauses offered temporary salvation.

What most Americans still fail to comprehend about Prohibition is that the Eighteenth Amendment didn't actually restrict citizens from drinking. In fact, those smart enough to have stockpiled reserves were well within their rights to enjoy whatever they'd stashed. The law merely stated that no one could legally buy, sell, make or transport alcohol—and a lot of loopholes surfaced. A pair of backdoor avenues to drinking that were made popular were imbibing sacramental wine made for religious ceremonies and—with a doctor's note—purchasing medicinal whiskey to cure an ailment. The ordeal was not unlike the current debate over medicinal marijuana. To put the situation lightly, caveats like these had many feeling ill and running for the arms of God. Another angle working in favor of the country's grape men dealt with a semi-pardon on homemade wine production.

Los Angeles Times, October 10, 1921
CROP IS SAVED BY HOME BREW

Grape Men Owe Salvation to Big Demand in East.
In New York Foreign Section "Everybody Makes Vino."
New Crop of Quarter Million Tons Eagerly Bought.

The clause okayed the home-based production of up to "200 gallons of *fruit juices*," with the stipulation that it would only be used for personal consumption and the alcohol content would not exceed 1 percent. Soon, folks all over the country were making their own wine. While the exception allowed grape growers to move a large volume of product, it did little for vintners whose art had been restricted to producing wine for use in religious ceremonies. "Most of the wine grapes" in places like New York were "absorbed by the Italian population." With some 600,000 New York Italians, this accounted for a lot. In addition to Italians, winemakers back east included other "people of the Ghetto"—"Slavonians, Greeks, and others of foreign birth" who'd been "accustomed to the use of wine all their lives."

One problem grape men encountered in accommodating this thirst was the long trip back east. Shipment by train could take up to fifteen days, meaning not only were special railway cars needed to regulate temperature, but specific grapes were a must. Jostling around for two weeks rendered less-durable product unsalvageable, forcing growers out west to rethink their strategy. Most replanted their fields with a tougher-skinned variety, and the play worked; "the price of grapes vaulted from $30 per ton in 1918, to from $90 to $120 per ton" by 1921. In response, landowners doubled the acreage devoted to grapes, which sparked the beginning of newer problems. The increase in shipments due to an excess of goods stirred strikes among railroad drivers and inevitably sent dry agents cracking down on home wine makers. These factors, compounded with the immense over-saturation of the market, soon killed the hefty profits California's grape men were raking in.

"It is true that when prohibition went into effect, for a few years an unprecedent rush of grape buying boosted the prices." These goods—"as everybody knows"—were used "for the purpose of home-wine making." Prices since that time declined steadily, "owing to increased production and diminished consumption." This drop in clientele could be attributed to inflated prices and "the activities of the prohibition agents." "For some reason or other," prohis "chose to enforce the law against the home-wine makers more rigidly than against more important offenders." Their livelihood once more in jeopardy, California's grape men got back to the fight.

Opposition to dry movements among the Italian colonies dates as far back as 1905. Seeing it as a threat to their way of life, Italians united and organized protests against dry ordinances. They strongly affirmed that these restrictions "amounted to an abridgement of personal liberty" and "posed a hardship to those engaged in viticulture." More and more groups formed, organized, and rallied for repeal. They united, held meetings and dabbled in politics in an effort to influence the vote and alleviate their hardships. One of these groups was the Italian Welfare League.

Los Angeles Times, *January 10, 1926*
ITALIANS UNITE FOR REPEAL OF STATE DRY ACT

More than 5,000 Los Angeles Italians have organized to campaign for nullification of the Wright Liquor Enforcement Act, State Senator Pedrotti announced yesterday. They have formed the Italian Protective League with temporary headquarters at 205 North Spring Street. Pedrotti is chairman of the league's temporary board of managers. His associates on the board are John Lopizich, Jack J. Dragna and Joseph E. Ardizzone. Joseph E. Bernardo of New York has been made temporary manager.

Odd to think that two LA bootleggers would ever kick-start an organization with such a mission statement. After all, the league sought to end legislation that had allowed Joe and Jack to make a lot of money. As makers of bootleg tonics and owners of pharmacies licensed to sell medicinal whiskey, Jack Dragna and Joe Ardizzone profited handsomely. But as ranchers and vineyardists, they'd suffered at the hands of an oversaturated market, and as Italians, the overzealous, unconstitutional and ethnically based targeting instigated by dry agents gave plenty of reason to oppose the situation, especially under California's Wright Act. The act came into play in 1922 and gave state officials room to handle the laws of Prohibition however they deemed best.

Similar to the California Grape Protective, the Los Angeles–based Italian Welfare League fell under what would commonly be called a protective, and as the name suggests, they looked out for their own.

Los Angeles Times, *March 7, 1926*
ITALIANS OF CITY CHARGE DRY ABUSE
PROTECTIVE LEAGUE HOLDS MASS MEETING
DENOUNCING ASSERTED ILLEGAL METHOD

Frank Dragna on horse Rocco. *Standing from left to right*: Victoria Rizzotto, Julia, Tom and Jack Dragna, Sam Gariffo, Nick Costa, "Patsy" Vasta, Luke Perrino, Ben and "Sonny" Rizzotto. *Seated from left to right*: Frances Dragna, Lucy and baby Mary Ann Gariffo, Morris Costa, Anna Dragna, Lena Perrino and Tilda Rizzotto. Dragna ranch, early 1930s. *Courtesy of Frannie LaRussa.*

> *Charges that homes of Italian-Americans have been illegally entered, families insulted and humiliated by members of the Los Angeles county liquor squad, were made last night by Griffith Jones, attorney for the Italian-American Protective League, who addressed 300 members of that organization in a meeting conducted at Walker's Auditorium, 730 South Grand Avenue.*

The League's attorney contended, "the county liquor squad habitually operates without legal authority and that it has frequently taken men into custody in one end of the county and taken them to Sherman *where the judge would do its bidding.*"

In November 1926, an initiative to repeal California's Wright Act was put to a vote, resulting in a narrow triumph by the dry contingent. The crusade for the grape men carried on. When newspapermen from the *Los Angeles Times* began printing uninformed advice on how to improve the situation, however, it became too much for some to swallow. Reading a proposal suggesting money be sunk into a campaign to get folks to eat more grapes and raisins and to drink more grape juice stirred one vintner to respond to the editor: "It is probably the best suggestion anyone could

make except to turn our 457,000 tons of wine grapes into wine!" Little did the poor grape man know that it would get far worse before it ever got better; a year later, the stock market crashed. Eighty-five years after that editor printed a sarcastic letter from a fed-up vintner, *LA Times* journalist Kent Crowley made a confession. Individuals such as Jack Dragna, who purchased "grapes to ship back east," actually "ended up rescuing many small family vineyards, wineries, and wine stores that populated Route 66 from San Bernardino to Los Angeles." Apparently, one man's menace served as another's Robin Hood.

Bootleg Survival

Folks were happily making and selling their own beer, wine and alcohol long before the likes of Prohibition, and while the Volstead Act may have deemed their art illegal, many of them never stopped. Call them criminals or riffraff or bootleggers. Whatever the title, they pursued a highly profitable industry that, for a small window of time, legislation deemed unlawful. But the demand never died. If it had, there wouldn't have been any money to be made, begging the question of whether the bootlegger deserves to be considered an outlaw entrepreneur. Before and after the drought, not only was the activity legal, viticulture also served as one of California's most profitable industries. Ranchers harvested grapes, shipping companies hauled them all over the world and vintners crushed them into wine. In regards to alcohol, moonshiners, as the popular Big Bopper song made famous by George Jones explains, did their thing in secret, way up in the mountains.

> *Well in North Carolina, way back in the hills / Lived my pappy and he had him a still. / He brewed white lightning till the sun went down. / And then he'd fill him a jug and pass it around. / Mighty, mighty pleasin', my pappy's corn squeezin. / White lightning! Yeah, the "G" men, "T" men, revenuers too, / Searching for the place where he made his brew. / They were lookin, tryin' to book him but my pappy kept on cookin. / Whew, white lightning!*

The heat the Big Bopper writes of—those "G men"—are "government men," special agents like the feds. Those "T men" are more or less the IRS version, and the "revenuers" were members of the U.S. Treasury

INSIDE THE WORLD OF OLD MONEY, BOOTLEGGERS & GAMBLING BARONS

Dragna, Rizzotto, Costa and Gariffo women at the Dragna ranch, early 1930s. *Courtesy of Frannie LaRussa.*

Department, the umbrella under which the IRS, the Secret Service, the ATF and various other entities fell. Each agency had it in for the bootlegger, and each racked up its own set of charges. The running list of offenses against these outlaw men contained such beauties as the following: failure to register a still; operating an unregistered still; engaging in illicit distilling and in the business of a distiller; the sale of alcohol; tax evasion; violating the Internal Revenue Act; conspiracy to defraud the government; and more. Most if not all are still applicable under section 5601 within title 26 of the U.S. Code, and for good reason—when all the nonsense of Prohibition ended, some bootleggers kept up the practice. Legalizing alcohol production and transport, however, did not mean that just anyone could now take up making and selling booze. Any still in operation had to be registered so that Uncle Sam could get his cut, which is a bit humorous, considering that nowadays hobbyists can buy a brew-it-yourself kit from the local grocery or via the World Wide Web and play bootleggers any day of the week.

Anyone serious about the art of making beer, wine or spirits—every brewer, distiller, vintner and even some of those gung-ho hobbyists—will admit that sugar is at the heart of what they're producing. Even the grapes smashed and barreled to ferment and the grains dried into malt equate to sugar. Of course, yeast, water, heat and some kind of vessel—like a vat—are all necessary components of the formula as well. Together, in the right balance, these ingredients have the capacity to create a harmony

better known as the fermentation process—the metamorphosis of that raw, sweet, grainy crystal into the potent juice most folks seem to love.

Although the process of alcohol production can be viewed as magical, it has also proven to be quite dangerous. *Time* magazine pointed out that "it wasn't just the violent Prohibition-era gang wars that were dangerous to Americans drinking homemade moonshine and bathtub gin." In New York, one bootleg batch killed dozens, while other botched brews rendered drinkers permanently blind. Despite the presence of "would-be chemists," some artists did—and do—truly know a thing or two about a thing or two. By nature, bootleggers are a creative lot. They've drummed up innovative ways to brew and distill and have even devised solid methods of doing it without being caught.

During the drought, many secured a fairly steady supply of liquor legally by merely getting a note from their doctors. The Treasury Department gave a thumbs-up to prescriptions for medicinal alcohol for such ailments as indigestion, depression and cancer. For that reason, a lot of speakeasies opened under the guise of pharmacies. Late in Prohibition's first year, Jack Dragna purchased the Cosmopolitan Pharmacy, at 1400 East Twelfth Street in Los Angeles. Chances are this wasn't the only pharmacy he acquired. Taking advantage of the religious end of things, some bootleggers even became rabbis just for the wine of it.

Companies that legally manufactured alcoholic beverages had to get crafty in order to stay afloat during the drought, as did drugstores, distributors and shipping companies. If not, the "noble experiment" would have not so nobly put them out of business. The greatest innovators morphed into whatever would allow them to sustain. Drugstores did well selling medicinal whiskey, which launched small chains like Walgreens into the flourishing giants of today. While many beer makers kept doing what they were doing, only at a lower alcohol level, some icons spun off in completely different directions. Pabst Blue Ribbon switched to cheese, then sold the line to Kraft when Prohibition ended. Others, including Anheuser-Busch and America's oldest brewery, Yuengling, put out a product that all ages could enjoy—ice cream! Although Yuengling's ice cream line died in 1985, it recently made its return to grocery store freezers. Way out in left field, Coors got involved in one of the oddest markets imaginable for a brewery: ceramics. Not only is its ceramics line, CoorsTek, still going, with $1.25 billion in sales, it also out-generates the company's beer in revenue!

While 1 percent beer, pottery and delicious ice cream won't catch a buzz, someone in the business did brain up a marvelous way of making

that happen—the malt syrup. With minimal effort, these syrups could be fermented at home to create an alcoholic beverage. Syrups, which lined grocery shelves, caught on quick. Stroh's was just one of many producers. Smartly following suit, vintners came up with something similar, a package of dried grapes just waiting for the user to activate—the grape brick. Humorously, some of these items even held warning labels cautioning the user that the product might ferment and turn into wine.

Not everyone in the liquor trade made their money off production. Some distributed. Boats, planes, trucks, buggies, mules, false gas tanks, wooden legs—whatever it was, somebody somewhere probably tried using it to transport beer, wine or liquor during Prohibition. And these individuals weren't just hauling homemade batches. Some headed north to Canada, while others devised routes that traveled down to Mexico. Rather than peddling hooch, these runners smuggled in cases of the genuine article. Bottles that would forever sit low in the well of any bar grew to the heights of the top shelf during the dregs of Prohibition.

Runners and smugglers devised some fairly smart routes and systems, but clever or not, it was only a matter of time before the authorities grew wise to their methods. Once Johnny Law caught on to the specifics of this illegal traffic, the U.S. borders fell under tighter surveillance, and airports and cargo flights suffered greater scrutiny. On the water, the Coast Guard took up watch, hunting for the likes of the famous rumrunner Tony "The Hat" Cornero. When the authorities really started cracking down, it became a desperate time for the bootlegger and for anyone who truly needed to dive into a bottle. But despite the decade-long war on booze, not everyone considered bootleg liquor to be the country's biggest problem.

>Oakland Tribune, *August 23, 1931*
>*GAMBLING, LEADING RACKET IN AMERICA*
>
>*Bootlegging, America's original racket? Her biggest? Not by a jugful! America had rackets before the eighteenth amendment was ever passed—and today's racketeers gain on an average of not more than 20 per cent of their total tribute revenue from liquor sources. America's giant racket dwarfing other rackets—spotlight publicity to the contrary notwithstanding—is gambling. The bigtime gambler boss is Uncle Sam's toughest, unequaled crime problem.*

Backing the *Oakland Tribune*'s claim was a statement made by U.S. Attorney General William D. Mitchell, who pointed out that gambling "was flourishing before 'prohibition' became a familiar word." Mitchell indicated that "those who dream of wiping out the dark blot of racketeering completely from our slate by finding a solution to the liquor-violation problem would have a rude awakening were the liquor issue solved tomorrow," and he couldn't have been any more right. As soon as the repeal set in, many an "underworld" operator who'd been branded a bootlegger shifted his focus full-speed toward another popular vice—gambling. Those already in the betting racket thickened their interests. This included Big George Niotta, who went from an importer and businessman bootlegger to a brewery and gambling parlor owner and businessman bookie.

3
FRANK BORGIA AND THE TAX MAN

Businesses don't always run smoothly, and the earliest media coverage of Big George Niotta's successful importing company is certainly representative. After the 1925 robbery, the papers wouldn't link the Boyle Heights's establishment on Kohler to crime again until the 1930s, and when it did, Big George and associates were no longer the victims. In the last years of Prohibition, the importing concern got caught up in three courtroom cases. Each involved large shipments of sugar and supplies delivered to illegal liquor stills, and Frank Borgia had his hands in all of it.

Although Big George Niotta founded the Italian Wholesale Grocery, as Celie expressed, her father "had Frank Borgia run it for him." Why Big George turned over management of such a profitable business is a question some family members have raised. Others believe he simply lost interest, which may have had something to do with all his good fortune in the stock market. According to this view, under the success and attention gained from the market, importing lost its luster. Moving goods became a distant second to trading stock and frequenting Hollywood parties. Big George had already established the grocery concern. It had a steady stream of clients and accounts, and despite the sorry state of the economy, all the hard work turned a profit. That aside, the importing affairs still needed to be tended. Of great annoyance to George, none of his sons were old enough to take over. Faced with the gap, he eventually looked to Frank Borgia.

The oldest uncovered documents establishing Frank Borgia's affiliation with the Italian Wholesale Grocery Company are dated May 1930, though

Former Italian Wholesale Grocery Company's Kohler warehouse, Boyle Heights, 2017.
Photograph by author.

it is likely he had been running the concern for at least several years prior. The documents in question are receipts from the storefront on Kohler. Many just like them no doubt existed; whoever did the books probably filled out a receipt for every legal transaction conducted. What makes these documents in question so special, and accessible, while others have gone the way of the dinosaur, is simple: they became courtroom evidence.

"Frank Borgia and his wife were close friends with my Aunt Cecilia and with my grandfather," relayed the younger George. "The wives used to go out to lunch together." This relationship between the Niottas and Borgias probably stemmed from an introduction made by Jack Dragna. Celie was eighteen when these three families jointly baptized their children, but exactly when—and how—they all came to know one another remains unknown. Frank Borgia was a fruit vendor turned bootlegger who, after a spell in prison, became a successful vintner and industry head. He arrived in America roughly two decades after George. The SS *Caserta* dropped him at the Port of New York in December 1914. In just a few short years, Frank found his niche in the Los Angeles grocery market, just as George had.

Clearly, for a time, these two men were friends, yet the circumstances of their working relationship remain a bit cloudy. Both came from Piana dei Greci, Sicily, a place known for its rebelliousness. Frank's cousin Joseph

INSIDE THE WORLD OF OLD MONEY, BOOTLEGGERS & GAMBLING BARONS

Above: Frank Borgia. Photograph used in the 1951 manhunt for the "missing" vintner. *USC Library, Los Angeles Examiner Photographs Collection.*

Right: A luncheon gift to Celie Niotta-Cacioppo from the Borgias in the late 1920s. *Belgium Lion Photography.*

Ardizzone also called the spot home, and Joe and Jack Dragna worked together. Although not from the same small town (Jack came from nearby Corleone), all four men had Sicily in common. But there is more to the connection. Crime historians contend that during the 1920s and up until his 1931 disappearance, Joe Ardizzone served as a leader of "organized crime" in Los Angeles. To the contrary, some argue that LA of the teens, and especially earlier, more aptly resembled the Wild West—rivalries ran personal and bloody. Without applying tired media terms like the "Black Hand" or the "Mafia," it's accurate to say that in the early days, Jack and Joe pulled a lot of weight in the City of Angels.

To bring these Sicilian men even closer, Frank and Joe, who were cousins, shared blood with the Matranga family, and a friendship between the Matrangas and the Niottas went all the way back to dei Greci. Not only did they immigrate over on the same boats, marriage also tied them. These close affiliations, along with the strange coincidence that they'd all come from the same small town, way up in the mountains, on an island clear on the other side of the globe, certainly accounts for why Borgia

was selected—or at least accepted—for the role of managing George's company. Of course, there is always the other possibility. Borgia was a known bootlegger, as were the others; the profession may have been the common string that webbed them together. It is very probable that Big George controlled the sugar delivered to their stills, and that after the importing warehouse began to be pillaged, Borgia came into the fold to ensure its protection.

Big George earned a great deal of notoriety, success and wealth in Los Angeles, but Joe Ardizzone and Jack Dragna stacked up as men of a higher caliber. The pair had not only been established in the city longer, but their work with the Italian Welfare League rendered them civic leaders among the Italian colony. Additionally, Jack shared a relationship and business arrangements with Chicago's Fischetti family (cousins of Al Capone) and had been close with New York's Tommy Lucchese since before settling in Los Angeles. Big George longed for the same clout and to be accepted as a member of this inner circle. And so, Frank Borgia's association likely held sway over George's judgment; he would have agreed to Borgia's involvement in order to secure the good graces of Jack.

Dapper Jack and Frances Dragna with friends, possibly aboard the *Queen Mary*, Long Beach, circa 1930s. *Courtesy of Frances LaRussa.*

While Frank Borgia's affiliations sufficed to persuade—or perhaps even force—a union, Big George probably employed him out of friendship, convenience and in order to strengthen existing ties. The pair shared mutual friends, were born in the same small town and, now, their children even shared godparents. Big George would naturally want to trust him. Plus, Frank had been running his own fruit vending business for years, meaning he was capable of managing the wholesale company.

Sugar Case No. 1

In May 1930, federal agents raided a hidden still in San Bernardino. Less than a year later, the trial began. But neither the raid nor the case that followed proved to be a media splash. With Prohibition a full decade in, authorities were plenty wise to bootlegging methods—where caches were hidden, the routes of transport and even the names of suppliers and distributors. By 1930, stills of all sizes were being discovered and raided fairly often.

> San Bernardino Daily Sun, *May 9, 1930*
> WHISKY STILL NEAR COUNTRY CLUB RAIDED
> FIVE MEN, WOMAN ARRESTED BY U.S. OFFICERS WHEN
> 100-GALLON PLANT CONFISCATED.
>
> *Operating on Valencia Avenue within one-quarter of a mile of the San Bernardino Valley Country Club, a 100-gallon still, completely equipped, was raided by Federal prohibition agents yesterday and five men and one woman were jailed, charged with owning the plant. The plant was located in a barn at the rear of the first house north of Highland Avenue on the east side of Valencia Street. County dry officers under the direction of Ira B. Caster had received a meager tip that there was a still in the vicinity, but the actual discovery came when Federal officers trailed a truck load of sugar from Los Angeles Wednesday night.*

The still inside the barn "was equipped with a 12-foot column fitted with a gasoline burner." Agents also found sixteen 1,250-gallon wooden vats containing "19,000 gallons of mash." The score served as "one of the largest amounts ever discovered at a still in San Bernardino County." Also on the premises, "officers found 260 empty five-gallon cans, 60 sacks of sugar, and

25 five-gallon cans of gasoline." Husband and wife Pete and Mary Calli were taken into custody along with Mario Matranga and three others.

Mario Matranga, alias Mike Matranga, had been under police surveillance since April. On four different occasions, authorities witnessed him loading a Chevy truck with sacks of sugar "stamped *corn*" from the loading platform of the warehouse belonging to "the Italian Grocery Company at 957 East Fourth Street." This Arts District warehouse, just one short mile from Big George's all-brick storefront on the industrial stretch of Kohler, stood beside Coca-Cola's first LA shipping and bottling center. Agents tried tailing Matranga but lost him on their first three attempts. Accompanying the Chevy truck was a Maxwell auto driven by Pete and Mary Calli. The second vehicle served as a lookout that purposely kept doubling back and changing position to throw off any tails that might be following. To avoid being spotted, the pursuing agents hung back—but too far back, apparently.

On May 7, agents had better luck; they shadowed Matranga to his destination. "Agents went to the ranch in question, noticed an odor of mash as they approached, and found a complete still and apparatus and a quantity of intoxicating liquor." Officer B.G. Williams, an investigator on the scene, "went into the barn" and spotted a "large high pressure still, and a number of vats containing mash." The contraption stood "between nine and eleven feet high." Although "not in operation" at the time, Williams could tell it had recently been in use; it was warm to the touch.

Officers apprehended Billie Morgano near the still then headed into the house behind the barn. They discovered Matranga asleep in a back bedroom but didn't let him sleep long. Awake, Matranga "attempted to throw under the cot some bills to himself from the Italian Wholesale Grocery Company." These bills, addressed to the store on Kohler, were admitted into evidence as exhibit no. 4. The bills were "written in longhand" and "dated and receipted May 5, 1930." They were made out "for undisclosed items purchased during April and May of 1930, amounting to $1,565." Officers arrested the Callis along with Morgano and Matranga, but this wasn't to be the end of the evening's excitement. "About 3 a. m., a few hours after the arrest…a Buick sedan automobile turned off the highway and drove to the dwelling with its lights out." Out of the vehicle stepped a man by the name of Jack Crono, who walked right into the barn. "One of the officers testified that the defendant looked surprised and, addressing the officer, said, 'We can fix this up all right.' The officer replied, 'I don't think so.' Defendant then said, 'Oh, yes we can.'"

On Crono—or Krono or Klime, depending on which alias he was wearing that day—agents found another receipt from the Italian Wholesale Grocery. This document also found its way into evidence, entered in as exhibit no. 12. Surprisingly, even though the evidence clearly established the importing concern as a supplier, no employee or proprietor was ever subpoenaed to testify. More miraculously, the Italian Wholesale stayed out of the papers. None of the lot taken in pointed any fingers, leaving Big George and Frank in the clear. If investigators had bothered to follow up on the evidence, though, it would not have been hard to link Frank to the scandal; he'd initialed the receipt by hand.

Further details implicated Frank Borgia in the sale of contraband. Officer B.G. Williams testified that while tailing Mario Matranga, he "followed the truck to the fourth door north of Mozart Avenue, on the west side of the street which has a number 231 on the building. This is the city of Los Angeles." Williams added that Matranga got out of his vehicle and went into the building for about twenty minutes. Though a bit faulty with its specifics, this testimony is certainly relevant. There is in fact a Mozart Avenue in California, but it rests all the way up in the northern end of the state, in the city of Los Gatos. In Los Angeles, it would be Mozart Street. The officer's second mistake lies in the address: 231 Mozart doesn't exist in LA, there aren't enough numbers. Either Williams misread the number on the building, as well, or was in desperate need of prescription glasses. Perhaps too much of a coincidence, Frank Borgia lived at 2621 Mozart Street at the time of Matranga's arrest. During those twenty minutes, Mario Matranga and Frank Borgia were likely hashing out logistics.

Exhibit no. 12, case 6702, *Crono v. US*, 1932. Initialed by Frank Borgia. *Courtesy of Public.Resource.org.*

Sugar Case No. 2

The ongoing court proceedings regarding the raided still inside the "Vaughn" barn out in San Bernardino did little to discourage the Italian

Wholesale's sugar business. Despite just wiggling free of the guillotine's chop, Big George and Frank got right back to sending out shipments. Perhaps they didn't know that the import warehouse was still under surveillance. In November 1931, Special Intelligence Agent A.P. Rumberg and his men "surrounded the Italian Wholesale Grocery Store" at 957 East Fourth Street. They had a "hunch" about the sale "of large quantities of corn sugar and other materials," which they accurately asserted were to be "used by the purchaser to make illegal beverages." This time, Frank himself was arrested by dry agents, along with four employees. The group quickly posted bail, forking over sums ranging from $1,500 to $7,500. The raid was far from the end of it. Come January, a dozen affiliates were being arraigned.

> Los Angeles Times, *January 12, 1932*
> *ILLEGAL SUGAR SELLING DENIED*
> *TWELVE ENTER PLEAS TO DRY AGENTS' CHARGES*
> *TRIAL DATE TO BE SET IN RAID OF WHOLESALE GROCERY*
> *WOMAN DEFENDANT ASSERTS OFFICERS GOT ROUGH*
>
> *Frank A. Borgia, president of the Italian Wholesale Grocery Company, and eleven employees of the company yesterday pleaded not guilty when arraigned before United States District Judge Cosgrave on charges of conspiracy to violate the national prohibition act.*

The trial date was set for the first of February, with charges hinging on the contention that "the sale of sugar and other materials" was "intended to be used in the manufacture of intoxicating liquor." The accused had claims as well, though. "An affidavit charging arresting prohibition agents with using rough tactics was filed" by the group's attorney, Otto Christensen, on behalf of Maria Covina. Covina, an employee of the importing store, claimed that after "agents forced her car to the curb," they "seized her purse and attempted to handcuff her to the steering gear of the car." The search of the premises and seizure of company records went under the lens, too, as the overzealous "agents were not armed with search warrants."

The law moves slow, and the court system slower still, with both frequently less than effective. Eight and a half months passed before Big George Niotta surrendered.

Los Angeles Times, *September 25, 1932*
PAIR SURRENDER ON INDICTMENT IN LIQUOR CASE

Secretly indicted several weeks ago by the Federal grand jury for participating in an asserted conspiracy to violate the National Prohibition Act, Max Weber and George Niotto, surrendered yesterday to Chief Deputy United States Marshal White, and put up bonds of $5,000 each for their release, pending their arraignment. Bench warrants had been issued for their arrest. The investigation was said to revolve about a former liquor investigation concerning the operation of an Italian wholesale grocery house, in which Niotto was a business associate.

Half a year later, in March 1933, Big George's attorney petitioned for the company's records to be returned and for the evidence to be suppressed. The agents' use of unauthorized wiretaps on the importing company's phones served as Attorney Christensen's ammo for the request. The establishment's records had been seized without a warrant as well, making the work of the law in this instance far from legal. Congress was fed up with the illegal and unethical tactics dry agents had been using to thwart bootleggers and speakeasies. So much so that, not two weeks before the Niotta trial, the *Los Angeles Times* indicated, "Congress has adopted a law…prohibiting Federal prohibition agents from purchasing liquor as evidence on which to base search warrants, to pay informers for information, and forbidding them to resort to wire-tapping." The issue was a hot topic, and the play made by dry agents backfired in the courtroom. Humorously, because California law stipulated that "to tap a telephone line is a felony punishable by a maximum of five years' imprisonment," Big George's attorney even turned the tables, asking Chief Deputy DA Stewart "to determine whether felony charges should be filed against the officers!"

Frank, Big George and the others had a technicality going for them, and it would work in their favor, but that didn't stop the proceedings from dragging on. Altogether, the drama lasted more than a year and a half. Come July 1933, the charges against the "dirty dozen" were finally dismissed, and yet—despite these two near misses and the fact that Prohibition agents were more than just on to them—the Italian Wholesale continued to move sugar. A short breath after the charges over the second incident dropped, bootlegging activities yanked the family importing company back into court—this time for a fatal bout. But the story involves

so much more, because the tale of the death of the Italian Wholesale Grocery and of Frank Borgia's unraveling involves the raid of the largest unregistered liquor stills ever discovered in the history of Los Angeles and, quite possibly, one of the largest ever nabbed in the state of California.

Sugar Case No. 3

On August 21, 1933, less than a month after the Italian Wholesale Grocery's reprieve, the police responded to a report of an automobile accident in Burbank. They arrived on the scene around 4:30 a.m. and discovered that a wrecked truck had been abandoned. In the hull, officers uncovered a load of metal cans filled with bootleg liquor. Oddly, a man named Frank Staccio showed up at the police station a short while later, saying, "I am the driver of the truck, and want to give myself up." Staccio was booked for possession and transport of the illegal substance then promptly arrested. The strange occurrence would later resurface in court.

On September 22, 1933, a month after Staccio's accident, a shipment left the warehouse of the Italian Wholesale for the deserts of Kern County. Driving through the quiet, dark night, the driver headed for the hidden still by memory. What the man behind the wheel didn't—and couldn't—know is that officers had just raided and nabbed four of the still's operators. Not long after the arrest, agents heard an approaching sound—the next delivery. Approaching with his headlights off, the driver reached his destination, parked, then got out. Agents on site caught him off guard, but the man refused to freeze, if that's what the authorities shouted. Instead, the unidentified driver ran off into the darkness, somehow managing to escape.

Inside the truck, officers sifted through a bevy of empty five-gallon cans and boxes of compressed yeast. But the real score was in the still. The site was impressive. "In the desert near the edge of Muroc Dry Lake," officers came across a pit—"in length about 200 feet, in width about 80 feet, and 8 feet in depth." Inside the pit stood quite a contraption: "copper columns, steam boiler, pumps, engine, and a number of redwood vats…nearly all full of fermenting mash." Making the setup "inconspicuous," they roofed the trench with corrugated iron and covered it with sand and brush. To put the find in perspective, the still uncovered in the previous raid—the barn on the Vaughn Ranch in San Bernardino—had a one-hundred-gallon capacity. Although not small by any means, the still that agents sniffed out in the desert near Muroc Dry Lake could produce ten times that amount.

A few days after the raid, authorities learned that some items recently purchased by the importing concern matched those confiscated at the still—yeast, five-gallon cans and redwood tanks. Records showed that the Italian Wholesale purchased six redwood tanks, exact duplicates of those inside the pit; they even still wore the initials of the manufacturer. In the abandoned truck, agents scored 15 fifty-eight-pound boxes of compressed yeast, plus 175 five-gallon cans—containers for moving the finished product to its final destination. As if the coffin needed another nail, records indicated that "the grocery company had very shortly before purchased from the manufacturer over 200 cans of a similar size." Most of the labels had been scraped off the yeast; however, some boxes at the site still read "Consumers Yeast Company," which was "the same company from which the Italian Wholesale Grocery Company purchased yeast."

In addition to this, a freight agent with the Santa Fe Railway at Muroc testified that "numerous shipments of sugar" had arrived "and that they were unloading at night." If that weren't enough, one witness "testified that a carload of sugar billed from Crockett to Muroc was diverted at Bakersfield to the Italian Wholesale Grocery Company at Los Angeles." Although placed on the day of the raid, the order was cancelled once word of the bust got out.

This is right about when Frank Staccio's accident with that truckload of alcohol came up in court, along with the documents and testimony linking the vehicle to the Italian Wholesale Grocery. Staccio admitted to the crime—whether or not he'd been behind the wheel—to avert an investigation. The diversionary plot may have worked, had a simple error not been made: they used the same car company. Naturally, Frank Borgia's lawyer objected to testimony about the accident being heard in the courtroom, arguing that Staccio had been nowhere near the still. The judge green-lighted the testimony anyway and allowed the jury to view the evidence. The Italian Wholesale Grocery had made two payments on the truck authorities picked up in Burbank, and on the very same day Staccio allegedly wrecked it, a representative from the importing company went back to the dealership for another vehicle. It wasn't hard to figure out that the second truck was the one abandoned in Muroc. The records confirmed it. This also proved that the Italian Wholesale wasn't just supplying raw goods; it was involved in distribution as well.

Although Big George had been implicated in the previous caper, on this one, Frank stood alone. George's name never even hit the papers, and one Niotta story may account for why. "Borgia took advantage of the fact

that my grandfather couldn't read or write" claims the younger George, a contention backed by his Aunt Celie, who further alleged that Frank "tricked him into signing over ownership." Chances are that Big George wasn't party to this final caper. In fact, by the time agents raided that still, he'd already "reformed." Repurposing his remaining trucks to legitimately move beer, Big George began serving as El Rey Brewing Company's So Cal distributor. He held the title for six months before taking over ownership of the San Francisco–based brewery.

After the raid, police had four still operators in custody, but because they refused to talk, authorities wouldn't arrest Frank until a full year later. Three months after the bust, Prohibition was repealed, but that didn't stop the taxmen or dry agents from pursuing the matter. The lengthy legal notice that continued to appear in the *Bakersfield Californian* shortly after the raid served two agendas. It no doubt amounted to procedure, a formality authorities had to go through in order to "legally" keep their plunder. But the other purpose was clearly bait. They wanted to sniff out the still's owner. The notice indicated that the seized items would be returned. All the owner had to do was come in and claim his property. While the effects for one of the largest illegal liquor stills in California history no doubt cost the owner plenty, it was of little surprise that no one ever showed to take back the seized items. Freedom is worth a bit more than a handful of redwood vats and the stale liquor stored inside them.

Media reports covering the trial didn't appear until a full year after the raid. By then, Prohibition had been over for nine months. Papers implicated Frank Borgia as at least a part owner in the still.

Bakersfield Californian, *September 10, 1934*
FORMER GROCER OF KERN FACES CHARGE

Los Angeles—Frank Borgia, former grocery company executive, was arrested today by Deputy U.S. Marshal Dave Hayden, who alleged that Borgia had been revealed as part owner of a large camouflaged underground still near Muroc, Kern County. The Federal Grand Jury secretly indicted Borgia last week on charges of conspiracy to defraud the government. Three other men indicted on the same charge are sought. More than 1,000 gallons of alcohol and a still capable of producing 1,000 gallons of alcohol daily were confiscated in a federal raid on the plant near Muroc a year ago.

During the trial that October, Ed Capece, Joe Vernaci, Al Costello and Nick Provenzano—the still operators nabbed during the raid—pleaded guilty. Frank, on the other hand, went the other way, denying all knowledge. "Assistant U.S. Attorney Jack Powell argued that the grocery firm owned by Borgia shipped more than a million pounds of sugar, large quantities of yeast, and empty cans to Muroc, where there is a population of but 100 persons." Powell also highlighted that on "the day after the still was seized he ordered 1,200 sacks of sugar…consigned to Muroc, returned to his warehouse in Los Angeles." Stacked up, Borgia faced conspiracy, failure to register a still, evading taxes, engaging in the business of a distiller and a few other charges. The still operators received six months each and paid fines of $501, but Frank Borgia got a much rawer deal—he was found guilty on six counts.

> Fresno Bee, *November 1, 1934*
> *L.A. GROCER GETS PRISON TERM AND FINE OF $8,000*
> *FRANK BORGIA OF LOS ANGELES ALSO FACES FEDERAL INCOME TAX INVESTIGATION*
>
> *Frank Borgia, L.A. wholesale grocer, who was sentenced yesterday to pay fines and penalties totaling $8,000 and serve four years in McNeil Ireland Federal Prison following his conviction on a revenue act conspiracy charge, also faces an income tax investigation which has resulted in a federal lien on $17,000 in bank deposits in Los Angeles.*

After hearing a report from federal officers, Judge Cosgrove denied Frank a motion for a new trial. The report indicated that Borgia had "handled thousands of pounds of sugar, yeast, tin cans, vats, and other equipment during the past seven or eight years through his grocery concern and that on many occasions such goods were traced directly from his place to numerous stills." Officers further contended that if not for "the cleverness" of bootleg drivers, "many other stills would have been seized," arguing that "federal agents trailing sugar from his place at times had been deceived in their attempts to locate illicit distilleries." Even with the judge against him, Frank managed an appeal. He fought his case all the way up to the Supreme Court, but at that level, he was denied a review. Frank now realized that, without a doubt, he would be seeing the inside of a jail cell.

All the untaxed activity got the IRS sniffing around, a fact which later proved more than meddlesome for the Niotta family. Frank's back-to-back,

drawn-out courtroom cases smeared the papers for years, which must have been double-edged for Big George. On the one hand, redemption and irony could be tasted in knowing Frank would pay the price for betrayal. On the other, the affair proved quite embarrassing. George made a key mistake. Not only did he trust too strongly, he also gave that trust to the wrong man. The desire to fit in with a "prominent" crowd and to be viewed as a big shot had impaired his judgment. Desperate to be on top, he'd employed reckless moves, and the brash action cost him his profitable business. It was something the big boys he rubbed elbows with would have taken note of. Lending to forgiveness, with the way of the world during that era, a lot of high-flying princes—Big George's prestigious connections included—had already been damaged by the hefty brunt of LA business. In the long run, the Niottas lost much more than just a friend and a successful operation; all the heat Frank Borgia brought on soon proved devastating.

The Ripples

Finally the IRS caught up.
—*Celie Niotta-Cacioppo*

Eventually, the taxmen got around to auditing the records of the Italian Wholesale Grocery, and as Celie hotly asserted, "Borgia put in the books that George earned $5,000 a week!" The family claims that Big George never received anywhere near that sum, at least not as a wholesale supplier. True or not, the taxmen cared very little, and unavoidably, "finally the IRS caught up." Luck and a technicality kept Big George a free man during the last sugar caper, but this time the G-Men and T-Men had him. They wanted their due, and they were going to have it.

Agents of the Internal Revenue Board visited the famed Wilshire District and knocked on the front door of the Niotta family home. Not long after, they opened shop on the front lawn, conducting their business in plain sight of the esteemed neighbors. "Borgia ruined him" Celie expressed, recalling sadly that the revenuers "sold all of their possessions and house at auction." Furniture, jewelry, wardrobe, heirlooms—the taxmen gladly signed it away. The younger George was only about two when it happened. "The auctioneer for the IRS just started auctioning off everything. In those days the IRS would come and auction off everything right there on your lawn." Being legally robbed stirred a powerless feeling, and seeing

members of the community vying for their possessions served as a hard reality for the Niottas to swallow. John and Celie Cacioppo bid frantically but weren't equipped to compete with the big-money neighbors, wealthy residents of Beverly Hills and the Miracle Mile. "I had to buy my mother's bedroom set," Celie confessed grimly. Unfortunately, it was "the only thing we were able to save." This bedroom set is still in the family and resides in George's San Dimas home, where his Aunt Celie lived out her remaining days in his loving care.

Agents raided the desert still in Kern County during the final hour of the sugar trade. Prohibition was repealed a few months later. Call it bad timing. If all had gone as planned, popular items like pasta, cheese and olive oil would have returned to the roster, and Big George's sons, Michael and George Jr., would have taken over. And if that had happened, perhaps the Niottas would still own the Italian Wholesale Grocery. In April 1937, an act used to dissolve a large number of delinquent corporations wiped the business out of existence. Big George moved on to other endeavors while Frank Borgia left for a four-year stretch, a sentence fitting for the act of treachery. Some years later, Frank went missing and, according to Jimmy "the Weasel" Fratianno, met with a violent end.

> Fresno Bee, *December 26, 1951*
> *POLICE FEAR FOUL PLAY IN CASE OF MISSING LA MAN*
>
> *Los Angeles—The police reported today that Frank Borgia, 56, wealthy wine merchant, former moonshine king and known associate of underworld figures, has been missing for 24 days and is feared to be the victim of foul play. Dep. Det. Chief Thad Brown said Borgia's car was found abandoned in Tijuana, Mex. Dec. 6th with his topcoat in it. Brown said he suspected Borgia "has been taken for a ride."*

4
HOW WE GOT TO LOS ANGELES

Piana dei Greci

Roughly fourteen million people—one-third of Italy's population—left the country between 1876 and 1914. Aside from city-leveling earthquakes and tidal waves, outbreaks of malaria and hordes of insects that decimated crops, the wages were by no means sufficient. As Mariann Gatto pointed out, "Italian peasants lived in abject poverty, earning on average only 31 cents for working a twelve-hour-day, a wage that proves even bleaker when one considers that sugar cost 19 cents a pound." An "outsider" class, Sicily's peasants even lacked the right to vote. Faced with unfair treatment and a lack of laws to protect them, and embraced in a desperate way of life, few saw prospect of a better future—which is why so many came to America.

On May 7, 1924, the mayor of a small town in the mountains of Sicily, the town of Piana dei Greci, waited to greet the Kingdom of Italy's new prime minister. Mayor Francesco Cuccia—better known as Don Ciccio—was waiting for Benito Mussolini. Because of the troubles he'd heard about in Piana, Mussolini made it a point to pass through the town and speak to its people. By this time, Big George, a native of Piana dei Greci, had already made it out to Los Angeles by way of Louisiana, and Jack Dragna had made the trip from Italy to New York twice. Upon Mussolini's arrival, Don Ciccio quickly noted that an

entourage of guards accompanied the official. Expressing friendship, he offered, "You have nothing to fear as long as in my company." Wise to Don Ciccio's methods, the gesture was snubbed. In addition to learning of the violence and criminal activity employed in dei Greci, Mussolini had also been informed about how Ciccio "arrived at the office of Mayor." He'd forced the Socialists, now the majority in Italy, "to resign from the City Council in 1921" and ensured they wouldn't run in the upcoming election. Offended by the dismissal, Don Ciccio ordered the townsfolk not to attend Mussolini's speech. When few showed later that day, Mussolini's pride also burned, but there would be no question as to who held the greater power.

In 1937, after nearly a dozen years of imprisonment, Mayor Don Ciccio—now just plain Francesco Cuccia—was finally released. As for the others imprisoned by Mussolini, nearly fifty men rotted in prison until July 1943. Leading the U.S. Seventh Army in the invasion of Sicily during World War II, General George S. Patton mistook these corrupt individuals for political refugees and released them, reinstating an old problem thought long dead.

Mercurio and the Traveling Niottas

Big George, his father, Mercurio, and the Dragna family—along with a swarm of others immigrating in the latter part of the 1800s—joined one of the first large waves coming to America. Nearly one quarter of these travelers were south Italian, the bulk from the island of Sicily. If the 1924 Immigration Act hadn't limited the number of Italians who could land on U.S. soil, there's no telling how many iterations of Little Italy America would currently offer.

Mercurio Niotta was born on August 26, 1856, to Giorgio Niotta and Anna Pecoraro-Niotta. In May 1889, at the age of thirty-two, he boarded the SS *Letimbro* for New York. Back in Piana waited his pregnant wife, Cecilia Parrino-Niotta, who would soon give birth to Giorgio "Big George" Niotta. "The economy was so poor they couldn't make a living," says Mercurio's granddaughter Celie, who'd been named after her grandmother Cecilia. The hopeful pair made plans to reunite once he found steady work, a plan typical of families coming over. After securing a job, Mercurio sent word home and learned that Cecilia had given him a son. George arrived on the Fourth of July 1889. A happy man, Mercurio continued to make preparations, but

unfortunately, the dream never materialized. Sadly, Cecilia passed before the family could unite. Devastated over the loss, Mercurio wrestled with a difficult dilemma—return to Sicily or wait until someone could bring his son to him. Deciding to stay, baby George went to live with relatives.

Little George made the trip at about age two, accompanied by cousins on the long boat ride to America. "The Marcella family was coming to New York," says Celie, and "Mercurio asked if they would bring his baby George to him." The ship's log for Mercurio's 1889 voyage suggests he made the trip with two other men—Pietro Messina and Giorgio Marsala. The family name Marcella was likely misspelled by the ship's registrar. The same can be said for the Niottas, whose name became "Neoto" at Ellis Island. Mistakes such as this would prove common. Finally united, Mercurio and little George left New York for Louisiana, charging by train to Kenner. Celie believed her father made the trek to meet up with family, which makes sense in Mercurio's predicament—he didn't have a wife and now he had a five-year-old to care for. It is also possible the pair left for Louisiana to seek help from friends. The Matrangas had already made the trip, and marriage tied these two families.

Louisiana

In the late 1800s and early 1900s, when Sicily was an awful place for a commoner, Louisiana was a bad place for anyone Italian—wealthy or not. Rivalries among Italian fruit vendors had been raging since as early as the 1870s. In New Orleans, the ongoing feud between the Matrangas and the Provenzanos turned violent. Accounts in the local papers suggest they spent a fair amount of time shooting, stabbing and killing one another. The *Daily Picayune* called it "Italian Vendetta." In an effort to discredit one another and to ward off customers, each family had taken to accusing the other of belonging to the dreaded Mafia.

In America, the Mafia, the Camorra and the Black Hand extortion gangs served as a form of big entertainment. The papers printed weekly serials about the diabolical plots of these and other secret societies. Little more than pulp, these stories ran alongside tales of ghosts, men from Mars and short fiction about robots. Even Jules Verne cashed in, penning the faction's name with two *f*s in his 1880s weekly. "For eighteen years there had existed in Sicily, and principally at Palermo, its capital, a formidable association of malefactors." Paralleling these mafioso with Freemasons, Verne bragged

that in Italy they numbered in the thousands. "Theft and fraud by every possible means were the objects of the Society of Maffia, to which a number of shopkeepers and working people paid a sort of annual tithe to be allowed to carry on their trade without molestation."

Whether or not the crime was perpetrated by an Italian, the 1890 murder of police chief David Hennessy made matters exceedingly worse for Italians living in Louisiana. Allegedly, the chief whispered "dagos" with his dying breath, a claim that quickly dragged the Provenzanos and Matrangas into the picture. On the supposed whisper of a dying man, the city's cops rounded up and arrested Italians en masse. While alibis and a lack of evidence eventually allowed the majority of the accused to be released, a miraculously high number—nineteen—for the murder of just one man remained in custody. Charles Matranga, the patriarch of his family, sat in jail among them. From this group, only nine suspects ended up going to trial; lacking the evidence to convict them, the ruling came down in their favor. Six of the accused received acquittals, and the judge declared a mistrial for the remaining three.

On March 14, 1891, the front page of the *Daily Picayune* read, "None Guilty!" The judgment didn't sit well with the city's residents, and in response, a mob of angry white Louisianans promptly reacted. Thousands rallied and broke into the jail to take out vengeance. Although blacks were most commonly lynched in the state—and fairly often—Italians were second on the list. The lynching of eleven Italians in that New Orleans jail is still seen as one of the nation's largest mass lynchings. Rather than label the event criminal, reporters instead chose to justify it. "They took in their own hands the sword of justice, and they did not lay it down until they had executed vengeance upon the criminals whom the corrupt ministers of justice had excused and set free."

It came as no surprise that charges were never brought up. Many of the mob's participants were considered upstanding members of the community. Word about the lynching quickly spread among Italians everywhere, saddening and outraging colonies throughout the country. All across the nation, Italians congregated to discuss recourse. New Orleans Italians, representing some fifteen of the city's most prominent associations, assembled at Mechanic's Hall. Two hundred gathered in Nashville; in Boston, the numbers reached nearly three thousand, filling Faneuil Hall. In Kansas City, six hundred Italians met and decided to get word to Baron Fava, the Italian minister in Washington. "We, the Italians of Kansas City, Mo.," read the telegram, "deplore with the deepest feeling the massacre

of our country men in New Orleans Saturday last by a violent mob. We voice one sentiment in our request, that you demand a just and impartial reparation."

Fearing further bloodshed and retaliation, Baron Fava bid America's Italians to be dignified and calm and to exhibit legal behavior. He reached out to the Italian premier, Marquis di Rudini, who gave word to Italy's King Humbert. The issue of indemnity to the surviving families was raised by the foreign government, but American officials pointed out that Italy had no right to demand such a claim. Displeased, Italy ceased diplomatic relations with America, and Baron Fava was called back to Italy. Rumors of war even surfaced but never came to fruition. Eventually, the international dispute cooled, but for Louisiana, it wasn't over. In the summer of 1899, when an altercation between two Sicilians and a physician ended up in the death of a "white man," a drastic response resulted.

The Difatta brothers of Piana dei Greci—Frank, Joe and Charles—ran a general store and a successful fruit stand in the town of Tallulah. Though the area had virtually no Italian colony, the Difattas fared well. A dispute over a goat, however, put an end to the brothers' prosperity.

> Times-Democrat, *New Orleans, July 22, 1899*
> *DETAILS OF THE AWFUL TRAGEDY*
>
> *The town of Tallulah, on the Vicksburg, Shreveport and Pacific Railroad, about fifty miles from Monroe, was the scene last night of a terrible tragedy, one of the worst in the history of North Louisiana. Five Italians were swiftly sent to meet their maker at the hands of a mob, and the primary cause of all the trouble resulted from the killing of a billy goat. The five men made up the entire Italian colony of Tallulah, there being no women or children.*

The goats belonging to the Difatta brothers proved to be a bit of a nuisance for some neighbors, namely physician J.F. Hodge, who complained frequently about the animals' "depredations." The Difatta goats had taken to "trotting up and down" the doctor's "veranda day and night," whittling his patience into action. After discovering one of his goats had been shot dead, Frank Difatta approached his prime suspect. Openly and defiantly, Dr. Hodge admitted to the crime then confessed he had no gripes about doing it again. "You killa my goata, you killa me," Difatta exclaimed, then stormed off to avoid further conflict.

On their way to dinner later that evening, Dr. Hodge and one of his associates passed by the Difatta brothers' storefront. Seeing the doc, Frank Difatta jumped to action and "endeavored to knife him." "The doctor grappled with him and at the same time drew his pistol." He gave no warning; he simply fired. The pistol's chamber jammed, though, and as the doctor attempted to clear it, Frank's brother Joe reacted accordingly. "Standing in the doorway of the store," Joe Difatta saw the doctor's weapon pointed at his brother. Without hesitation, he "discharged a Winchester shotgun," scattering buckshot into the doctor's groin, abdomen and hands.

Judging from the wounds, it was evident the doctor wouldn't make it, which bleakly solidified matters for the Difatta brothers. "It didn't take the people of Tallulah long to learn of the shooting." A group gathered and entered the Difatta brothers' store. "Quickly they were hustled into the turnpike and marched about a quarter of a mile from town." In an old warehouse, ropes surrounded their necks, "and in a moment their bodies were dangling from a beam." Unfortunately, this violent satisfaction failed to sate the residents of Tallulah. They'd started something drastic and figured they might as well see it through. The hateful mob went after the town's remaining Italian populous next, tracking down Charles Difatta, Si Deferoch and John Cereno.

The three innocents were taken to the jailhouse, where, conveniently, there "is a small oak tree." The men begged for their lives, but "there was no mercy shown." "Almost in the time it takes to tell, three bodies were swinging from the limbs of the little tree." They hung so close, "as they swung" they "touched each other." And "thus ended the lives of Tallulah's Italian residents." The small Louisiana town didn't sit too far from where Mercurio and his young son George had settled. Thankfully, the pair was not alone. The Marcellas made the trip as well.

Big George Niotta

Leaving at just two, George Niotta never attended school in Sicily. Unable to read or write in Italian or English for the duration of his life, it's doubtful he received much book learning stateside, either. Far from uncommon, illiteracy remained especially prevalent among agricultural societies—both in Italy and in the United States. The odds that a child of southern Italy would not learn to read or write, however, remained far higher than it did for residents living farther north, on Italy's mainland.

The southern region had long been thought inferior by its exceedingly providential neighbors, who boasted not so much being Italian as they did being "Venetian," "Florentine," "Milanese" or "Roman." Despite this division, for a long time in American history, anyone at all who came from Italy was considered lowly and seen as nothing more than a meddlesome dago wop.

In Louisiana, Mercurio and George harvested sugar cane, cotton and rice for truck farmers Roy and Jesapina Guarneri, who sold product at a market stand. Early on, young George took a liking to the farmer's daughter Bienia, and eventually the pair began to go steady. Never much caring for the family name, the young girl from Baton Rouge went by Phyllis instead. As life was often harsh and short for the poverty stricken, most started their families young, and George and Phyllis were no exception. At seventeen, they married and made their home in the city of Montz, right on the edge of the Mississippi River. Celie, the first of what would end up being eight children, arrived in the next year, 1908. Speaking of herself, Celie noted that "the first girl baby was named after the father's mother," Cecilia. Italian tradition strictly outlines what each and every child should—and must—be named. Birth order and gender take precedence in the rigid system, and although it is far less honored today, older generations adhered to it fairly religiously—even in America. As Celie strongly threatened, "It was a disgrace if you did not honor your father and mother!"

A few months after the birth of their first child, Phyllis contracted typhoid. As her condition was highly contagious, they needed help. Thankfully, family friend Sarah Bovi was able to care for little Celie during the recovery. Making the ordeal all the more difficult, the men—Big George and Nick Bovi—were not around. They'd taken up work with the railroad far north in Rockford, Illinois, and were sending back whatever they could. At the foundry, George and Nick pulled in thirty-five cents an hour—not bad considering the average wage for a blue-collar worker stood at a whopping twenty-two cents. Like the Niottas, the Bovis had also worked for Roy Guarneri, which is how the families became friends.

Big George and Phyllis's marriage certificate, 1907. *Courtesy of Anthony Amador.*

Left to right: Nick Bovi, his father, Tony, Anthony Amador, Johnny Cacioppo and George "Bully" Niotta, circa 1951. *Courtesy of Anthony Amador.*

While toiling in the fields, they became close, but it was the aid given in a time of great need that really strengthened their union. This bond, which started in Louisiana and carried over into Illinois, did not die in the South. More than three decades later, a marriage in Los Angeles would officially unite them.

"It is an Italian custom that the first boy child would be named after the husband's father," explained Celie, though Michael is a far stretch from Mercurio. While this rule would certainly account for George's given name, Celie's niece Frannie Niotta points out something to the contrary, stating that the first boy born is always named after a saint. In the case of the many Georges among the Niotta clan, either rule usually fits—the patron saint of the family's hometown is Saint George. Nearly four years passed between the births of their first and their second child. By then, the men had returned to fieldwork in Louisiana, finding a home and job in Phyllis's hometown of Baton Rouge.

Despite a lack of formal education, George displayed a natural ability with numbers. Before bearing the title "Big George," folks referred to him as "the walking calculator." This knack, which grew impressively, later proved to be a gift, securing him higher-paying positions. "One of

his first jobs before my grandpa came to California," relayed the younger George, "was as an estimator of acreage, because he knew numbers well." This skillset is exactly what Big George put to use after the return from Rockford. He secured work as an advisor and estimator. After surveying the land, George was able to provide an estimate of "how many tons of grapes" a farmer could expect to yield. He proved quite accurate in his estimations.

In Baton Rouge came Michael, then another daughter. According to custom, "the next child would be named after the mother's side. The third child—second girl—was named Josephine." Although one for honoring tradition, George strayed from the formula with the birth of his second son. The child "should have been named Roy, but because of a disagreement with in-laws, Grandpa George named him after himself." For George, moves like this—bending the rules in his favor—would become an art. The Niotta family had grown, and quickly. George and Phyllis could now boast four children—Celie, Mike, Josie and little George—and with the addition of a junior, their patriarch finally took on his lasting title, "Big George." Although already well stocked, the couple was only halfway there. But the final four Niotta children wouldn't arrive until after they landed out west.

Los Angeles

In 1917, Mercurio, Big George, Phyllis and their brood hit Los Angeles. The reason for the move was the same as before—more and better opportunities. Arguably, the Matrangas served as trendsetters; they'd left dei Greci for Louisiana first and were already basking in the California sun by the time the Niottas made their entry. Big George found his old friends established as fruit merchants, grocers and ranchers. Matranga cousin Joe Ardizzone had followed a similar path. Although the Matrangas and Ardizzones shared blood, by the start of the 1900s, a feud had erupted, and it was about as bad as the New Orleans rivalry with the Provenzanos; the quarreling escalated into murder. The Cuccia family of Los Angeles—relatives of the former mayor of Piana dei Greci, Don Ciccio—became casualties of the violence, likely because of Joe Ardizzone's mother; her maiden name was Cuccia. When Joseph Cuccia was shot by an unknown bicyclist way back in 1906, police believed the crime to be one of reprisal and sought Tony Matranga. The mess was sparked a few months earlier, when Ardizzone shot Matranga associate George Maisano in the back. He'd been running from lawmen

ever since. The hit on Ardizzone's young relative was certainly personal and may have been carried out solely in an effort to draw him out of hiding. Thankfully for the Niottas, the excitement died before their arrival.

Like many Italians finding their place in Southern California, the Niottas made their home in an area of the city that had been carved out for them. Mariann Gatto explained that "restrictive racial covenants" that were "designed to enforce segregation" huddled Italians into communal sections, keeping them from areas like "the San Fernando Valley and West Los Angeles," where the laws prohibited them from owning property. Boyle Heights became one of several popular Italian destinations, and although the Niottas moved around a bit, they resided in and around this area for their first dozen years in the city. Surprisingly, they never situated within the Sixth and Seventh Wards, near Wilson and Alameda, where a large community of south Italians from Piana dei Greci and Corleone had gathered. There, the familiar dei Greci dialect of the Sicilian Albanians was even spoken.

Marion, the first of the Niottas' native Angelenos, arrived in 1919. During the summer of the following year came the last of George and Phyllis's boys, Stevenson George, "Stevie." Though many would say six is plenty, the couple had two more girls for good measure. Anne "Annie" Elizabeth joined them in 1922, and the baby of the bunch, Lucille Marie, was born in 1925. "Marion was named after Grandma Phyllis's grandmother, Marion Guarneri." Stephen was named after Uncle Stefano, his mother's older brother; "Stefano was Americanized to Stephen." Next came Anne, named after the youngest of the eight Guarneri children, and "the last child was named Lucia," which they Americanized to Lucille, though everyone just called her Lucy.

While Los Angeles of old remained fairly segregated—and predominately white—Boyle Heights of the late teens and early twenties in no way mirrored the image. Big George's son-in-law Anthony Amador contends that this trend carried on into the forties, as well. A student at Boyle

Big George and son Stevie, circa 1930. *Courtesy of George Niotta.*

Left: Michael Niotta (*seated far right*) and Boyle Heights buddies, late 1920s. *Courtesy of George Niotta.*

Below: Niotta market on North Boyle Avenue, circa 1924. *Far left*: Mercurio "Mike" Neoto. *Center*: Big George Niotta with arm around son Stevie. *Courtesy of Catlin Meininger.*

Big George, mid-1930s. *Courtesy of Catlin Meininger.*

Heights's Roosevelt High during the late thirties and at the start of World War II, Amador explains: "The high school that I went to…had Russians, Mexicans, Italians, Armenians, Japanese, Chinese, Jews and…we had some black students in school, too—on the football and track teams. Segregation in California," he pointed out, "wasn't like it was in the South." Many of the assorted nationalities making their way into the crowded ethnic ghettos intermingled, yet they still managed to maintain their own identities within these shared neighborhoods, forming little communities all their own. Only now is Boyle Heights truly segregated, boasting an almost exclusively Latino demographic. And it was in that Italian borough that Big George raised his family and scratched his way into LA's fearsome business world.

Big George didn't start out as an all-out success. He had bosses, and he made mistakes. George came to work as a foreman for Mr. Small at his L.K. Small Company. In this role, he exercised his talent with numbers, traveling out to farmlands with a crew of men to handle estimates and counts, just as he'd done in Louisiana. In addition to this, by as early as 1920, he peddled fruit at his own stall in the Grand Central Market. Though doubtfully

much, whatever income he could spare he channeled into promising outlets. This eventually included the Bohemian Distributing Company but may have commenced with a confectionary supply formed with his cousin Mike Marcella and his wife's brother-in-law Pete Siggia. The success of the business, which had been run out of a supply warehouse, led George to open a retail shop in 1922, the Neoto Candy Company. And by at least 1924, the family established another storefront, a neighborhood grocery.

Big George's father, Mercurio, made the long trek out to Los Angeles as well and was running the family store at 669 North Boyle Avenue. Making the job easy, the shop stood directly beside the family home at 675. Laughingly recalling the family business, Celie commented that her baby sister, little Lucy, "would eat the butter out of the display." But butter, Kellogg's Corn Flakes and Camel cigarettes weren't the only merchandise stocked on their shelves. Prohibition had kicked in, and seeing an opportunity to capitalize, Big George got into distilling his own hooch; the "bootleg liquor" was "stored in olive oil cans" right there in the shop. At about the same time, George also became a wholesale supplier and importer, specializing in Italian goods. Working out of a warehouse on nearby Kohler Street, he began delivering product to storefronts throughout the neighborhood. From there he would move on to running sugar and eventually learn to play the stock market, falling in love with the rush.

At last, the future began to look favorable for Big George Niotta. He'd sprouted a family and pushed hard to do more than just survive, going from pennies an hour to dressing well and becoming his own boss. Still unsatisfied with this achievement, he continued the stride upward, hungry for status, recognition and a catchy title. For George, a word like *mogul* sounded nice, but *millionaire* sat a little closer to what he was after.

5
SWEETS AND INCENDIARIES

*One of the most unusual incendiary "plants"
ever brought to the attention of the police.*
—*Boyle Heights law enforcement division*

The records of Piana dei Greci/Piana degli Albanese list the Niotta name in its current spelling, but for more than three decades, the family wore the phonetic version handed out at Ellis Island. Birth certificates, marriage licenses and other documents until the late 1920s all read "Neoto." A revert to the proper spelling didn't take place until around the time the market crashed. Come 1931, Big George had acquired the Casa Aleros Apartment building, located in "the heart of the Wilshire District." Considering the economic climate, chances are the original owner had problems keeping the rooming house afloat. George must have picked it up comparatively cheaply. Wanting to boost his acclaim as a budding LA businessman and add his own flare to the venture, Big George renamed the spot the La Niotta, marking what may be the first public appearance of the proper spelling here in America. The shift achieved more than just restoring the family name, though; strategically, it offered George a clean slate.

Police deemed a 1918 blaze an unexplained accident, but an incident three years later left little to the imagination. The first mishap was set off by a vehicle fire that grew out of hand, causing grief for Big George and two of his North Boyle Avenue neighbors—"Auto truck and twenty-five chickens add to loss in Boyle Heights fire." One of the three barns torched belonged

to George; the others were owned by "several poultry dealers" who used the space to store their goods. Seeing it as an accident, the police didn't bother digging. The next fire; however, was a different story.

> Los Angeles Times, *January 22, 1922*
> *INCENDIARY DEVICE IS DISCOVERED*
> *OFFICERS FIND "PLANT" IN BUILDING AFTER MAN TURNS IN FIRE ALARM*

The second fire involved the candy supply outfit Big George partnered to form. According to the Boyle Heights law enforcement division, it also involved "one of the most unusual incendiary 'plants' ever brought to the attention of the police." If not for the "prompt action of an unidentified man" who saw smoke and pulled a fire alarm, the authorities may have never learned the truth. The fire "would have obliterated all trace" of the intended crime. Unfortunately for the Niottas, the papers weren't shy about pointing out that the building was "used by George Neoto as a warehouse for confectionary stock." Because it had been caught early, the warehouse received little damage, making the assessment an easy job for fire investigator Captain Enos. The inspector discovered five "cans filled with gasoline" spread around the warehouse. Each had been "connected by a line of absorbent cotton saturated with gasoline." As if taken straight out of a James Bond death scene, "in the center of a heap of the cotton" stood two melted candles.

The warehouse contained six hundred pounds of candy and hundreds of empty cardboard boxes. Although the haul only amounted to "a few hundred dollars" worth of goods, the insurance covered a five-grand loss. Quick on the case, detectives grabbed four suspects "connected with the candy firm": Big George, Mike Marcella, Pete Siggia and their partner, James Puzzutto. The group of tenants renting the warehouse space "denied the charges against them," and their alibis must have checked out, because four months later, the *Los Angeles Times* announced the opening of the Neota Candy Company at 5823 Moneta Avenue in the city of Carson.

The confectionary job and the deliveries to hidden liquor stills weren't the only "sugar" Big George tried hiding. Another sweet he fought to keep secret was a sweetheart. Even though the family contends that George never divorced Phyllis—and he probably never did—for a brief spell he did have another wife. Pageant beauty Ann Sharar, a youthful Montana looker, had been entering and placing high in her hometown's local popularity contests

CALIFORNIA RESIDENT VISITOR

MRS. GEORGE NIOTTA
Mrs. Niotta, formerly Miss Ann Sharar of this city and now a resident of Los Angeles and San Francisco, is spending the summer in Great Falls visiting her parents, Mr. and Mrs. Sam Sharar. She also is a guest of Mr. and Mrs. Fred L. Woehner.

Big George's "trophy bride" Ann Sharar visits her hometown. *Great Falls Tribune*, August 17, 1936. *Courtesy of Publisher, J. Strauss, retrieved from www.newspapers.com.*

and bikini competitions since an early age. How Sharar came to know, and wed, Big George Niotta isn't certain, nor is the legality of their union. Chances are that the relationship ran its course exclusively in Northern California while George conducted business tied with the brewery. Because he'd secured a second home in San Francisco, this is likely where he hid his trophy wife. The legal issues surfacing for George around this time probably account for why he sent the young model packing. Conveniently, the new Mrs. George Niotta spent the summer of 1936 in her hometown of Great Falls, visiting her parents and family friends, the Woehners. Perhaps less than convenient for Big George, ten months after her Montana stay, the Woehners made a trip to Los Angeles for something a bit more lasting—the marriage of Miss Ann Sharar and Angeleno Matt Tonkovich.

6
THE EL REY BREWING COMPANY

The Cacioppos

He came upon two men in the road—a big guy with a shot gun and a small guy with a machine gun.
—Jerry Cacioppo

Come late 1933, after being robbed of his successful importing concern, Big George retired from the sugar racket, but he hadn't left the liquor industry entirely; he'd merely decided to work it from a legitimate angle. Although the bootleg art was still alive, impending repeal was anything but secret, and the smarter lot had already launched in other directions. Earlier that year, a popular brewery in the northern end of the state reopened, and although the name had changed, the place still peddled the same old business. With a desire to move product in the Southland, the brewery's new owner reached out to Big George, who had apparently gotten more out of his dealings with the Bohemian Distributing start-up than thought. But if George were to achieve the ultimate goal he had in mind, he would need to recruit the help of his family.

By the time of George's affiliation with the brewery, his children had already sprouted families of their own. In 1927, Celie married her teen sweetheart, Johnny Cacioppo; two years later, they had a daughter. Though

Left: Best man Tom Leventhal, flower girl Anne Neoto, groom Johnny Cacioppo, bride Celie Neoto, ring-bearer Don Siggio, maid of honor Rose Cacioppo, 1927. *Courtesy of George Niotta.*

Right: Celie and little Georgie, mid-1930s, Wilshire District. *Courtesy of George Niotta.*

named Eleanor, the nickname "Lolly" would stick. Come 1933, the couple was expecting their second. Celie's brother Michael had a baby on the way, as well, and George Jr. had just given Big George his first grandson. Keeping with tradition, they named the boy George. To minimize the confusion, the handle "Bing" was cooked up. Confounding such efforts, George's brother Michael would have a boy—he, too, would bear the family name. The littlest George arrived on July 30, 1934, and was from then on known by all as "Georgie." Thirty years later, Georgie would meet Tommy Boscio and learn all about the family's bootlegging secret. Sadly, Johnny and Celie were not as fortunate. The couple lost the baby. Because Michael's wife, Rose, was pregnant at the same time, Celie grew exceptionally close with her new nephew, Georgie. He became her godchild.

The Niotta and Cacioppo families had plenty of reason to be close—Big George's son and daughter had married another brother-sister combo. Michael Niotta's wife, Rose, was kid sister to Celie's husband, John Cacioppo. But by the time marriage tied them, they'd already entered arrangements with Jack Dragna. The trend of George's brood marrying his associates

wouldn't end with the Cacioppo pairing. Not long after the end of World War II, another wedding would bring them even closer—the union of Big George's youngest son and Jack Dragna's only daughter.

The Niotta-Cacioppo connection culminated when John was still quite young. By the end of 1924, the Cacioppo children had lost both of their parents, leaving John to care for six younger brothers and sisters. "The boys had to find some kind of work," conveyed John's niece Frankie, who offers a romanticized version of how a pair of teenage brothers got involved in the bootleg liquor trade. "My dad ran the booze for Jack Dragna, and so did my Uncle Johnny." Mere months after the death of their patriarch, forty-four-year-old Calogio Cacioppo, Anaheim police discovered ten cases of bonded gin in the back seat of Johnny's car. New to the trade, the young runner had neglected to cover his cargo. The arresting officers contended that "they would never have suspicioned the car"; however, "in these days of Volsteadianism, bottle necks, while perhaps objects of beauty for their sheer gracefulness, are also considered objects demanding a closer inspection." Journalistic humor aside, the offense forced Johnny to choose between a year in jail or a fine of $1,000. Thankfully, his associates promptly paid. As "small time" as the infraction appeared, by the close of Prohibition, the papers had come to call John Cacioppo a "public enemy," pointing out that he'd been arrested nine times and that the police knew him by at least six aliases.

John's kid brother played an active role in the illegal booze trade as well and could also boast an impressive rap sheet. Although he'd been arrested some fourteen times for hauling bootleg liquor, Gaspare Cacioppo was never once convicted. "Juice" and "payoffs," explains Gaspare's oldest, eighty-year-old Jerry Cacioppo. "My dad used to be a runner. He had a little '29 coupe with hollow fenders—a little Ford." Gaspare made an art out of driving with his headlights off and ditching the cops in the dark of the California desert; he just loved to run in his little four-cylinder Ford. The routes the runners took weren't limited to the Southland. The outfit also delivered far north into the other end of the state, with the larger batches hauled by truck. On one trip, however, the goods never made it.

"The booze was going to San Francisco out of Fresno," Jerry indicated, adding that after his father rounded a turn, he came upon two men in the road—"a big guy with a shotgun and a small guy with a machine gun." Facing execution, young Cacioppo acted, praying the move wouldn't leave him riddled with slugs. "My dad turns off the ignition, gets out, walks over and hands the keys to the guy…then walks all the way into San Francisco!"

Johnny Cacioppo and daughter Lolly, early 1940s. *Courtesy of Frannie LaRussa.*

Thankfully, they did not feel the need to kill him. After the close call, John furnished some photographs for his brother to look over, asking, "Are these the two guys that held you up?" Sure enough, Gaspare identified them. "Dad didn't tell me who," Jerry admitted, but he was informed that "the young guy with the machine gun killed quite a few people."

The highway wasn't the only way the booze came in; the real stuff arrived by boat. "It was San Pedro. A ship came down from Canada with cases of Canadian booze." Being a twenty-two or twenty-three-year-old "wise ass," as Jerry Cacioppo put it, his father "hijacked three cases." While unloading the ship with the other workers late one night, Gaspare secretly dumped three cases into the ocean. Returning later, he claimed them, but not without being noticed. Learning about the deception, Frank Borgia demanded, "Go get him!" Before long, Gaspare realized that he and his '29 coupe with the pilfered whiskey were being followed. Figuring he'd been caught, the fear of the grave penalty sank in. Desperate, Gaspare pulled off the highway and parked in front of a hardware store. Hurrying in, he purchased a .38. Deciding instead to run, he snuck out the back and got to a telephone, then rang his brother. "John! Borgia's men are gonna kill me, John. They're gonna kill me!" Pleadingly, the young man confessed his misdeeds then listened intently as his older brother assured him, "I'll take care of it." John explained the situation apologetically to Jack Dragna, who quickly intervened. Relaying his father's story, Jerry said, "Jack Dragna told Borgia, 'Lay off Cacioppo, he's a paisan.'" After that, Gaspare would be forever grateful and always think of Dragna as the man who saved his life.

Eagle Brewing

The brewery up in San Francisco that Big George handled distribution for in 1933 had been around since before the start of the century. Swedish-born brewmaster and yachtsman Carl A. Tornberg opened the Eagle Brewing Company in 1899. Over the course of many years, the well-respected Swedish American, whom many San Franciscans believed to be the creator of steam beer, had ties with several Bay Area breweries, including North Star Beer Bottling Works, the Consumer's Brewing & Bottling Company and his self-titled Carl A. Tornberg Brewing. With the Eagle endeavor, Tornberg had partners—his wife, Elizabeth, and Mr. and Mrs. John H. Claasen. The couples held Eagle sites at 1329 Guerrero and 2213 Harrison. In 1902, they incorporated with three other investors, but the arrangement proved short-lived. In 1904, the Claasens purchased the Tornberg half, and following the not-so-happy transaction, the families ended up in court.

Under the Claasens, the brewery got off to a rough start that never quite lifted. Although Bad Luck Brewing was never on the list of titles the company wore, it certainly would have been the most fitting. The year the

Inside the World of Old Money, Bootleggers & Gambling Barons

Carl A. Tornberg's North Star Brewing, 1899. *Courtesy of Debra Turner.*

Tornberg's brother-in-law and employee, Carl Ahlmen, standing below the Twenty-Sixth Street sign. *Courtesy of Ahlmen's great-granddaughter Debra Turner.*

Claasens bought out the Tornbergs, the city's brewery workers went on strike, creating a whole slew of problems. A series of accidents followed that, resulting in more than one Eagle employee being injured by gunfire. In 1905, the Claasens' five-year-old daughter passed, and in the next year came major earthquakes, fires and a construction crew that laid down train tracks directly in front of the brewery entrance, discouraging patrons. Although Eagle survived the fires and earthquake of 1906, 1911 delivered a devastating scorcher they just couldn't escape. The blaze nearly cost the family the life of another child. The stable of incinerated horses couldn't boast the same fortune. When the fire rekindled two weeks later, it mattered very little; the initial flare-up resulted in a complete loss, totaling roughly $20,000.

Functioning at the same time as the Claasens' Eagle Brewing was San Jose's Eagle Brewery—the first established in Santa Clara County. Adding customer confusion to the competition, the not-so-far neighbor with a nearly identical name also peddled steam, brewing its trademark Old Joe's. Thankfully for the Claasens, when the Bay Area's taste buds shifted, the other Eagle switched over its plant to produce lager. Further alleviating the troubles of a desperately similar product, the all-brick San Jose brewery eventually met with four charges of dynamite. And if a second Eagle wasn't enough, a third Eagle Brewing Company out of Grants Pass, Oregon, proved just as unlucky, losing an ice plant, a roadhouse and a brewery to a fire in 1905.

After the Bay Area blaze, San Francisco's Eagle Brewing began anew, setting up on a half-acre plot that the Claasens owned in Mission Terrace. They built on Mission Street between Mohawk and Amazon. Mohawk would later become Seneca, but not before the brewery put out a beer in its honor. The Claasens' seven-lot space also included a saloon that the family rented out then later sold. Following suit, bad luck tailed them to the new location. Working as a night watchman, John Claasen Jr. added to Eagle's list of accidents—"while making his rounds in the brewery yard" early in the morning "his revolver dropped accidentally from this pocket, and, striking the ground, exploded, sending a bullet into his abdomen." Thankfully, the younger Claasen lived, and despite clumsiness, he later became a partner in the company. Eight more years and the family faced the Eighteenth Amendment.

Oakland Tribune, *March 7, 1919*
BREWERY IS OFFERED FOR USE AS SCHOOL

San Francisco—Mrs. Mary J. Claasen believes she has found a new use for breweries made useless for their original purpose by reason of the

prohibition laws and regulations. In her opinion, as submitted to the Board of Education, one brewery at least will make an ideal school. She owns the brewery, which is at 5050 Mission street, and her communication to the board offers it for sale or under lease terms.

By the coming of Prohibition, John Claasen Sr. had passed. Claasen's widow was far from helpless, though. In fact, Mary J. had been an avid buyer and seller of properties since the turn of the century and appeared in the papers far more often than her late husband. In addition to the brewery, she owned grocery stores, corner flats near Haight Street and other assorted real estate properties. Eagle Brewing had been under Mary J.'s control since the 1911 fire; perhaps she blamed her husband for the incident. Rather than turning over the brewery's operations to her son John Henry Jr. or allowing the facilities to be used as a schoolhouse during Prohibition, Mary J.—for whatever reason—instead chose to let Eagle sit unused. The site remained that way for two years. After finally proposing a use for the premises that his mother would approve of, the younger Claasen leased the property and opened a coffee concern. Beer delivery had gone from horse-drawn carriage to car, and now as Eagle Packing Company, those brewery vehicles were allegedly hauling only coffee.

Claasen Jr. eventually took over ownership, and come 1929—twenty-five years after the family's legal dispute with the Tornbergs—Eagle flew into another courtroom battle. The affair marched through the Bay Area papers as "The Eastbay Liquor Scandal." Federal agents linked illicit bootleg activities to a laundry list of high-ranking law enforcers. Fifty in all were indicted. The ring was headed by "beer baron of the Eastbay," G.B. "Bacci" Ratto, and another hopeful liquor czar, Oakland bail-bond broker John Filipelli. With the help of law enforcement, the ring attempted to open up drinking parlors all over the city. Despite influential connections and backing, the efforts toppled. Double-crossed, one of Filipelli's associates "squealed."

The mass arrest that followed snared Alameda police judge Edward J. Silver, Oakland captain Thorvald Brown, three Oakland sergeants and a handful of the city's patrolmen. Former Oakland deputy constable Edward Bennett—also a one-time Prohibition agent—made the list of the accused as well, not only for sale and possession but also for the crime of impersonating a federal officer. Next, authorities came after Eagle's Claasen, charging him with selling and transporting illegal beer and "furnishing the malts used in the Eastbay breweries." But Claasen held a legal permit to manufacture and

sell the malt beverage, a point his lawyer aggressively clung to. And with a name like Assemblyman Hornblower, it's likely Claasen's legal counsel got the point across enthusiastically. "The liquid malt put out by Claasen will not make beer by itself," Hornblower explained to the jury, pointing out that "something has to be added, something has to be done to it." Hornblower also reminded the courtroom that the man who provided tanks of carbonated gas to the brewery hadn't been indicted. Making the connection, he then questioned why his client was being held "responsible for what might be done with his product after it leaves his plant?" Highlighting the fact that folks could make alcohol with nearly anything, he also jokingly argued that "George Washington made beer with molasses." In the end, Claasen paid a $3,000 fine. It looked as though he'd serve a year in prison as well, but luckily, he swung probation.

>Oakland Tribune, *August 29, 1929*
>U.S. CLOSES BREWERY OF RACKETEER
>FEDERAL PERMIT OF EAGLE PLANT IN S.F., OPERATED
>BY JOHN R. CLAASEN, CANCELLED BY DRY CHIEF
>
>*The federal permit of the Eagle Brewery, 5050 Mission street, San Francisco, source of the materials used in manufacturing beer sold to the Eastbay "beer racketeers" convicted in the recent trials, was revoked today.*

EL REY BREWING

It was too lively to get into a bottle.
— Oakland Tribune

For the second time, Eagle Brewing at 5050 Mission sat dormant. And the cobwebs would have likely continued to gather if a man named Edward J. Preston hadn't been stirred to action. After receiving a bit of encouragement in 1933, Preston secured a U-Permit then purchased Eagle Brewing. With repeal so near and the legal paperwork in order, Preston made plans for success the legitimate way. Although California remained fairly uptight throughout Prohibition, the state did give "near beer" its approval. Originally, the law capped the alcohol limit of these products at 1 percent, but this figure had since doubled. Bumping the ceiling to a whopping 2 percent still wasn't enough gusto for anyone to catch a buzz on,

though, so the change in policy did little to wake the industry. It wouldn't have any real movement until 1933.

Campaigning for the presidency, Franklin Roosevelt spoke out against Prohibition. By then, a lot of folks were fed up with the negative effects of the drought. The play not only made Roosevelt popular, it secured the win. Unfortunately for the new president, he'd stepped into a climate of exceedingly high poverty and unemployment. The country approached its fourth year of being locked in depression. Despite this bleak reality, it wasn't long before Roosevelt gave the depressed hordes something to cheer about. Right around the time George "Bing" Niotta entered the family, Congress received a knock on their door. While the attempt flopped as an instantaneous victory, it did stimulate visible progress. Signing of the Cullen-Harrison Act allowed the 2 percent legal cap to jump all the way up to 3.2, more than three times the original limit. Rumor has it that after signing the document, President Roosevelt even remarked, "I think this would be a good time for a beer." It was this nudge that moved Preston to reopen Eagle Brewing.

> Manitowoc Herald-Times, *March 18, 1933*
> *STEAM BEER WILL RETURN*
> *SON OF ORIGINATOR CLAIMS HE IS ALL READY*
>
> *San Francisco—Steam beer, exiled these many years along with lager, German old-style and other brews, will be back as soon as 3.05 or 3.02 per cent beverages are legalized. For San Franciscans and ex-San Franciscans, the news meant something. Beer drinkers of other sections had never heard of steam beer, or, if they had considered it something no one but a hardy native son could enjoy.*

While the papers in the Bay Area rejoiced over the coming return of steam beer, the reports in Los Angeles tallied up the damage of the 1933 Long Beach earthquake. A month after the destruction, Preston reopened Eagle as El Rey Brewing Company. Translated from Spanish, "El Rey"—like Elvis—is "The King." Budweiser may have become famous as "the king of beers," but during the 1930s, El Rey reigned as "the king of beer." Considering that a Budweiser beer out of the Kingdom of Bohemia established itself long before Anheuser-Busch spawned an American version, who were they to holler? Like Eagle before it, El Rey specialized in steam, yet, when the legal limit was initially raised, Bay Area drinkers doubted the stuff could be

El Rey Brewing Company letterhead, mid-1930s. *Author's collection.*

brewed at such a low alcohol level. Addressing the public's concern, Carl A. Tornberg's son Gunnar C. Tornberg stepped up and assured the masses, "We're all set." These words carried a lot of weight, especially considering that many San Franciscans believed the senior Tornberg had created steam beer decades earlier. To dispel popular belief, beer drinkers were enjoying steam way back when wee Carl was only five.

Today, steam beer ranks high and occupies the microbrewery realm. Despite modern opinion, the odd-flavored brew didn't always sport such a gleaming, elitist appeal. Originally, steam beer had a raw, working-class vibe and was considered by some to be low class and cheap. And, in truth, the process of producing steam beer may have come about more out of necessity than art. Some say it dates back to the California and Nevada gold rushes. Others believe it was crafted that way even earlier. Without access to ice or coolers, beer makers had to get creative in order to chill the hot, sugary mash of grounded malt known as wort. One popular method involved pumping the hot brew up through the ceiling into open-topped bins. High overhead on the roof, the blowing winds cooled the liquid radiator style. The steam wafting off the building top gave the brewery the appearance of a ship's smokestack sending out billowy clouds, which is what likely spawned the name "steam beer." While many breweries went this route, others tried another approach— the use of a yeast that fermented at higher temperatures. This special yeast gave the beer a very distinct flavor, though, and it wasn't a taste suited for everyone. Some call it a mixture of lager and ale. Others refuse to comment. In reference to El Rey's potion during its 1933 release, the *Santa Cruz Sentinel* labeled the odd pairing "colloquially peculiar to SF's taste."

Under the Eagle name, the brewery gained fame slinging beer for a nickel a pound. Smartly, Preston brought the popular product back just how the drinkers liked it. That summer, El Rey Beer reached north into southern

Above: King Matchbook, El Rey's SoCal distributor, mid-1930s. *Author's collection.*

Left: El Rey beer ad, Beverly Distributing Company. *Courtesy of Catlin Meininger.*

Oregon. Farther south, from the Tijuana border past the far reaches of the Southland, Preston looked to Big George for distribution. King Beverage Distributors Inc., out of Long Beach, may have even formed and found its name solely for the endeavor. On the surface, everything appeared to be going well for El Rey Brewing, which encouraged Preston to keep pushing forward. At the end of the next month, he announced plans for a $59,000 expansion, an addition expected to double production numbers.

About this time, Big George sat his daughter and son-in-law down and asked to borrow a large sum of money. Pretty sound financially, John and Celie Cacioppo agreed. Family records indicate a $32,000 investment. With the cash in tow, the family's patriarch set out for Old Frisco for a sit-down with E.J. Preston. Despite having sunk in such a large investment—$59,000 in the expansion alone—and despite standing on the cusp of what looked to be a rocket ship of continuing success, Preston sold El Rey Brewing. The transaction went public a month and a half before Prohibition's repeal.

Oakland Tribune, *October 20, 1933*
S.F. BREWERY SOLD

Sale of the El Rey Brewing Company, operating a plant here, to George Niotta of Los Angeles, who has been Southern California distributor for the company, was announced today by E. J. Preston, owner.

In theme with the brewery's history, bad luck followed the deal. Less than two weeks after signing the contract, a leak from one of the ammonia tanks

triggered an explosion. Steam beer is an exceedingly high-pressure beverage, which accounts for why it was originally only sold on draught—"it was too lively to get into a bottle." "The blast shook the neighborhood, shattering windows in the brewery building. Swiftly the fumes spread through the corridors, and the workers fled, gasping for breath." Twenty-five workers "were driven coughing and reeling into the streets," and once the firemen arrived on scene, "equipped with gas masks," they "fumbled their way through fog like fumes and dragged three stupefied workers to the street." The injured parties—an assistant brewmaster, an engineer and a barrel washer—were treated for suffocation at the Alemany Emergency Hospital.

The extent of the physical and financial damages remains unknown. Whatever the cost, El Rey managed to keep its doors open; a month later, Prohibition was lifted. The event changed the world of the bootlegger beyond what anyone could have ever imagined. On the legitimate side of the house, nothing too drastic took place, at least not on the inside of a bottle. The stuff El Rey put out went from 3.2 to what ads began to call "full strength," 4 percent. Defunct breweries quickly resurfaced, and newer competition sprouted. Despite the competition, El Rey looked pretty solid. According to records from the defunct California Brewers Association, El Rey outsold the local outfit Globe Brewing, moved more product than nearby Salinas Brewing and even managed to outsell Grace Brothers all the way down in Los Angeles. Like Eagle, El Rey had grown quite popular, but the brewery as a whole remained one of the smaller operations in California.

Over more than four decades and several name changes, the brewery that eventually became Big George's El Rey brewed and bottled quite an assortment. In addition to a steam and ale version of its signature El Rey beer, it also put out varieties of Albion, Steinbrau and Mohawk, plus Tornberg's Old German Lager and, of course, Eagle. The plant brewed and bottled under private label as well, producing signature products for independent stores like Rocca's Market. For the chain of Leidig's stores, it made Dutch Mill Brand. One of its popular beers found its name as a result of the brewery's location; the plant stood on what was originally Mohawk Avenue. Many streets in the Mission Terrace area bore the names of Native American tribes. In theme with the name, the beer's logo had a feather-headed profile of an Indian chief. Attempting to go more authentic with its advertising, the company even placed the tribal symbol for peace on either side of the chief. Although few likely made this connection, the image's similarity to another symbol—one growing exceedingly popular in war-stricken Europe—eventually became a problem. The Native

American symbol for peace looks exceedingly like the Nazi swastika. To remedy the situation, little black squares were soon inked over this portion of the Mohawk logo.

Taking on a new owner wasn't the only change at El Rey. As his grandson explains, "Breweries owned baseball teams" and "George Niotta had a baseball club with the brewery." The younger George even brags a bit when he contends that one of the star players was none other than Dom DiMaggio, kid brother to the slugger Joe. Whether or not DiMaggio played for the El Reys, they were "rated as one of the best semi-pro teams in the bay district," and Big George was thought of as anything but fair weather. He even got situated in a home in the city. As the local papers announced, San Franciscans quickly learned that "George Niotta, sporty sponsor of El Rey Beer team, believes in doing things first class." In addition to arranging games at Catalina Island and Los Angeles, he made frequent gestures of goodwill, such as purchasing large amounts of benefit tickets. He even fought for the team at the board level.

EL REY GAME CALLED, NIOTTA THREATENS TO QUIT LEAGUE

George Niotta, owner of El Rey beer baseball team, may withdraw his club from the Seals Stadium Winter League race because Doc Renton, umpire, called the Dalmo Mfg–El Rey Game at the end of the seventh inning on account of darkness yesterday.

The ump's decision caused a win for the Dalmo team and "put them in a tie for first place." It also "put a stop" to the "Beer team's winning streak"—something Big George took harshly. "Niotta, it is said, will appear before the Northern California Baseball Managers Association tomorrow night to protest." Cleary, Big George was invested. For reasons such as this, he became "rated the best bush baseball sponsor since the death of Jack Blum."

In 1935, when the brewery team was actively playing—and winning—the world of beer got thrown for a gigantic loop. Beer was no longer exclusive to a bottle! Collecting beer and alcohol memorabilia is a popular and profitable industry. Depending on condition and scarcity, the early artifacts go for top dollar, and among the hardest to come by, in terms of cans, are the cone tops. In the 1930s, El Rey Brewing put out "one of the most colorful groups of low profile cone tops" on the market. El

Rey Brewing cone tops in grade A1+ condition have sold for as high as $21,000. The brewery's products were aesthetic and unique, and for that reason, they grabbed attention. According to the book *The King of Casinos*, the beer did exactly that for a man named Willie Martello. So taken by the taste and style was Martello that he named his clubs after the Niotta brew. The Searchlight, Nevada gambling den and brothel, the El Rey Club, got its start in the 1940s and later served as the film site for Francis Ford Coppola's directorial debut, *Tonight for Sure*. Unfortunately, the popular Nevada spot suffered the same fate as Eagle Brewing's first location—the place burned to the ground.

As monumental as the year had already been, 1935 ushered in even more change for El Rey; another George came into the fold. In October 1935, two years after Big George Niotta grabbed the helm, the *Chicago Packer* announced George Musante as president of a newly formed corporation that had just purchased El Rey Brewing. For the family, as was the case with Frank Borgia and the importing company, Big George's trusting nature comes into question. A poor contract sealed with a handshake is one theory. "Everything was first class with him—hotels and restaurants—but he couldn't read or write." Not knowing the true cause of the family loss, the younger George assumes that "he must have signed some paperwork that caused him to lose the brewery." But as he'd also asserted, his grandfather "took the chances," and with any gamble, there's always a losing party.

The family is certainly right when they make claims about issues over contracts. Although Preston appeared to have it all together when he put in for that brewery expansion back in 1933, in reality, it may have been too much to square alone. Whether or not Preston started out as a sole proprietor, he ended up forming a corporation, and as the brewery's distributor, Big George learned of the business's financial problems. In true opportunist fashion, he looked to play the situation to his favor. George lent "between $30,000 and $50,000" to the corporation when "it was in financial straits" and "creditors were threatening suits." Preston had obtained the U-Permit in his own name, and during Prohibition, the brewery could not legally buy or sell its products without it, which made him a vital and irreplaceable asset. Perhaps to ensure the longevity of his importance, Preston "did not transfer the permit" to the corporation. When Big George came on board, however, Preston "transferred his interests" personally.

In the legal mess that later ensued, attorney Milton Marks pointed out that Preston and his associates "abandoned the corporation and notified Niotta he would have to take over the entire business," which "he did."

Left: El Rey cone top (1935–38), 2017. *Belgium Lion Photography, author's collection.*

Right: Eighty-one-year-old George with eighty-year-old can of his grandfather Big George's brew, 2017. *Belgium Lion Photography.*

Unfortunately, the break was not that clean. "The fortunes and misfortunes of El Rey Brewery, 5050 Mission Street," would later continue in a courtroom. Big George hired Marks to help "in straightening out" a list of problems. According to George, "the business had been looted" and he was "being defrauded." When Marks failed to produce the kind of results his client expected, Big George stopped paying for his counsel, which added a fight with a lawyer to his tally of mounting troubles.

As a member of the corporation, Big George wore the title "Vice President and Manager." Who exactly held the presidential hat remains uncertain. Praise in the papers for George's involvement with the El Reys ball team referred to him as the brewery's VP and manager at least until the early part of 1935, so the partnership, however uneasy, must have lasted at least a year and a half. El Rey's other board members included E.J. Preston, promoter, and directors Thomas Stevenson, Julia Britain and Edgar Mathews.

Regardless of how and when Big George left El Rey, the brewery didn't wear its crown for that much longer. Two years after Musante signed on,

Left: Unrolled El Rey beer bottle label, Albion Brewing (1938–41). *Courtesy of Andy Martello, author's collection.*

Below: 5050 Mission, former brewery building mid-demolition, 2016. *Courtesy of photographer Kari Orvik from her upcoming book.*

El Rey reintroduced an old favorite, Albion Ale. Perhaps going for a new identity, the brewery soon made another change—its name. By the summer of 1938, El Rey had become Albion Brewing, but the switch did little to save the corporation. Early in 1941, Albion filed for bankruptcy. The proceedings were held up by a pending court case, though. In an effort to achieve industrywide uniformity, the board of equalization placed restrictions on beverage container sizing. Albion and the Colorado-based Adolph Coors

Brewery each had smaller, signature eight-ounce cans that the board had targeted. Despite achieving a courtroom victory, the company still folded. The resilient plant at 5050 Mission carried on once more, though, reopening under its original Eagle title shortly after bankruptcy. But this, too, proved short lived; Eagle closed shop for good in 1942.

After the plant stopped brewing, the nearly half-acre lot on the corner of Mission and Seneca took on various identities. Staying longer than any other tenant were Louis, Frank and Bill Cresta and their family-run Cresta Bros. Auto Parts. Later ventures included King of Furniture and A&A Tops & Trim. In 1956, the Order of Sons of Italy in America (OSIA) moved into the building kitty-corner, with an address just one number off—5051—and christening the spot the Grand Lodge of California. OSIA's state first vice president, Arlene Nunziati, remembered the old furniture store and indicated that the former brewery site had since been demolished. "It's now under construction, and condos are being built with underground parking and businesses on the first floor." Hopefully, the six-story, sixty-one-unit mix of condos and storefronts will have better luck than Big George Niotta and El Rey Brewing.

7
THE 1936 MULTIMILLION-DOLLAR LOTTERY RING

The Niottas didn't limit their less-than-legal end of business to bootlegging ventures. When the liquor rackets died, gambling picked up heavy and a lot of money traded hands over running horses. Big George and sons made their share of racetrack dough in more than one way—as bookies, as racehorse and betting establishment owners and by tying into the illegal lottery.

THE WIRE SERVICE

To operate a book without a reliable wire service is about as feasible as flying without an engine.
—The Green Felt Jungle

The wire service and bookie system allowed gamblers to pursue their art without having to make it down to the track. But like any convenience, the service wasn't free. Subscribing bookies received printouts of the race results from tracks all over the country via teletype machine. Bookies phoned these outcomes in to the betting houses. Bookmakers recouped the hefty expense of this subscription by laying it on the bettor. Considering sanctioned racetracks took a cut of bettors' money, plus added on taxes, the act didn't sit too outlandish. Adding to the popularity of offtrack betting, with a bookie a gambler might even earn a line of credit. Although placing offtrack bets remained illegal, the wire service itself sat completely legitimate. In fact, in Las Vegas, licensed casinos not only subscribed,

LA bookie house bust by an undercover agent. *Los Angeles Times Photographic Archive, Library Special Collections, Charles E. Young Research Library, UCLA.*

they became dependent. Without the wire, casinos lost a big chunk of their earnings. The same can be said of the vast number of independent bookies acting as middlemen in just about every American city. The federal government may have deemed a bookie's services unlawful, but it only seemed to deter them a little.

 Reid and Demaris said it best in *The Green Felt Jungle*: "To operate a book without a reliable wire service is about as feasible as flying without an engine. You may stay up there awhile, but sooner than later you're going to drop." Any bookie foolish enough to try and get by without a subscription was forced to rely on the radio and newspapers for results, which left them susceptible to bettors who already knew the winners of the races they were about to bet on. Losing the inside word to the horses crippled a bookie, leaving him to peddle the numbers, the lottery and whatever else gamblers would throw their money at. This demand and dependency on the wire meant that service providers could hike their rates without receiving much resistance, which is exactly what Benjamin "Bugsy" Siegel did with Trans-American. This got

pricey, considering the weekly fees laid on a bookie house were based on the number of telephones in use at their establishment.

Control of the racing wire spurred a bloody struggle that sent authorities investigating affiliated parties nationwide. They tried suppressing bookie action by cutting off access to telephone and telegraph services and by continually raiding clubs and bookie houses. No matter what the feds tried, though, the wire kept going. Gambling itself hadn't changed much since the inception of the wire, but by the end of World War II, the same could not be said of the climate of the country. Bootlegging now an afterthought; speakeasies had either closed or were legitimized. More importantly, with the Depression lifted and our boys back from the war, jobs and a steady income had again become the nation's norm, ensuring a much larger pool of cash to swim in.

Bookies and the Tracks

Overall, as was the case with alcohol, Uncle Sam proved indecisive with gambling. Although California chose to play wishy-washy, nearby Nevada re-legalized it in 1931. Why not take a percentage off the bettors? For Californians, however, it would take a couple more years before the coming of progress. Pari-mutuel wagering received state sanction in 1933. "Pari-mutuel" is a French word that roughly translates to "mutual stake." Here in America, though, it mostly just means "betting on the horses." It's not much different than the lottery, either. Everyone buys a ticket, and all the money gets pooled into one pot that's shared among the winners—minus the house's cut. The obvious difference lies in how a winner gets picked. One involves grabbing ping-pong balls marked with painted numbers; the other depends on which horse crosses a line in the dirt first. On a somewhat deeper level, bettors argue there's something more than chance with playing the horses. That's what Moses "Moe" Annenberg and other big-time operators in the racing wire industry capitalized on—the bettor's belief that they have an angle. Odds, such as a horse or jockey's stats, certainly do come into play; not to mention favorites, long shots, ringers and who's having a bad day. The finer details aside, via a constitutional amendment in 1933, this specific type of gambling was legalized once again, and shortly after that, the tracks reopened.

For the bookie, the action triggered the opposite effect that Prohibition's repeal had on the bootlegger—the industry boomed. In a sense, these fellows became the new bootleggers in the authorities' eye. These enterprising men

could be found at local bars, pool halls and just about any other popular haunt around town; anywhere away from the track, that is, hence the term "offtrack betting." To put it into perspective, after knocking off from a ten-hour day of work, whether or not a bettor has "got a feeling," chances are there's no way of getting all the way down to the track in time to place a bet. Enter the bookie.

The dilemma is illustrated well in Charles Bukowski's novel *Post Office*. Henry Chinaski decides that today's the magic day. He has a feeling on a horse. It's gonna be a winner! He's going to finish delivering the mail a little early so he can beat the traffic down to the track. He's got to get there before the betting window closes. Chinaski delivers the mail double time. He's jogging, he's sweating, he's not even turning off the delivery truck engine—it's just idling in the middle of the street. The other guys on the route take notice and ask, "Hey Chinaski, you gotta use the toilet or what?" Well, he does, but he lets them know the real reason he's in such a hurry. Today's the day, he's got a winner! He's gonna knock off early, he's gonna get clear across town before the traffic's bad, he's gonna place a bet before the window closes and he's gonna see the No. 4 horse cross the line with his teeth in front of all the other runners. And how do the other postmen respond? "Hell, this Chinaski's a genius!," they decide then to turn out their pockets and grab for their wallets. "Can you put five bucks down for me?" "I'll take six on that four." "Make mine eight, buddy!" What Chinaski and his fellow postal workers really could have used were the ever-convenient services of a bookie. Once these accommodating chaps came on the scene, bettors could hit their local pub for a short beer and a smoke instead of weaving madly through the clog of LA traffic. And if a bookie wasn't already inside waiting, chances are it wouldn't be long before someone peddling the action came along asking. The main problem associated with this trade was that Section 337a of some penal code somewhere made "pool-selling" and "book-making" not only illegal but an honest-to-God felony!

The Lottery Ring

They said it was the largest lottery scheme ever uncovered in the United States.
—Arizona Republic

In 1934, a dentist and a movie mogul got to work on a course out in Arcadia. They named the new spot Santa Anita Park, after a racetrack that opened

nearby back in 1907. The original closed when the government banned gambling the first time around, and sometime later it caught fire. The newer facility opened on Christmas Day 1934. Soon, runners like Seabiscuit gained legendary fame there, and before long, the Irish Sweepstakes hopped the pond. The government of Ireland authorized the Irish Sweepstakes lottery in 1930 in order to help fund hospital building programs. "In its heyday, Irish Sweepstakes tickets were sold in 180 countries around the world, with winners coming from Caracas to Cape Town, Bengal to Buffalo." Although available on a global scale, the Yanks out-bought everyone. The Irish Sweepstakes sold more tickets in America than it did anywhere else on the planet, which is impressive considering it never received sanction from the U.S. government.

Tickets could be found all over the United States, but because the lottery wasn't legal, gamblers had to seek out a vendor. Finding lottery tickets at the tracks made sense. What better place to sell than where people congregate en masse, and what better lot to appeal to than those already resigned to a game of chance that might rob them of their money? And so, lotteries like the Irish and Manchester Sweepstakes gave bookies a reason to come back to the tracks. Ticket sellers had been getting arrested at Santa Anita since as early as January 1935, mere days after the park opened. And for the same reasons that racetracks appealed to lotto sellers, they enticed pickpockets and other criminal elements. The environment was by no means a cesspool, though. High society frequently congregated. On any given day, landowners, actors, industry heads, entrepreneurs, racehorse owners and even princes of small countries could be spotted. It made the setting a regular mixed-salad representation of the California community while simultaneously showcasing its bevy of vacationers.

What was thought to be a simple local lottery based on the 1936 Santa Anita Christmas Day handicap soon snowballed into the heights of more than a million dollars, and the Niottas got caught in the mess early. Initial reports listed George Niotta as a lottery ringleader. Just days prior to the first arrests, three bookies from Anaheim were being charged for their part in a sweepstakes based on the previous year's handicap. The suspects in tow over the 1935 job appeared to be little more than street-level operators, bookies carrying four grand in tickets and slinging the goods for a buck a piece. To strengthen this theory that they'd nabbed small players in a large scandal, any sportsman during the mid-1930s with enough pull and smarts to drum up, organize, financially back and delegate sales and collection of an illegal lottery scheme of that size—let

alone actually successfully pull it off—was definitely not the same fellow out there winking and nodding at the track for a dollar a throw. One major difference separating the 1935 and '36 capers lies in the size of the purse—$100,000 versus more than $1 million. Another contrasting factor relates to the criminals netted; with the 1936 lottery, the authorities did far more than nab just street-level vendors.

On November 19, 1936, approximately $15,000 worth of lottery tickets were seized in Los Angeles. Deputy sheriffs brought in Frank Burnham, Howard Atcheson, George Niotta and George's oldest son, Michael. In addition to charging them with "violation of the bookmaking laws," authorities also tacked on "conspiracy to cheat purchasers." Oddly, an astronomical bail for the crime was recommended—twenty-five grand each! Apparently, some hefty lottery action had gone down in Texas and the LA sheriffs felt the incidents might be linked. Turns out they had the right idea.

The tickets grabbed in California matched those confiscated in Texas. The stubs, which were printed south of the border, invited buyers to "come to Old Mexico, the tourists' paradise." Law enforcement's score in San Antonio involved a small group of Angelenos who'd been arrested near the Texas-Mexico border for possession of roughly $100,000 in tickets. Like those taken in Southern California, the wager pended on the results of the 1936 Santa Anita handicap. These LA men out in Texas—Frank Thayer, Ed Hayes and Walt Olsen—claimed to be promoters of a Los Angeles-based organization known as the International Sweepstakes Corporation.

Naturally, lottery tickets printed in Mexico, smuggled into Texas and seized before being sold to make off-track money from a sanctioned horserace all the way out in California piqued the interests of federal agents. They began digging. Authorities dropped in on the usual bookie establishments around town, and before long, they came upon another lucky score—fifteen thousand tickets in a shop in El Paso. Already, the new lottery had surpassed the prior year's attempt. Following the second score in Texas, officers picked up the phone; after speaking to officials in Mexico, they started ringing agencies across state lines, eager to sniff out similar activity. The more they dug, the bigger it got. The papers caught wind early. Originally, they called it a million-dollar lottery scheme—quite an uproar during the mid-thirties and already by far the largest endeavor in U.S. history. That one mill soon jumped to three, though.

Arizona Republic, *November 7, 1936*
RACE LOTTERY SCHEME BARRED

San Antonio, Texas, Nov. 6—Customs officers said 3 million tickets to be sold for $1 each were printed in Mexico City on order of a Los Angeles corporation and 1,200,000 were in the California city for sale. They said they seized 35,000 tickets in a bookmaker's shop here and 17,500 in Laredo. They said it was the largest lottery scheme ever uncovered in the United States, and was brought to light by the combined efforts of agents in many parts of the country. Officers said 20,000 tickets had been sold here.

Back in LA, Big George's face turned up in the *Los Angeles Times*. Though certainly one for popularity, this wasn't the sort of attention he was after. The local reporters kept George's son Michael out of the papers, but journalists elsewhere neglected to extend the courtesy. "Two of the men arrested yesterday were apprehended in an automobile on Ventura highway with 15,000 sweepstake tickets valued to $1 each in their possession, while a third man, George Niotta, 47 years of age...said by Stensland to be one of the leaders, was arrested in a downtown rooming-house." Agents picked up Big George "in a raid" at the Beaconsfield Manor Apartments. The building, addressed at 329 South Manhattan Place, sat just a few blocks from the La Niotta. When they took George in, he had 3,000 tickets in his possession.

Big George nabbed in million-dollar lottery, *LA Times*, November 20, 1936. *Los Angeles Times Staff Photographer, copyright 1936,* Los Angeles Times, *reprinted with permission, retrieved from www.newspapers.com.*

Inspector Norris Stensland (*far left*) sniffing for clews. *Los Angeles Times Photographic Archive, Library Special Collections, Charles E. Young Research Library, UCLA.*

Rising in the sheriffs' ranks and making a name for himself, Inspector Norris Stensland had been appearing in the papers often. And he would continue to do so, eventually gaining a measure of fame; 1940s journalists loved quoting his threatening taunts toward bookmaker thug Mickey Cohen. Under the sheriff's guidance, a large number of tickets were confiscated and a handful of arrests had been made. But Stensland remained certain that a venture of this magnitude required multiple backers—and George Niotta was only one. Just who these other heavy players were, however, he couldn't yet figure. Undeterred, Stensland kept at it and quickly landed a few prime suspects. But things got dicey once he did.

Fresno Bee, *November 24, 1936*
OFFICERS SUSPECTED IN L.A. SWEEPSTAKES PLAN

Los Angeles—Arrest of several former law enforcement officers is predicted today by Sheriff's Inspector Norris Stensland as he investigates the

> *ramifications of a huge Santa Anita Sweepstakes lottery which is claimed to have authorization of the Mexican Government. Frank Benham, Mike Niatto and George Niatto are now held in jail while a fourth man, Howard Atcheson, is at liberty on $2,000 bond. Their trial has been continued pending further investigation. Stensland charged the sweepstakes was to have flooded western states with tickets and that millions of dollars would have been taken in had not officers blocked the plan.*

The lottery wasn't confined to Texas or California. Large quantities of tickets were seized as far north as Seattle. The reach of the caper continued to fan out into newer territories, and for that reason, Stensland received help. "In view of the fact that a large number of the tickets are known to have been offered for sale in adjoining States, the Department of Justice has entered the investigation." Taken aback at how well the operation had been put together, and how deep the corruption ran, Stensland shockingly admitted to the press that "one of the men suspected of being a member of the sweepstakes ring is a former agent of the Federal Bureau of Investigation."

> Bakersfield Californian, *November 28, 1936*
> *EX-U.S. AGENT IS HELD FOR INQUIRY*
>
> *Los Angeles—W.H. McKague, reportedly a former federal investigator, was held for questioning today in connection with an investigation of a sweepstakes ring, which recently attempted to flood the Pacific Coast.*

McKague marked the seventh suspect hauled in, but as Inspector Norris Stensland promised, "additional arrests" were coming; "the officials of several counties" remain "under suspicion." But investigations to bring said corrupt high-ranking, or high stature, individuals to light took a lot longer than Stensland expected. Such is the way of red tape. Although a preliminary hearing was set, a new grand jury investigation postponed it indefinitely. The timing of the lottery fiasco—happening a short while after the courtroom mess with Frank Borgia over sugar deliveries and raided stills—is probably what stirred such aggressive action on the part of the IRS. During the lengthy trial that ensued, the Niottas lost their home and possessions.

The case of the multimillion-dollar lottery ring remained silent in the press during 1937, suggesting the weavings of some deeply rooted political strings. Early in the year, wedding bells rang for Big George's daughter Josephine and her beau, Frank Loveday—a union that essentially married

her away from the family. And later in '37, John Cacioppo faced bookmaking charges for activities up north at Tanforan. With the lottery trial on hold during the long stretch of investigations, much of the Niotta kin relocated farther east. Reports on the lottery ring picked back up in January 1938, and when they did, they brought plenty of fire. That's when the police chief of Santa Ana hit the front page. Like Big George, he'd been implicated as a financial backer. Chief Floyd W. Howard and his brother-in-law, mortician Ernest Winbigler, surrendered to the U.S. marshal and promptly posted bail.

Other new suspects in the lottery ring included Balboa Beach amusement parlor owner C.W. "Big Hutch" Hutchings and former Federal Alcohol Tax Unit investigator and former special deputy sheriff H.W. McKague. Authorities hauled McKague in for questioning the year before but didn't have enough evidence to hold him; now they did. Another new development dealt with Frank Thayer, the LA promoter arrested in Texas when things first got started. Thayer was now believed to be the mastermind behind the scheme. Conveniently, no one could find him. Thayer skipped bail after his 1936 release and was currently thought to be hiding out in Mexico City. Already across the border, Stensland worried "his man" might never surface.

The count on those indicted by the federal grand jury now stood at more than a dozen, sitting at lucky number thirteen. As the papers severely warned, "conviction in the case would make the defendants subject to sentences of two years in prison or fines of $10,000 each, or both." Somehow the list of the accused no longer included Michael Niotta, though his father, Big George, remained guilty for his transgressions. The docket of "bad men" now listed him as a Riverside resident. The formal charges tallied against the accused now included "concealing, buying, selling, and transporting lottery tickets," and because the tickets crossed the Mexican border, the Customs Act had been violated.

Although involved, Curt E. Henderson was not among the men indicted; he'd turned witness and had goods on everyone. Based on Henderson's testimony, the jury got the inside word about all the money and tickets trading hands. "George Myotta" received roughly "18,000 lottery tickets from George F. Olsen." As the VP of Los Angeles's University Women's Club and a board member for decades, news of the scandal likely proved more embarrassing for Mrs. George F. Olsen than for mister. A hearing date was set, and a call to all those indicted was made. Former Federal Prohibition agent McKague, Santa Ana man Howard Atcheson and LA liquor dealer Edward F. Hayes turned themselves in. And after "Big Hutch" surrendered, lawmen could boast that they'd rounded up the last of the

LA and Orange County indicted. This didn't account for the adjoining county, though, where Big George headed, or the suspects located out of state. "The government dragnet swung toward Texas, to seize more distant members of the asserted lottery ring." Frank Thayer, alleged "originator of the lottery scheme," which he'd been "operating from the ring's base at Mexico City," was still missing. So were Frank Gowen and George Luigart. Less than hopeful about the hunt, Stensland and his men scoured El Paso and San Antonio.

Henderson's testimony confirmed the estimated three million marker of the lottery, and to further excite matters, the informant was no longer the only defendant to turn witness.

> Santa Ana Register, *January 25, 1938*
> *HAYES EXPECTED TO BE WITNESS IN LOTTERY CASE*
>
> *Edward F. Hayes, Los Angeles liquor dealer, pleaded guilty today to conspiracy charges based on an alleged lottery…and probably will be used as a government witness to testify against 12 others, with whom he is jointly accused.*

Seven more of the accused pleaded guilty and received a trial date. Those still claiming their innocence were Police Chief Howard, his mortician brother-in-law and the former fed, Henry W. McKague. Four more joined them in their fight to be exonerated, while the whereabouts of five other indicted men remained unknown. Either these missing men hadn't gotten word they needed to appear or they'd hightailed it after posting bail and were holed up somewhere in hiding. Among those unaccounted for was Big George Niotta, who hadn't fled the country. He had just moved over one county.

If the public had come to view each of these lottery ring installments printed in the papers as a form of daily entertainment, then the long stretch without coverage that followed must have been exceedingly frustrating. Ten months passed before fresh news arrived. By the time coverage returned in late November 1938, Big George had surrendered and readied himself with legal counsel. But his attorney, Mark Watterson, still hadn't entered a plea. In addition to George, Frank Gowen now also sat in custody. He asked for nolo contendere—no contest. The assembled batch of clever, high-dollar defense attorneys hatched plans to attack the accusations against their clients. The group expected to "prove that the defendants on trial were

merely 'suckers' for the 'slickers' who promoted the venture and escaped arrest and prosecution." Standing in the way of this freedom, however, was Curt E. Henderson, the well-prepared key witness armed with implicating telegrams, documents and letters.

Henderson explained that after getting buy-in—and cash—from the chief of police and others, he and Thayer went to Mexico City and obtained a permit to hold the lottery. "The permit authorized Henderson and Thayer to print the tickets, with the provision that $540,000 prize money was to be put in escrow"—hence the need for financial backers. Stensland had been rattling to the press that the lottery was an all-out scam, saying the prizes were a farce, but Henderson's testimony swore different; they'd taken the legally required steps—at least in the beginning. When the Mexican government failed to receive the full agreed-upon amount, it canceled the permit. Stensland's meddling may have been the blockade that kept them from meeting their deadline. Somehow, despite Henderson's testimony and all the evidence stacked against them, the lottery ring received a favorable ruling.

> Bakersfield Californian, *December 3, 1938*
> *SANTA ANA POLICE CHIEF IS FREED ON LOTTERY CHARGES*
>
> *Police Chief Floyd W. Howard of Santa Ana and seven other prominent Santa Ana residents today stood acquitted of charges of violating federal lottery laws. A jury in Federal Judge Neterer's court late yesterday returned the verdict after two hours of deliberation.*

Those fancy lawyers did a real swell job. Contrary to the *Californian*'s contention, the jurors made up their minds in all of five minutes. Those "two hours of deliberation" can be chalked up to the judge's dinner reservation. The big selling point in the win was the contention that the accused "invested their money in the lottery on the understanding that the tickets were to have been sold only in Mexico, where the lottery had the sanction of the Mexican government." Whether or not these fine members of the community knew what they were buying into, they managed to get out without too many bruises. Pocketbooks and public standing no doubt took a beating, but ultimately, no one served any real time or was ousted from office.

Frank Thayer, "accused by the other defendants of having evolved the plan" and who "received large sums from his associates," remained "a

fugitive believed in Mexico." They never caught him. Frank Thayer was either the multimillion-dollar lottery ring mastermind or merely a convenient scapegoat. Chances are he lived out the remainder of his days drinking chilled tequila in Old Mexico. What he pocketed would have gone a long way. In the case of the Niottas, although the *Bakersfield Californian* neglected to mention the fate of Big George, the *Los Angeles Times* wasn't so forgetful; it listed him by name among the eight lucky acquitted. And in regards to the Christmas Day race that inspired the whole scandal, by the close of the courtroom antics, the horses had long since finished their run. Top Row, the Thoroughbred that took the prize in 1935, again took honors, breaking a record in each instance.

A handful of months after Big George's initial arrest over the lottery scandal, legislators actively tried licensing and regulating bookies. "A commission to supervise a state-wide lottery, similar in scope to the Irish sweepstakes," was even sought. In December 1938, days after Big George's acquittal, an attorney for the liquidation of public debts approached Congress and proposed the benefits of legalizing and regulating bookies. Smartly, he argued, "states could painlessly meet relief costs and decrease taxes by licensing and taxing the lottery business." As practical as that sounds, lawmakers went the opposite direction.

> Santa Ana Daily Register, *April 1, 1939*
> U.S. SPEEDS DRIVE TO BLOCK SALE OF SWEEPSTAKE TICKETS
>
> *Justice Department officials said today all American winners in the recent Irish Hospital Sweepstakes may be subpoenaed to appear before grand juries if the attempt to break up a Los Angeles ring of ticket importers is successful. U.S. Attorney Benjamin Harrison at Los Angeles has subpoenaed 72 winners. He will ask them to tell a grand jury who sold them their lucky tickets. The "small fry" distributors, it was said, then will be asked to reveal the ticket importers, primary objective of the investigation. Officials said issuance of the subpoenas to winning ticket holders was a "test technique" which, if successful, might be copied by other U.S. attorneys.*

Nearly fifty years would pass before anyone bothered to listen to the advice of Lewis B. Perkins, attorney for the liquidation of public debts. Voters passed the California State Lottery Act (Proposition 37) in 1984, and by the end of the next year, the first tickets were available for legal purchase.

8
A RIVERSIDE ACCIDENT

The Niottas packed up their remaining assets and bid farewell to Los Angeles. With the lottery trial on hold pending further investigation, the family didn't move very far, and after settling into the dry heat of the Inland Empire, they began to make new friends. "I think there were about four or five brothers," remembers George's grandson about the prominent Tavaglione family he came to know as a small boy. This figure may be correct, though it's certainly possible more brothers existed. By the time Big George hit Riverside, Joe Tavaglione had already fathered eleven children!

The Tavaglione family—a very political and Democratic one—held a quite favorable reputation in Riverside. The community considered them successful businessmen and community leaders, and still does. At one point, Joe even served as president of the county's Italian American Society. The Tavaglione brothers George vaguely recalls from his youth are Leonard, Tillio, Dominic and Frank. Of the four, Frank was easily the most popular; he had a tenor voice the papers raved about and had even done a bit of touring. Like Big George and his sons, Papa Joe and his boys had their share of problems with the law, and with taxmen and dry agents specifically. Scars from similar battles no doubt made them kindred.

> San Bernardino Sun, *October 13, 1935*
> *JURY DELIBERATING TAX FRAUD CHARGES*
>
> *Tavaglione and Fred Chaddick were the only ones out of 57 accused of conspiracy in operating illicit stills and distribution of its product to plead*

> *not guilty and stand trial. Tavaglione, prominent in Italian-American affairs in Riverside and the father of 11 children, testified in his own defense and disclaimed any knowledge of the operations of his co-defendants. Government attorneys contend that the defendants were part of a large state-wide ring which operated numerous stills and defrauded the government out of alcohol tax.*

Situated just one county over, the Niottas kept close ties with Los Angeles, often entertaining guests from out west. John and Celie Cacioppo dropped by whenever they could, and family friends the Costas—a big name in the macaroni manufacturing business—also visited. The Niottas rejoiced at the gifts these visitors brought. Specialty items they'd grown accustomed to had proven difficult to locate in the new surroundings. This included cheeses and other delights Big George previously imported.

Without scrubbing any blame from their patriarch, the Niottas had suffered more than a little—jail time, a fatal run-in with the IRS, the loss of their ritzy Wilshire District home and at least two profitable businesses, plus being branded criminals in the papers and enduring a long, drawn-out courtroom battle. After all the heartache and frustration, a bit of a reprieve was certainly in order. Fortunately, the patch of luck they all so desperately needed soon arrived.

> Bakersfield Californian, *July 27, 1937*
> TAX CLAIMS ABATED
>
> *The IRS abated today tax claims totaling $57,389 against George Niotta of Los Angeles, determining an over-assessment in this amount on Niotta's income taxes for 1927 through 1931.*

This timeline coincides with Big George's affiliation with Frank Borgia. In 1927, the two families co-baptized their children with the Dragnas, and late 1931 marked the last time they got nailed jointly on a sugar caper. The over-assessed amount no doubt reflects the sum Frank had cooked in the books of the Italian Wholesale Company. The Niottas lost their home and possessions over those falsified records, so perhaps this was the IRS's way of owning up and providing restitution. By today's standards, the tax reprieve equates to roughly a cool million. To bolster the figure's worth, this was a cool million when folks were scrounging to pay the electric bill. Unfortunately, amid the immense joy and celebration, more grief waited. Three months later came a terrible accident.

Young Georgie Niotta, early 1940s.
Courtesy of George Niotta.

The younger George tells a tale of an awful wreck from his childhood. He believes he was three or four when it happened. It wasn't until last year that he learned he'd made the papers—"Eight Injured in Head-On Collision." The event took place at the very end of October 1937, ensuring a Halloween in the hospital. Georgie had just turned three, and his big cousin Bing was a whopping four and a half. It was a Friday evening, right about the time most people knock off from work, and a couple of guys in their late teens had just left a football game. Either joyriding or overly anxious to get home, the driver had a heavy foot. The car sped down a one-lane highway just outside of the Corona city limits. Coming upon a curve, he pulled around the bend carelessly and crossed the dividing line, hogging the path from opposing traffic. That's when the driver spotted the other vehicle, but by then it was too late. Flustered, he passed on the left in a desperate effort. The move forced the other auto off the road, but not until after the front right corners of each vehicle violently came together.

> *The accident, happening just at that hour, attracted scores of people and the cars lined either side of the avenue for more than half a mile. With the hundreds of headlights of cars and the red light of the ambulance, together with the screams of the little children and moans of their mothers, the whole provided a sickening sight with the two battered cars upside down in the ditch by the side of the road.*

Although far more than just scrapes and bruises resulted, luckily, no one perished.

> *Mrs. Florence Niotta suffered several fractured ribs, several of which were broken in two places, a crushed chest and other bad cuts and bruises. Her young son was fearfully cut about the face and neck, requiring between 70 and 80 stitches. He also was painfully bruised all over his little body. Mrs.*

> *Rose Niotta was severely cut about the face and rendered unconscious. Her little boy was also badly hurt but less seriously than the others.*

Confusion set in over George's face as he continued to read. It didn't take long before he commented that the journalist had it wrong. Although he'd stumbled upon several clear inaccuracies, the name of the driver is what really put him on the defensive. According to the paper, the Niotta vehicle contained three-year-old George Niotta, his mother, twenty-four-year-old Mrs. Rose Niotta, four-and-a-half-year-old George Jr. (Bing) and his mother—the driver—twenty-four-year-old Mrs. Florence Olive Niotta. This definitely was not how George remembered it. In fact, from what he recalls, his Aunt Helen—Bing's mother—was the one driving the vehicle. Still more confusing, he didn't even know who this Florence Olive woman was!

Bing and Georgie (*bandaged head*) shortly after their 1937 car accident, Riverside. *Courtesy of George Niotta.*

The notice of an "Intent to Wed" between twenty-four-year-old George Niotta Jr. of Louisiana and twenty-seven-year-old Helen Maurine West of Oklahoma didn't hit the papers until August 4, 1938, some nine months after the accident. By then, Bing was already five. This information, along with several details in the article about the accident, suggest that Helen was not Bing's birth mother after all. Clues hint that George Jr. and his first wife, Florence, were having problems. The *Corona Daily Independent* listed Florence's residence as the Riverside Motor Inn; she may have moved out of the family home.

Flustered over the subject, George switched topic to the wounds suffered by the two little boys. It was clear that the journalist had mixed up the injuries. Reading that he fared better than his cousin Bing, George barked, "I had over 150 stitches!" Another error then came to light. "The women had married brothers," which is true, "and each named their son after their uncle," which was not. The two Georges were named after their grandfather George, who was named after his.

George "Bully" Niotta with son "Bing," Riverside, 1938. *Courtesy of Frannie LaRussa.*

While further errors are certainly possible—such as mixing up the name of the driver—it is far more plausible that little Bing and Georgie were simply too young to remember. They'd suffered a traumatic experience, and shortly after that, Florence exited the picture. Pondering the past further, still milling the words he'd read, George eventually voiced something he figured coincidental. There had been a Florence in his Uncle George's life, but she didn't come around until after he'd divorced Helen—she filed papers in 1949. While many more women by the name of Florence were running around California in the 1930s, George's realization begs the question—were these two ladies actually one? Considering the possibility, George even woke to the idea. "Maybe Helen," he managed later in a quiet tone, "never told her son—her adopted son."

All but George and Florence's marriage mended after the accident. The crash sent Georgie and Bing flying through the windshield of the family car, and a lot of staples, stitches and fractures followed. Contrary to the newspaper description, Georgie received the worst of it. A piece of his skull the size of a silver dollar was never recovered. The three-and-a-half-year-old's recovery required an extended period of full-time care. Coincidentally, the nurse who assisted the doctor during the operation just so happened to be one of Joe Tavaglione's daughters. Being friends, they offered a hand. Georgie camped out at the Tavaglione ranch for a long stay. As the only patient, he received 'round-the-clock attention.

Doctor Templeton never inserted a plate in Georgie's skull. Either the boy was too young or the procedure was beyond the scope of the late 1930s. Whatever the case, the gap did eventually cover over. The accident left him with a permanent soft spot, though. "He'll never grow hair and he'll never go in the army," the doctor predicted. But he got it only half right. George joined the army in 1954 after being drafted for the Korean War. At Ford Ord, he waited for the order to head overseas until a new medical examination switched his profile from "A1" to "C," ensuring he'd never go over.

9
A GAMBLING PARLOR

We moved to Riverside because we were going into another business and that business was bookmaking.
—*George Niotta*

It didn't take long for Big George and his sons Michael and George Jr. to get back to the trade. They'd peddled the lottery and placed off-track bets out in Los Angeles, and the move inland only broadened their clientele. The initial flare-up from the multimillion-dollar lottery generated a lot of heat, but that fire lay dormant throughout the course of 1937, which is when the family got situated in their new surroundings. Michael's home became the center of the family's Riverside operation, an operation run by two brothers. Both played an integral part, with each role suited to their individual personalities and talents. Michael manned the teletype and handed off the printouts to his younger brother, who made the rounds about town and phoned results to the betting houses. George Jr. lived nearby and dropped by often. With the time difference to contend with, he sometimes came in at odd hours.

Whenever George showed up for the printouts, he'd visit with his nephew Georgie, and for good reason. "The wire service teletype was in my bedroom," remembers the younger George, who says his father hid it in the closet. "Uncle George called the races across the states to different tracks." Explaining further, he stated, "by reading the teletype paper, and by telephone lines, he would transmit the results to the club," sometimes

even calling "the race as it was being run." Anthony Amador said this of his brother-in-law George Jr.: "He was great at relaying the races—really good at it! He would practice in front of the family." "Sometimes it would come in early," George added, explaining, "tracks were running by Eastern Standard Time." Thinking of those off-hour visits, he reflected, "my uncle would come in like he was going to work, and he'd grab me and say, 'C'mon Georgie, let's sit on my knee and sing a song for everyone down at the club.'"

After receiving that big chunk of change from the taxmen, Big George got the boys situated in a new location. "Back then it was illegal to have off-track betting. My grandfather opened an off-track betting parlor." Describing the spot, George commented, "It was a huge hut. It had a round roof, and it was all sheet metal." The timeline of Big George's gambling parlor predates the popular Quonset, a hut that grew to fame during the 1940s war effort, meaning the family must have kept their desert club in a hut of another kind. Confirming this, the younger George explained that the place was up and running by the time of his horrific accident. They named the venture the Alliance Recreation Club.

Placed just north of Mission Boulevard, the Alliance Rec was nestled a bit out of the way. "It was right next to the bridge where the waterfall came down on Mount Rubidoux," says George, who, as a boy, sometimes visited. The Santa Ana River bleeds beneath this bridge, separating Riverside from its neighbor, Jurupa Valley. While the locale may have served to hide the gambling hall from public view and from the eyes of the authorities, in truth, concealment mattered very little. The club's presence would have been far from secret to the local sheriff, a man who initially paid the place little mind.

The gambling parlor catered to the horserace crowd, servicing offtrack bettors. Back then, Jack Dragna ran the wire in the Southland, operating the service in conjunction with East Coast newcomer Benjamin "Bugsy" Siegel. Siegel had just arrived in Los Angeles. Speaking of Jack, George indicated, "he and my grandfather were friends, so that's possibly why he had his wire service for the club." Considering the family's jukebox and vending machine connections, in addition to offtrack betting, the Alliance likely offered a variety of gaming tables. Michael and George Jr. remained involved in the wire end of the business, receiving and disseminating the outcomes for the club and other locations. Big George's youngest boy, Stevie, helped out as well, though on a far smaller scale. He wandered in after school to make some pocket money. Anthony Amador indicated that his brother-in-law "cleaned up around the club" and "made drinks at the bar." Family stories indicate that Stevie also washed the customers' cars.

Agents having a bit of fun after raiding an illegal gambling establishment. *Los Angeles Times Photographic Archive, Library Special Collections, Charles E. Young Research Library, UCLA.*

Although predominately a family-run establishment, the Alliance did employ a few outsiders, folks Big George knew could be trusted. This included one of Joe's boys, Leonard Tavaglione. Though only roughly thirty, by that age he must have been fairly well versed in the art of bootlegging. He'd been raised in a household of well-known distillers and vintners. During his time healing up at the Tavaglione ranch, George witnessed a fair share of the family at their trade. They made liquor and wine in a barn and even mixed up liqueurs for the ladies. "Neighbors would bring in gallon containers—four of them in an empty box—and the Tavagliones would fill each of them with a red or a white. If they wanted a rosé, they would blend it."

Built, dialed into the racing wire and staffed with a trusted crew, the club needed only a steady stream of customers to sustain and generate a profit. Lucky for Big George, the Alliance became a happening spot to visit, socialize and gamble. The club took off with the local crowd of horse-racing enthusiasts, sprouting regulars among bettors anxious to avoid the thirty- or forty-mile trek out to Santa Anita Park and the long commutes south to Del Mar or to Tijuana for Agua Caliente. Although certainly off the path,

the Alliance's location actually worked in the family's favor. Set between San Diego and Nevada, the club served as a convenient stop for motoring sportsmen en route to Las Vegas, where far more than just horse racing had received sanction. Stuck in the California blaze on the seemingly endless route, the diversionary temptation of a little shade, cocktails and gambling became a welcome detour for traveling gamblers.

Occasionally, the club even drew in a celebrity. Among those of notoriety who came to frequent the Alliance Rec was funnyman Morey Amsterdam. During his stint of gaming at Big George's establishment, Morey worked as a radioman and on the joke circuit, penning material for comics like Jimmy Durante. He'd begun as a straight man in a vaudeville act with his piano-playing brother then moved on to performing as house entertainment in one of Al Capone's speakeasies. After a close call there, though, Morey felt a little too close to "the life," so he packed up and headed west for California. In another couple of decades, Morey would land a starring role on *The Dick Van Dyke Show*, bolstering his success even further. Morey and Big George hit it off, and if given a chance, the pair may have built a deep relationship. Unfortunately, lawmen cut the club's existence short.

A Change in the Guard

I'm going to break the power these men have.
—Mayor Fletcher Bowron

The second half of the 1930s offered a slice of California history when elected officials and law enforcement took a very public beating. As a result, long-standing relationships among politicians, cops and "gambling barons"—many of whom the papers had formally referred to as bootleggers—fizzled. After the death of the bootlegger witch hunts, District Attorney Buron Fitts and other officials adjusted their sights. They had clubs raided, subpoenaed the usual suspects and handed out a healthy threat to those in office.

> Berkeley Daily Gazette, *July 31, 1937*
> ALLEGED GAMBLERS TO BE SUBPOENAED
>
> *Los Angeles—seven alleged members of the big, inner ring of Los Angeles city gamblers, will get subpoenas, if they are still here, early next week to*

appear before the County Grand Jury. It was announced today by Jury Foreman J.E. Bauer. Simultaneously, District Attorney Buron Fitts stated he had served notice on the mayors and chiefs of police of 42 cities and towns in Los Angeles County to clean up gambling or be "called on the carpet" before the grand jury. Those for whom subpoenas were ordered for appearance before the grand jury were: Guy McAfee, Milton "Farmer" Page, Eddie Nealis, Tudor Scherer, Chuck Addison, Johnny Roselli, and Jack Dragna. Bauer did not say whether the so-called gambling barons would be questioned by the grand jury and thereby automatically gain immunity from prosecution…

Making matters worse for these "gambling kings," one of their own—Les Bruneman—was gunned down publicly two months later. Ben Siegel and the East Coast mentality had hit the LA streets. Every bold action that followed screamed loudly in the ears of Buron Fitts, Earl Warren and other straitlaced officials. Also responsible for the eventual climate shift in Los Angeles was the advent of investigative committees dead set on ending the city's vice. Corruption-fighting avatars like restaurateur Clifford Clinton and his private eye, Harry Raymond, threw more than a few players under suspicion and surveillance. Not surprisingly, the crusader efforts of Clinton's CIVIC Committee overturned some 1,800 bookies, 600 brothels and 300 gaming houses in the City of Angels. But all the tension and prying did far more than just hamper the flow of business. To stress that the meddling had to stop, a bomb was placed in Clinton's home. The device was not the only one of its kind to go off in the committee's honor. Surprisingly, these deadly tactics weren't tied to some gangster hood; investigations revealed they were backed and perpetrated by a high-level badge.

Bakersfield Californian, *February 19, 1938*
LA CITIZENRY AND PAPERS INTERESTED IN VICE CHARGES

Vice, the ugly word, really has had more than its share of front page use since a badly made bomb exploded. The 1938 County Grand Jury may bring the involved situation to a climax. Here is the chronological box score of the highlights of the city's amazing vice maze:
Jan. 14—Harry Raymond starts car in garage, bomb attached to motor goes off, seriously injuring Raymond.

> *Jan. 15—Clifford Clinton, head of citizen's group employing Raymond, says he knows who planted the bomb.*
> *Jan. 16—Raymond says he knows too.*
> *Jan. 17—D.A. Buron Fitts shows interest in the bombing.*
> *Jan. 20—Earl E. Kynette, head of Police Intelligence Squad, arrested on suspicion of wire-tapping. Fitts personally orders arrest. Kynette admits he has been shadowing Raymond for 3 months.*
> *Jan. 21—Kynette released, charges dropped.*
> *Jan. 23—Raymond discloses he is to be key witness in bankruptcy hearing of Harry E. Munson, who was the manager of the campaign that put Mayor Frank Shaw in office, alleged to have taken underworld money to further Shaw campaign. Munson made police commissioner during the first Shaw term. Resigned as result of publication of affidavits linking him with forgotten scandal; Raymond published affidavits.*
> *Jan. 23—Mayor Shaw denies Kynette had anything to do with Raymond bombing.*
> *Jan. 25—Kynette charged with planting Raymond bomb in complaint signed by Fitts.*

Out in the open, the obvious corruption led Angelenos to make a very serious vote, one which resulted in the first ousting of a mayor from a major American city. The ripples of the stone cast by the 1938 removal of LA mayor Franklin Shaw carried out across the state. To make matters even worse for those dabbling in underworld endeavors, DA Buron Fitts—a man who'd made eradicating vice a personal and moral vendetta—was about to get a new partner. When Shaw's replacement, Mayor Fletcher Bowron, addressed the media on the gambling "problem," he boldly announced, "As far as I am concerned, I'm going to break the power these men have." Like Fitts, Bowron also put the brass on the spot, indicating that he knew all about their criminal arrangements. "A monopoly has been built up here and the Police Department has been used to run out competition against those paying for protection."

Under the scrutiny of this new team, long-held arrangements to look the other way were no longer honored. Law enforcement—and sheriffs in particular—severely felt the burn from higher up. They would now be held strictly accountable for any misdeeds within their respective territories. Pushing further with this cleanse, a purge of the old-minded lawmen would soon occur, and to fill the ranks would come a mess of young green officers with something to prove. For those operating "in the shadows"—providing

services citizens willingly threw their money at—elected officials and badges would be anything but cooperative.

The combined efforts of the DA, the new attorney general and the new mayor drove the anti-vice crusade in the Southland. Pressured by these higher-ups, police and sheriffs quickly blamed their vice issues on corrupt politicians. To an extent, these accusations were correct, but Warren, Fitts and Bowron weren't the sort to listen. For them, gambling had become the new booze to a different kind of prohibition. Squeezed under the change, a number of gambling heavies left the state to get situated in nearby Las Vegas. But not everyone fled. For refusing to bail out of LA, Jack Dragna became a special target. Eventually, Earl Warren would brand him the "Capone of Los Angeles," a dime-store handle that would never wash. Unoriginal at best, the title had already been used by newspaperman Herbert Spencer in an attempt to slander one of Dragna's competitors, Guy McAfee. McAfee, a former vice cop turned criminal, became one of a handful of gambling czars to hightail it for Vegas under the strong arm of the new regime.

An onslaught of raids in the late 1930s caused the shutdown of numerous gaming houses and gambling ships all over Southern California. Tony "the Hat" Cornero even allegedly held the Coast Guard at bay with a fire hose when they attempted to board his gambling vessel. Federal agents and other assorted members of law enforcement pocketed gambling effects, auctioned items off or smashed them for sport—the spoils of a victor. Proprietors and customers of these establishments were hauled in, questioned, jailed or subpoenaed to testify. Clearly, Johnny Law had it in for anything that gambled, and yet, in the same breath, other state officials continued diligently to iron out details for the government regulation of the sport, presenting bill after bill meant to legalize gambling activities and to benefit from the bountiful tax revenue that would no doubt be generated.

> Santa Ana Daily Register, *June 27, 1939*
> *SEEKS TO MAKE GAMBLING LEGAL*
>
> *Sacramento—Governor Culbert Olson's announcement he will veto the Fulcher "bookie" bill to legalize off-track horse race bookmaking was followed here today by a move to have the people vote on measures to legalize all forms of gambling as well as bookmaking. M.J. Robb, a former Sacramento insurance man, said he had submitted two bills for title to Attorney General Earl Warren and was ready to open a drive to get the necessary 260,000 signatures on petitions to put each measure on the*

November, 1940 ballot. The Fulcher bill was approved by the legislature but Olson promised to kill it because it "would license gamblers to prey upon the cupidity of people who believe they can profit by gambling."

Goodbye Club

A new sheriff came to Riverside.
—George Niotta

The sheriff the younger George speaks of is Undersheriff Steve Lynch, who answered directly to shot-caller Sheriff Carl Rayburn. Rayburn had been a Riverside sheriff since 1931 and would remain so until the early '50s, getting into scrapes with the Hells Angels Motorcycle Club. During the dusty Depression of the 1930s, Rayburn represented the old regime, remaining agreeable to the prospect of a mutually beneficial arrangement. He has been accused of allowing certain casino and club operators in the desert to carry on unmolested. Running a bit contrary to this depiction of Sheriff Rayburn was his understudy, Steve Lynch, a man who stemmed from the newer system. A go-getter—green and energetic—the undersheriff remained intent on making a name and upsetting what was long in balance. Undersheriff Lynch cut his teeth on desert club raiding in late 1937, when he helped Rayburn roust the Dunes, an exclusive Hollywood celeb spot just eight miles outside of Palm Springs.

The advent of gaming houses in the Inland Empire offered a wellspring of commerce into what was more or less a desert. The economy had been crushed by the Depression, and the influx of consumers stood to revitalize many of the impacted communities. These patrons generated dollars for local hotels and gas stations, markets and restaurants, inevitably bolstering expansion. The prospect of rebirth and progress likely held sway over Rayburn's attitude and decisions throughout the 1930s. The will of ever-vigilant men like Earl Warren inevitably won out, though, forcing Rayburn and others of that breed to get on board by the end of the decade.

And so, the guard changed, the tree shook and now the young sheriff was all set to wrangle. The eager lawman arrived well armed to raid and close the Niotta club. That was the story a young George knew at five years old, but that was only a piece of it. He didn't learn more until many years later. At an Italian picnic in Riverside, some seven decades after the raid and shutdown of the Alliance Recreation Club, Georgie—now the family's

official Big George—met a man from his past who offered another angle: Nick Tavaglione, one of Joe's four sons. The two sat and talked, discussing the Inland Empire of old. Progress and development had swallowed much of the expansive ranchlands that once dominated. Nodding, each agreed that a lot had changed since childhood. Eventually, the conversation slid into a tale about a little boy who'd been treated and nursed to health on those lands after a near-fatal auto wreck in the late 1930s.

George explained who he was—likely showed off his soft spot—then thanked Nick for his family's kindness. Nick vaguely remembered the antics of the bandage-headed boy who'd come to stay at his home when he, too, was just a youngster. Georgie wanted to pour the wine for the customers in the barn when they came in with their empties, and he even locked Nick's older sister in the chicken coop for sport. Exchanging laughs, they spoke again of change—the only thing to remain a constant. The Tavagliones' bowling alley, Tava Lanes, which stood where the ranch had once been, became a topic, and George explained that he'd served as the establishment's liquor distributor many years back. But now even that place had shut down. Naturally, the Alliance Recreation Club eventually sprang up, and it was then that George heard a Tavaglione tale he'd never been privy to as a boy—a tale that made him smile. Yes, indeed, a new sheriff had come to town in the latter part of the 1930s, but what George didn't know then is that the lawman had also paid a visit to the Tavagliones.

Having a prominent role in Riverside County, Joe Tavaglione stayed well informed, keeping abreast of community happenings. He may have even had some say in the outcomes, which may account for his son Nick's story. Prior to the raid, the new sheriff dropped by the family ranch to let Joe know he intended to close Big George's gambling parlor. Sheriff Rayburn may have insisted that the undersheriff extend this courtesy. Seeing the scrappy lawman and hearing his plan, Joe wasn't too happy, and he voiced his objection, explaining that not only was Big

Tava Lanes Bowling, Tava Center, 2007. *Courtesy of Monika Seitz Vega Photography.*

George a good friend, but that the establishment also employed his son, Leonard. Unbudged, the new lawman refused to let it slide. He intended to take them in, and that's exactly what he did.

The patrons in the club who came to wager on the ponies put their money down on the runners at Hollywood Park, but even if they picked well, they wouldn't see a dollar. Out front of the desert casino, young Stevie Niotta got to work; two dozen or so cars crowded the lot, and each of them needed a proper scrubbing. Before long, Stevie's mother, Phyllis, arrived, but she didn't get more than a hug and a hello before the sheriff's cruisers dragged a cloud of dust over Stevie's hard work. They got out ready to go, already gripping their weapons. Seeing a teenage boy and a woman in their sights, however, they lowered their muzzles. Undersheriff Lynch looked to Phyllis, who stood frozen. Jerking his neck to the side, he motioned for them to scat.

> San Bernardino County Sun, *July 31, 1939*
> RIVERSIDE RAID CLOSES "BOOKIE"
>
> *An asserted Riverside "bookie" establishment known as the Alliance Recreation club was raided by Riverside sheriff's deputies Saturday and forty patrons and six attendants were booked on three gambling charges and lodged in the city jail, while the patrons were released subject to appearance as trial witnesses. Officers described the "club" as the most pretentious horse race gambling organization in Riverside county's history. Those who face trial include Mike Niotta, George Niotta, George West Niotta, William Capece, Leonard Travaglione and Edgar Reed, all of Riverside.*

"They went to jail for bookmaking. My dad got time too. I went to visit him." Though only five, George remembers his mother, Rose, and the rest of the wives filtering into the sheriff station to claim their husbands after they'd posted bail. Before long, they'd be returning for a longer stay. The group received a speedy trial, and the sentencing came just as swiftly.

> San Bernardino County Sun, *August 4, 1939*
> RIVERSIDE BOOKIE OPERATORS JAILED
>
> *Six men arrested Saturday in a raid on a West Riverside horserace bookmaking establishment were sentenced to county jail terms yesterday. Superior Judge F. G. West of Orange County meted a six months sentence to George Niotta, who pleaded guilty to a state charge of being the lessee*

of the establishment. The others, George West Niotta, Mike Niotta, Edgar Reed, Leonard Tavaglione, and William R. Capeace, declared to have been employees, were sentenced to two months each.

Big George and company went away, but only for a short spell. Considering the charges could have easily been stacked heavier against them, they figured themselves at least halfway lucky. Given the leniency, it's likely the Tavagliones still had some pull after all. "Judge West ordered money and equipment of the club confiscated" and donated the funds to the county. They'd long since moved the teletype and phone lines out of young Georgie's closet, so lawmen had their way with those pricey items, too. A week or so after the judge's gavel, Undersheriff Lynch opened shop, and after a public auction of the "furnishings," he informed the press that the confiscated gambling equipment "would be destroyed" just as soon as they closed the case. Thus ended Big George's desert gambling parlor.

10
THE HORSES

He had a guy. They called him a real good chemist.
—George Niotta

When the Niottas weren't financing multimillion-dollar lottery rings based on the ponies or placing offtrack bets on the street or in their bookie establishment, they could be found buying and racing Thoroughbred horses. Big George had been an avid longtime fan of the animal and just loved to watch them run. His oldest son, Michael, claimed his father was even asked to join in the development of the Del Mar Racetrack. But for whatever reason, Big George declined. Michael's son George tells other horse stories.

"When they moved the horses, they used a horse transport, and I remember a couple times I rode in it to a track up north." Three generations of Niotta sons hit the tracks up and down the coast. They drove far north to San Bruno near San Francisco's peninsula for Tanforan Park, where the horses ran for nearly sixty-five years. There, another horse-loving, horse-racing enthusiast and sugar baron was known for visiting. Adolph B. Spreckels of Spreckels Sugar and the Western Sugar Company could have easily been viewed as Tanforan's patron saint; he helped keep the track afloat during many a rough patch. What just couldn't be helped was the fire that burned Tanforan out of existence.

The family frequented local tracks—Santa Anita, Hollywood Park and the Fairplex in Pomona—and dipped south to San Diego for the ritzy track

at Del Mar. Not exclusively a California passion—or an American one for that matter—Big George and sons even drifted out of the country to get their fill. They journeyed south of the border into Tijuana for Agua Caliente. Despite the fun on these trips, the family usually ran into a bit of humorous trouble on their way back from Mexico. "We'd cross the border to watch Grandpa George's horse run in Caliente. Crossing the border there's George, me and Bing—who was also named George. That's three George's!" Adjusting the math, he added, "and then there's Stephen George! Customs didn't like that at all."

To look after his investment, Big George hired on San Bernardino man Joe Merola, as a trainer. Joe ensured that the Niotta Thoroughbreds were healthy and in top shape for competition. In the mid-1940s, Joe handled Liedevin—French for "wine colored"—and, later that decade, he worked with Hopes High, a young runner that ended up in a bit of a scandal. Procaine served as one of many drugs available and used by trainers and owners as a painkiller during the 1940s. Because it helped to ease the animal's suffering during recovery, Joe used it on the injured horses he trained. In November 1949, Hopes High was in rehab following a recent leg injury. Joe made the mistake of putting the gelding back into post too early, and the lapse in judgment became a problem. The amount of time that had passed since the horse's

Big George and grandson "Bing" in Tijuana, mid-1940s. *Courtesy of Frannie LaRussa.*

last treatment isn't known, but when Hopes High came in first in the third race—a long-shot win—traces of the drug lingered.

> Oakland Tribune, *November 25, 1949*
> *"DOPING" CASE AT TANFORAN*
>
> *Tanforan Race Track, San Bruno—Winners of the daily double, those who had long shots, and the management of the Golden Jubilee meeting, are thankful today over the Thanksgiving Day of racing here. But not George Niotta and Joseph Merola, owner and trainer respectively of the two-year-old chestnut gelding, Hopes High.*

Most journalists covered the incident for what it was—a mistake in judgment on the part of a trainer; however, some newsmen did opt for the sensationalized route. Headlines such as "Duo Suspended on Dope Charge" and "Track Victor Ruled Doped" suggest a high level of premeditation and give the impression that the con of fixing races never happened. In truth, tampering and foul play occurred fairly often in the industry. What made this specific instance stand out so boldly was the timeline; it was the late 1940s, not the 1930s. Doping racehorses with narcotics was no longer rampant. Urinalysis, saliva samples and blood tests had since been introduced and remained in regular use. In fact, the ringer had all but died. The Hopes High fiasco "was the first 'doping' case of the year on a major track in the state," hence the story going national.

"It wasn't for the horse to run better," affirms Big George's grandson, who was fifteen when Hopes High won that day. "It was for the leg injury, but you still had a substance in the bloodstream when they checked"—at least enough of it not to go unnoticed. "The horse won but he didn't get the purse." The family affirms strongly that this was not an intended case of pulling a scam, which is likely true, considering the practice of taking and testing the blood of the winning animal. How could Big George ever have hoped to beat that, even with a horse named Hopes High? That being said, George—like a lot of other sportsmen in the early days—was not above pulling a fast one. His grandson recalls one such tale with humor.

"My dad and grandpa had a horse. They were running horses at the fairgrounds and they didn't do the tattoo on the lips back then," which made it a lot easier to slide in a ringer. "So my dad is looking to buy a horse that looks like this real good one they had. He had a guy—they called him a *real good chemist*," and he "dyed the horse." The idea was to make their winner

The Los Angeles Sugar Ring

Joe Merola (*trainer*), Big George (*owner*), Stevie Niotta (*uniform*), Robinson (*jockey*) and Liedevin (*horse*), Agua Caliente Racetrack, Tijuana, Mexico, 1944. *Courtesy of Anthony Amador.*

"look like this clunker that my dad just bought," making "the odds long." Short story shorter, "the horse won and they all got a lot of money. That was called a ringer." As simple as it sounds, the kind of work George mentions required a "tremendous amount of skill and care." Sweat, rain and the potential for the horse to be covered in a white sheet made the art of dyeing a horse risky. The professionals who succeeded were partial to resistant dyes like henna, which held out against getting wet. In the industry, the term "chemist" also referred to those offering a wide array of pharmaceuticals that could give a horse an added edge.

In the early days, ringer cases happened so often that the tracks had no choice but to devise methods to weed them out. Smartly, the newly formed Thoroughbred Racing Protective Bureau came up with a plan— the use of mouth tattoos. Introduced into circulation in 1946, the tattoo system ensured that the right horse—not a ringer—made it to post. And it worked! In the first year alone, U.S. tracks nabbed twenty-two ringers. Within a decade, as many as fifty thousand horses had received tattoos on the upper part of their inside lip, markings that indicated the year of the horse's birth and listed a portion of the Jockey Club's registration number. Other symbols, like stars, explained details such as whether or not an animal had been imported. By August 1954, nearly eight years after the system was put in place, lip tattoo identification had "relegated the horse race ringer to pulp fiction and ancient TV movies."

Over the Hopes High upset, the Board of Stewards nabbed Big George and Joe for "violating Rule 309A of the California Horse Racing Board" and suspended them for the remainder of the term. The case was also referred higher up, to the commission. Barred temporarily from the tracks stateside, Big George took his horse farther south, where the ads boasted "Mexico's famous funland!" At Caliente, Hopes High ran well. For Big George, the punishment must have felt like World War II all over. Not long after the Japanese attacked Pearl Harbor, the racetracks along the coast were closed down. For lack of a better spot, these facilities became home to Japanese detainees. Tanforan housed about eight thousand—U.S. citizens and not—and more than fifty babies were born on the premises. Farther south, at Santa Anita Park, the grounds held more than twice that number. Upward of eighteen thousand lived in horse stables and in whatever barracks could be thrown together.

11
AND THEN CAME WAR

*Lucy didn't talk much about her father because of what he had done.
It would be the Fourth of July and she'd say, "It's my father's birthday."*
—Anthony Amador

The Return to Los Angeles

Not long after the new sheriff shut down the Alliance Rec Club, the Niottas made their return to Los Angeles. George Jr., Helen and "Bing" settled in Pasadena just before the 1940 U.S. Census. When the census man came knocking, George had a bit of fun answering the questions. He admitted he'd been employed only twenty-eight weeks during the previous year, which brought the calendar to the end of July, when the sheriffs had raided. George hadn't worked since and, along with his older brother, had even served a bit of time over the affair. When asked what he did for a living, George responded with the true spirit of defiance. The document has him listed as a "Teletype Operator." George even made sure the fellow marked "bookmaker" under the industry title.

When the census man reached the home of Michael, Rose and Georgie, Michael admitted he'd also been unemployed since the club's end. The family hadn't left Riverside yet and perhaps hung around in wait for their patriarch. After landing a job in LA, though, they bid farewell to the Inland Empire. Reunited with the clan farther west, Michael got to work as a

printing and publishing clerk with the original *LA Daily*. His kid brother Stevie, now a high school senior, delivered papers. Facing a stiffer sentence, Big George sat on ice dreaming of his next grand scheme.

After making it back to Los Angeles, Big George didn't waste any time. He quickly got situated in his favorite kind of business—working for himself. This kicked off with the record and jukebox outfit, Wolf Music Company. By then, Stevie had finished up at Manual Arts High. Getting an offer from his father, he left the paper and came to work at Wolf. Although George started Stevie out in service and repair, he immediately took note of the salesman gene. Seeing potential, he offered a promotion. This magic touch that Big George sensed in his son paired well with another talent that the young man had inherited—the Niotta way with numbers. From then on, Stevie would find great success managing the books and scouting out and signing up new clients.

Stevie Niotta delivering papers for the original *LA Daily*, Catalina Island, circa 1941. *Courtesy of Frannie LaRussa.*

Rather than return to Boyle Heights, Big George, Phyllis and their youngest four settled in an area nicknamed "Little Sicily." The formal title was Lincoln Heights. Creating a large pocket of Italians, the area bordered the city's official Little Italy—a place now known as Chinatown. After getting Wolf Music off the ground, Big George purchased another establishment. The building at 5710 South Western Avenue is a spot his grandson still remembers. "It was called Gerries and it was a classy neighborhood bar." In addition to the bar, Gerries had a lounge and a kitchen. "It had a room off to the side with a fireplace and one of those artificial logs. It was like your living room—sofas and tables. You'd just want to sit there and drink with your lady friend." Although Stevie kept busy drumming up sales and managing accounts for Wolf, he took on responsibilities at Gerries Bar as well. There he handled produce purchases, put together the menu and managed the staff. Keeping the place family run, Big George hired another of his sons to mix cocktails. George Jr. worked behind the bar.

Big George pours for a patron in his neighborhood bar, Gerries, early 1940s. *Courtesy of Frannie LaRussa.*

Smartly, Big George found a way to tie Gerries and Wolf Music together. "I was infatuated," admits the younger George, "because my grandfather had a record distributing company—jukeboxes and stuff like that—and the thing that Gerries had…you pushed the button to play a record and a girl would answer." Hearing "What is your choice?" always caused George to giggle. "You'd tell her, and she'd look through the files and put it on." What George described sounds simple enough, especially by today's standards, but the technology hovered half a century ahead of the curve; the deejays weren't sitting at Gerries, they had an office full of records and turntables in another part of town. "It was nice. You'd talk to the girl. She was at the record outfit where he had his records, and she'd play the music." The Manitowoc Wired Music Studio, out of Wisconsin, had adapted a similar technology while George was still sitting in a cell in Riverside. During the early part of the 1940s, "Automatic Hostess" spread over the country fast, becoming increasingly popular. Oddly, the trend died out in the mid-'50s.

As if running two businesses weren't enough, soon Big George embarked on a third endeavor. The family's barbecue café, the Oakwood Pit BBQ, sat

at 1744 West Slauson, near the corner of South Western. "He bought it a little after Gerries but he had them both at the same time." The restaurant had a large wraparound red brick oven similar to the setup at Marie Callendars, says the younger George, who remembers that the ribs were fantastic. "We had a big heavyset black guy who worked as the chef." Big George had the man "walk outside the restaurant on Slauson in his all whites and his tall hat" to "attract attention and reel people in."

The Italians Are Enemies, Too

My Uncle Johnny was real handsome but tough. He could handle himself. All those guys could. They grew up in Boyle Heights and Lincoln Heights.
—George Niotta

Although the United States was not yet involved in the war overseas, President Roosevelt instituted the draft as a precaution. Registration began shortly after the Niottas returned to Los Angeles. Just prior to this, another mandatory mass registration was put into effect. The Smith Act of 1940 called for the participation of all noncitizens ages fourteen and older living in the country. Never having naturalized, Big George obliged. The FBI added the information they gathered to the files they'd been putting together. The purpose of all the legwork was to identify potential threats, should the nation decide to enter the fight. And before long, it did.

Mere hours after Pearl Harbor was hit, it became painfully evident that authorities were after more than just the Japanese. What had happened during World War I was quickly repeated. America's alien residents who'd been born in Axis countries found themselves an immediate target. And shattering widespread thought, those of Japanese descent were not the only ones taken. For these ethnic groups—groups who'd collectively been labeled "enemy aliens"—the war brought on anxiety, fear, shame and loss. More than seventy years later, Anna Dragna-Niotta quietly talked about "the fear." "Many Italians," she noted, "worried they would suffer the same fate as the Japanese."

Hours after the attack, authorities flooded America's Italian enclaves, spilling into big cities like San Francisco, New York, Boston and Los Angeles. Italian American soldiers, sailors and airmen would come to represent the largest ethnic group to serve in the war, yet, while away in the fight, their families would face great injustice and discrimination. Armed with

presidential warrants, the FBI rounded up Italians, Germans and Japanese whose names had made their list. Interviews with survivors by Dr. Stephen Fox and accounts relayed in the Lawrence DiStasi collection *Una Storia Segreta* point out that these "enemy aliens" were not charged with any crimes during these roundups, nor were they given a reason why they were being taken. Some of these Italian citizens soon found themselves on a train charging toward an unknown destination. Although the windows had been blacked out, the passengers eventually learned that they'd been hauled farther inland. They settled into internment camps in states like Texas and Montana.

Enemy Alien evacuation sign posted in an area of LA deemed "prohibited" to Axis nationals. *Los Angeles Times Photographic Archive, Library Special Collections, Charles E. Young Research Library, UCLA.*

Wartime restrictions soon followed, bringing on curfew laws and home searches for those who'd been allowed to remain. In California cities along the coast, federal agents showed up at all hours to confiscate radios, cameras, flashlights and binoculars, calling these items contraband. The "enemy" had already been forced to relinquish their firearms, ammunition and assorted weapons. Mass unemployment, forced relocation and long-term internment also occurred as a result of these wartime restrictions, and in truly grave instances—cases in which the stigma of being branded an enemy served too much to bear—the directives instituted against Italians ended in suicide.

Authorities even entered the home of Anthony Amador's next-door neighbor, his own grandfather! "They came to the house and they took something out of his radio, so he couldn't transmit during the war," Anthony contends. This was done to ensure the elderly gentleman could not send or receive messages from Italy. The Breunle family—grandparents to the younger George's future wife—was also paid a visit. "When World War II broke out, they lived in Inglewood," explained George's wife, Jeanne. Because of its proximity to the water, this area of Los Angeles had been deemed a prohibited zone. The Breunles received word they would have to relocate. "They had to move from the ocean. They had to move inland. That's why they moved from Inglewood to Alhambra."

Although the Niottas managed to escape "special treatment" during the war, half humorously, when Big George's daughter Anne called to make a salon appointment, they refused to book her, thinking the "Niotta" name Japanese. Fortunately for Big George, each of his businesses sat outside the area that had been designated "off limits" to "enemy aliens." If the Oakwood, Gerries or the office and record room of Wolf Music had been any closer to the coast, he would have been barred from setting foot inside for the bulk of 1942. Other Italian businessmen were not so fortunate.

On Columbus Day 1942, DA Francis Biddle—head of Enemy Alien Affairs—made a very important announcement to the Italian colonies of America: they would soon be taken off the enemy list. Considering the importance of this holiday among the Italian populous in America, the choice of date was no doubt strategic. Publicly, Biddle indicated that Italians had demonstrated they could be trusted, and that these non-citizens had earned the right to fight in the war. Political rather than sympathetic reasons are believed to have fueled the decision, which may account for why an apology for the crimes against these Italians was never given. The U.S. military needed buy-in from the immense number of Italian American troops for the upcoming invasion of Italy, and the president desperately wanted the Italian vote in the upcoming election. It wasn't likely either party would achieve what they were after, though—not if the mothers, fathers and grandparents of Italian American service members continued to be persecuted. Although the wartime restrictions on Italians ended after only a year, the hidden but lasting effects on Italian culture are still felt. Perhaps the biggest casualty of the ordeal is that America's Italians no longer speak their native tongue—it had been deemed the "enemy's language."

By the close of 1942, all eligible Niotta men had filed for the draft, including Big George, "enemy alien." George hit fifty a few weeks before the raid on his desert gambling parlor. Now a successful, fifty-two-year-old multibusiness owner, he still hadn't learned to read or write—and he never would. His youngest son, Stevie, did all but sign the draft document. Removing the "enemy" status from his father, and from his people, impacted Stevie quite heavily. Now twenty-one, he'd officially become an adult. The day after DA Francis Biddle honored his promise to America's Italians, Stevie went in and enlisted.

Although the training Big George's youngest son received for the war effort qualified him to be a radio operator and gunner, overseas Stevie found himself in a far less desirable assignment: the ball turret. Being shoved down

Big George with GIs, early 1940s. *Courtesy of Frannie LaRussa.*

into the ball turret of a B-17 Flying Fortress was easily one of the worst and most dangerous jobs in the air. Serving with the Eighth Air Force out of Knettishall, England, Stevie manned twin .50 cals for Lieutenant Robert L. Rubottom's crew, surviving twenty-six heavy bomber missions over Europe. Back in LA, his brothers continued to tend bar at Gerries and hustle down at the *Daily*. Michael and Rose had another son. They named the boy Michael, after his father. The Niotta sisters kept busy as well. Lucy graduated from Lincoln High and traded in her part-time gig at the malt shop for a position at Gilfillan Radio with two of her sisters. Although Gilfillan Brothers Inc. could boast being one of the most well-known radio manufacturers on the West Coast since as far back as the early twenties, the war had put a stall to that end of the business. After receiving a special government contract to manufacture Ground Control Approach (GCA), a new radar system, they switched over production. Instead of repairing radios, Marion, Anne and Lucy put in long hours soldering radar panels. The Niotta sisters worked at Plant 3 on Venice Boulevard.

The war didn't keep Big George from playing the market or tending to his storefronts. It did, however, impact horse racing—more precisely, where the horses ran. Although the military repurposed racetracks stateside in

Hitchhiking sisters (*left to right*): Lucy, Anne and Marion, wartime "Rosie the Riveters" employed by Gilfillan Radio's Plant 3, Easter Sunday, 1944. *Courtesy of Anthony Amador.*

order to house the heavy influx of Japanese detainees, across the border in Mexico, the efforts of the U.S. Army had only reduced patron traffic. Agua Caliente received a slim five thousand guest limit. Considering the spot now served as the horseracing hub of the entire West Coast, it remained a difficult requirement to conform to. There in Old Mexico, Big George pursued his passion.

John Cacioppo was another fellow who preferred to be his own boss, and like his father-in-law, Big George, he wasn't shy about jumping into an opportunity. To more accurately compare, Johnny's landing may have been just a little better. He, too, had abandoned the less-than-legitimate end of the liquor trade for a more law-biding angle. John established his first bar at Eighty-First and Hoover, where his wife, Celie, cooked the food. Anthony Amador remembers that John also "had a bar down on Main Street and another one later on not that far from Gilfillan Radio." Plus, "he had a liquor store over on Imperial and Slauson," where Anthony held a job for a spell. One of these bars was the Gayway, which later changed names to the Galway. John's younger brother Gaspare also made this transition. After relocating to the northern end of San Diego, he opened the successful Escondido store Palomar Liquor. And in the back of the shop, Gaspare put his hands to use as a gunsmith and a gourmet.

Understaffed, with so many men away in the fight, John Cacioppo sometimes doubled as owner and bouncer. In his bars—"buckets of blood" as his nephew Georgie calls them—it could get pretty rough. On one such night, juggling the dual role ended badly. John hit a man in self-defense, and the blow proved deadly. "My Uncle Johnny was real handsome but tough," George relayed. "He could handle himself. All those guys could. They grew up in Boyle Heights and Lincoln Heights." Drifting briefly, recalling how it had been as a child, George tried to explain the visits to see his Uncle Johnny while incarcerated. "I thought it was like a picnic. They had him at one of those farms."

While the grown folks busied themselves with war and industry, a few of the younger ones tended to more heartfelt matters. Visits with her big sister Celie and niece Lolly brought Lucy Niotta out to Boyle Heights fairly often, and one of Celie's neighbors certainly noticed. Anthony Amador lived at the end of the block and met Lucy on one of her visits. They got acquainted around 1940, shortly after the Niottas left Riverside, and before long, a budding relationship sparked. Chaperoned playdates at the park soon turned into trolley rides downtown so Anthony could visit Lucy at the malt shop. Though only seventeen, he knew he'd stumbled upon something

INSIDE THE WORLD OF OLD MONEY, BOOTLEGGERS & GAMBLING BARONS

Left: Anthony and Lucy Amador beach bound circa 1947. *Courtesy of Anthony Amador.*

Below: Stevie Niotta's Official Lucky Bastard Club certificate, Eighth Air Force, 388th Bombardment Group, 562nd Bomb Squadron. *Courtesy of Frannie LaRussa.*

special, and he acted accordingly. "I gave her the engagement ring" before I "went into the Navy." Lucy's mother, Phyllis, "was a little upset" about the proposal with Lucy being so young and her older sister Anne still single. Coming to the young lovers' rescue, Celie calmed her mother, saying, "Well, Mom, don't worry about it. He's going into the service now so they're not going to get married right away. They won't get married 'till after he gets home." If Celie's words hadn't been enough, time would serve to alleviate all worry. Not only did Anne and Lucy both get married, the blessed event also happened during the very same ceremony. Marriage would have to wait a while, though; a war was on, and both hubbies to be were heading overseas.

Kimmey Daher, a pal of Lucy's whom everyone called "Turk," "was going in," and it didn't take much convincing on his part to get Anthony to join him. "I wasn't drafted. I quit school in my senior year and joined the navy." The pair served bravely aboard the USS *Mississippi*. Just before Anthony left for the fight, the youngest of the Niotta boys returned from his tour of service. Stevie Niotta survived more than two dozen missions over the skies of Europe, something thought undoable during the early part of the war. A bomber crew completing its required number of missions without being shot down, captured or killed was alleged to be a statistically impossible feat. As such, the local papers and community treated the young man like a hero.

LA Daily News, *1944*
ENGLISH ACE VISITS SISTERS HERE

Tech. Sgt. Steve Niotta, veteran of 26 missions over the English Channel as turret gunner and radio operator and wearing the Distinguished Service Cross with oak leaf cluster, is spending a 30-day furlough with his sisters, Marion, Anne, and Lucille Niotta of Plant 3. With the Daily News before enlisting, Steve has made real flying history in the Western European theatre.

After the short stay of leave, Stevie shipped out to Texas to instruct at one of the gunnery schools. Another year of service and he'd finish out his enlistment. A few weeks after his departure, Big George's other sons received word they'd been drafted. The pair processed out of San Pedro in April 1944, just one week apart. Like Stevie, Michael ended up in the Army Air Corps, and after training, he received orders to Guam. George Jr. was forced into the infantry, though the regimented way of life did not suit him. He never made it overseas. Always a bit too much the rebel, and at times also a

"bully"—a name his nieces and nephews would later come to call him—it's safe to assume George got himself into a heap of trouble.

Trouble on the Homefront

Eventually, the war ended, and one by one Big George's sons returned. Michael resumed at the *Daily* and climbed the ladder to its board of directors. Stevie picked up at the paper as well but moved on to other endeavors. A week after the USS *Mississippi* dropped Anthony stateside, he and his fiancée, Lucy, got married. Though still healing from his wounds after a kamikaze attack, Turk—the young man who'd talked Anthony into enlisting—served as the couple's best man. "It was a double wedding," Anthony announced enthusiastically. Also a bride that day was Lucy's big sister Anne. Another injured young fellow who nearly lost his life during a kamikaze attack in the Pacific was Anne's fiancé, Mike Campagna. The fortunate four tied the knot at LA's Sacred Heart.

Stevie Niotta *(far left, kneeling)* with the *LA Daily* ball team after World War II. *Courtesy of Frannie LaRussa.*

The Los Angeles Sugar Ring

Sacred Heart Church, Los Angeles, 1945. Brides Anne Niotta-Campagna (*left*) and Lucy Niotta-Amador (*right*). *Courtesy of Linda Galardo.*

Mike Campagna and Anne Niotta wedding party (*left*) and Anthony Amador and Lucy Niotta wedding party (*right*), 1945. *Courtesy of Linda Galardo.*

While nothing could keep Big George from such a special occasion, an odd air certainly surrounded his presence. As if an extra shadow, it tailed him. It had been there the year before, too, when his daughter Marion wed into the Bovi family. And now at this extra-special occasion, the cloud again hovered. Despite all the happy feelings shared by those around him, George just couldn't shake the unwanted feeling. The glares confirmed his suspicions. Big George Niotta had become an outsider.

Anthony Amador claims that before he left for the war, the Niotta family got along just fine. After he returned stateside, however, it was impossible not to notice the shift in dynamic. "Lucy didn't talk much about her father because of what he had done. It would be the Fourth of July and she'd say, 'It's my father's birthday.'" The sentiment, he soon learned, was widely shared. Discovering that their parents' marriage had failed stirred an ill feeling among the Niotta children. What ran far deeper was the knowledge that their father was shacking up with another woman—a younger lady whom all of them knew.

Marion Niotta-Bovi, Stevie, Big George and Celie Neoto-Cacioppo, mid-1940s. *Courtesy of Frannie LaRussa.*

The Los Angeles Sugar Ring

Michael, Stevie and Big George after Stevie's return from the war, circa 1944. *Courtesy of Frannie LaRussa.*

Whether or not Big George's children ever noticed, the romance had long since left their parents' marriage. Getting out of Louisiana was one thing, but when Big George forced the jump from Boyle Heights to an upscale part of the city, a problem festered. To put it plainly, the sort of life Big George battled and gambled so desperately for held not a drop of allure for the woman he'd married. And so, little by little, George's efforts to shine pushed the two apart. Because of George's success, the couple received countless invitations throughout the Roaring Twenties and on, but not craving the scene, Phyllis always found some excuse not to attend. Quietly she bid him to go on without her—and usually he did. Phyllis may not have cared for their new life or for Big George's fancy friends, but she never did voice an objection. The way she'd been raised never would have permitted it. Though George's upbringing mirrored Phyllis's—they'd both come from poor, working-class stock—the two were obviously very different.

Anthony Amador recalls his mother-in-law's stories of picking cotton in the fields of Louisiana. Big George had been down in those very same fields

blistering his fingers, and yet, there he was a few years later trading stocks and rubbing elbows with old money. Although he may have gotten his start by picking cotton, one thing was definitely certain; George would forever push against the standard and strive to not only be accepted among the wealthy and elite, but also to be viewed as a top dog and to walk gracefully among them. Content with merely minding the children, Phyllis never grasped such aspirations. As far as Mrs. George Niotta was concerned, the desires, fears and joys of her husband and his big-shot friends were just too far off from her own to even bother. And so, as poor country teens, love may have brought George and Phyllis together, but after decades of another kind of life, and of living without fire or passion, the divide between them had become too much. The version of love they'd come to share lacked all sense of romance. Necessity glued them. Tradition glued them. They remained married as much out of comfort as they did out of expectation—after all, they had eight children to think of. But settling in Los Angeles the second time around, a key element had changed—their children had reached adulthood.

By the time Frannie Niotta was born, her grandparents had long been separated. In regards to the family finances, she admits she isn't sure when the Niottas lost their fortune. When her mother, Anna Dragna, met her father, Stevie Niotta, Big George "was already estranged from the family and they didn't have money." One thing Frannie took note of while growing up was the contrast between her grandparents' habits of spending. Coming from nothing and having to raise eight children during the Depression had impacted each of them but left a different mark. Raised without, George always strove for more and better—desiring to be known, respected and looked upon as a success. He could not and would not accept the lot he'd been granted. For this reason, he took the risks others shied from—moves that either got him ahead or pushed him under. For the same reason George treaded so near recklessness, Phyllis clung to caution. Trotting around town in her '31 Nash, she minded every penny. Survival—rather than an urge to shine—drove her every action. Achieving frugality, however, became an impossibility. Not only had she married a man far too unpredictable with cash, she'd married a man who insisted on always paying. Making it even harder for Phyllis, her husband's bold acts were highly influential. After starting a family of his own, "I won't go if I can't pay" became their son Stevie's motto.

Commenting on this struggle, Frannie offered an example. "George would give her all this money to buy a nice dress to go out to these parties,

but she would put most of it away and buy a very plain, inexpensive one." Big George may have given Phyllis cash to go out and splurge with, but what he also gave her was plenty of reason to put that money away. His son-in-law Anthony is positive that George lost the La Niotta over a bet. No one ever really knew if the next endeavor would make them rich or leave their pockets empty. A fear that the IRS might return or that someone with a badge would haul their father away must have also lingered. Under such tensions, Phyllis squirreled cash away.

Money was a shared problem in their marriage, but for one of them, image became an issue. George dressed in a manner that allowed him to swim with LA's upper crust. Retaining a simple, functional look, Phyllis never adapted. For the early part of her life, the hand of necessity guided and commanded her. Deeply ingrained, utility webbed in stronger than just mere habit. What did a girl in the cotton fields of Louisiana need with Saks Fifth Avenue? When berated to "get something nice," Phyllis usually picked something black. The ensemble came off awkward or casual, and exceedingly so for the crowd Big George was after. Phyllis was still in her twenties when the Niottas arrived in Los Angeles. But even after two decades of city living, she never stopped being a girl from the country. Many a young lady would have jumped high and fast and even groveled for the luxuries Big George gladly offered, but bells and whistles just weren't Phyllis's thing; the Louisiana lady would have been far happier with a man who stayed in at night and went to bed at a decent hour.

In contrast was Frannie Niotta's other grandmother, the one she'd been named after. Representatives from Saks Fifth Avenue phoned the Dragna household in Leimert Park whenever a new designer dress entered the store. And it was this elegance, poise and style exuded by Frances Dragna that embodied all that Big George Niotta was desperately after. But Frances may as well have come from another world. Of privileged and wealthy stock in Corleone, Frances's mother, Victoria Vacarro, had little desire to leave Sicily and may have agreed to the move solely to appease her husband, Antonio Rizzotto. Born and raised in the "Big Apple," Frances was all New Yorker. One of the few commonalities she shared with Phyllis is that the decades of life in Los Angeles never changed her, either. Style and appearance mattered, and for Big George and Frances Dragna they mattered a great deal. But the prize George was after went far deeper than just the wrapper, and he knew that dressing Phyllis as a socialite for an hour would never pass in any of his desired circles. Although a good mother and an honest woman, Phyllis Niotta was neither poised nor articulate.

Inside the World of Old Money, Bootleggers & Gambling Barons

Left: "Plain clad" Phyllis with daughters Lucy and Marion, circa 1945. *Courtesy of Linda Galardo.*

Right: "Fancy" Frances Dragna (*left*). *Courtesy of Frannie LaRussa.*

George may not have seen Phyllis as his perfect mate, but after all she'd been through, she was certainly entitled to a list of gripes as well. George's high-dollar schemes for launching to the top of the LA pile had long been a festering issue. Not only had they teeter-tottered the family finances for decades, they'd landed the men in Phyllis's life in jail on more than one occasion. The turmoil and uncertainty to which she was continually subjected worked harshly on Phyllis's nerves. And to learn of his infidelity, she no doubt felt hurt and embarrassed, as well.

Frannie admitted, "The affair with this woman had been going on for a while." Infidelity "in those days," she explained, "was not uncommon." Men took mistresses. "That was just more accepted back then. It was just something a wife kind of turned her head at." Somehow, the fact that she "had the family and the kids" was supposed to mean she'd been chosen; she was "the one with respect." Reflecting on how it must have been, Frannie offered, "I don't think Grandma Phyllis had a problem with him not being

her husband in every way. She was just very quiet and timid and it was almost a relief to her, to not go anywhere."

Big George's daughter-in-law Anna Dragna contended that Celie was the one who "stirred the pot" and clued Phyllis in about the affair. Whether or not this is how her mother came to learn of the infidelity, Celie was certainly responsible for incessantly pushing the subject. And being her strong-willed and outspoken self, she wasn't delicate. "How could you put up with this!? How could you do this?! He's making a fool of you. You need to just leave him." It's doubtful Phyllis wanted a divorce; however, under Celie's constant nudging, she did eventually approach the difficult subject of the other woman. Whether or not Phyllis knew or had suspicions about the affair prior to being approached by her daughter remains unknown. It is possible that George and Phyllis had unknowingly agreed to an unspoken arrangement. Either way, according to their granddaughter Frannie, Big George "ended up saying 'I'm done' and leaving." Considering her grandmother's position, Frannie insisted, "I don't think she actually wanted him to leave. And then she was brokenhearted because she was alone."

The woman who came between their parents' marriage was a Mrs. Jenny Musso. Jenny and her bandleader husband ran in one of Big George's social circles. At some point, the couple fell into domestic problems, and the Niottas entered the picture. Anne Niotta-Campagna recalled that her mother, Phyllis, said she felt sorry for the girl, so much so that Phyllis even asked her to stay in the spare quarters behind the family home—a move that no doubt precipitated the problem. Just a small boy then, Georgie came to call Jenny the babysitter. Before long, Big George was taking Jenny to all those high-society parties Phyllis refused to attend. And the switch in partners may have even begun at Phyllis's request. Unfortunately, the intended harmlessness of the gesture eventually turned to passion.

Following the split with Phyllis, George shacked up with his mistress, bringing the affair public. This move put a major strain on his relationship with his children. They stopped calling and inviting him over. Making matters even worse, Jenny Musso soon took a job at Gilfillan Radio, putting her in frequent sight of George's three daughters who worked at the plant. Such awkward tension begged for an explosion, and when one of Lucy's co-workers mistakenly made what she considered an innocent comment, that's exactly what happened. Unaware of the domestic situation, the woman casually chatted, "I hear your mother's working here now." Fuming and roaring wild with her fists balled, Lucy screamed, "Don't call that bitch my mother!" Despite the difficult circumstances, Big George's oldest son,

Michael, remained faithful; he may have been the only one to offer George any understanding. "He would visit every Saturday, like clockwork," remembers Michael's son—the younger George—whose mother, Rose, would make a five-gallon can of Big George's favorite fig cookies.

The country had entered a war, and Big George a battle of his own. The strategy his children employed involved the old silent treatment, which, for their father, hit with a crippling blow. Being forgotten or neglected became a far worse punishment than anything else they could have given. Thankfully, George still had Michael and those fig cookies, but soon even this would end. Stevie had already left for Texas, so when Big George's remaining sons shipped out for the war, it left him without an ally. While the boys were away, his daughters had little to do with him, and he sadly lost touch. Even after his sons returned, though, Big George was only really ever welcome in the home of Michael, Rose and their two children. He received an invitation to each of his daughters' weddings, but likely only because their mother, Phyllis, insisted. From her perspective, their father may have moved out of the house and taken up with another woman, but he was still their father; and because they hadn't divorced, Phyllis always felt George remained her husband. During the reception of the famed 1945 double wedding, the separated couple was photographed dancing together. The expressions illustrate wonderfully all the awkwardness in the air.

Time, as it does, continued to pass, and yet the problem Big George faced remained unchanged. This lack of resolution left the somber man to ponder if the rift would ever mend. "While I was in the service, Lucy was still a little bit friendly with her dad," remembers Anthony from the letters his fiancé wrote. "During summer when Del Mar was open, she went down and spent a week or so watching the horses working out on the beach." The Del Mar Racetrack closed before Anthony's wartime departure, becoming home to the U.S. Marines. A few months before his return, though, the venue

Big George with grandsons Georgie and little Michael (*middle*), circa 1942. *Courtesy of George Niotta.*

The Los Angeles Sugar Ring

Big George and his wife, Phyllis, uncomfortably embracing in a dance at the wedding of their daughters Anne and Lucy, 1945. *Courtesy of Anthony Amador.*

reopened. The track welcomed bettors in July 1945. "She'd go to the track early in the morning with her father and watch the horses work out." At that time, Big George had his runner, Liedevin, which would have brought him to the track with the horse's trainer, Joe Merola. During their father-daughter excursion, Lucy and George watched the races together. Bing Crosby kicked it off with a forty-day meet, and the place was packed. "She couldn't bet," Anthony pointed out, "she hadn't reached twenty-one." Less than two months later, Anthony would make his return from Okinawa, where he and the rest of the crew of the *Mississippi* had witnessed the ceremony signifying the Japanese surrender. "That was the last time I remember her being social with her father," he relayed. "After that, she never mentioned him much."

Marrying into the Family

Although Anna Dragna and Lucy Niotta had been baptized together as babies back in 1927, and although Anna's father was Lucy's godfather, it was through Celie's daughter Lolly Cacioppo that she came to know her future husband—the youngest of the Niotta sons. A gap of nearly ten years separated Stevie from his big sister Celie. As a result, he only had about seven years on his niece Lolly, which came to work out well when he began courting Anna.

Confessing the trick her mother played, Frannie Niotta couldn't help but smirk. Anna knew that if she asked her father for permission to go to the movies with her friend Lolly, he would insist on there being a chaperone. And for this she had an ace, Lolly's Uncle Steve. Little did Jack Dragna know that Uncle Steve was a young man and, more important, one romantically interested in his daughter. By 1947, the couple had gotten serious and no longer wanted their romance hidden. Ready to make their relationship official, Stevie approached an influential man who'd once been in business with his father. To Stevie, the fact that the bond between Jack Dragna and Big George had faded mattered very little. He was calling on the man for another reason; he'd come to ask for the hand of his one and only daughter.

"I'm sure my dad knew nothing about this," contends Frannie about the actions of Jack Dragna. Frannie knew, because her mother told her. "Grandpa Jack wanted to make sure that she had the ring that Jack Dragna's daughter ought to be wearing, and he knew that my dad wasn't getting help" to buy it. "He was on his own and he just came home from the service."

"Go to this jeweler friend of mine," Jack directed. "He'll take care of you. He won't take advantage of you, and he'll give you a good deal."

"So my dad goes there," Frannie continued. "But my grandpa had already picked out the diamond."

"Just give it to him for whatever he says is his price," Jack told the jeweler. "Whatever he tells you he has to spend, it doesn't matter. I'll pick up the difference."

"My grandfather paid for the rest of the diamond," Frannie clarified, which ensured that Anna's ring was something fantastic. "I know that story, I know that ring. It was from my father and my grandpa, so it was doubly important."

Although Stevie and Anna paired wonderfully, getting the wedding figured out was far from perfect. For starters, they'd chosen a less-than-practical venue for the reception. "They had it at the Biltmore." The ceremony itself was held at Sacred Heart. Regarding the reception, Saks Fifth Avenue handled the arrangements. The idea that a million screaming kids might destroy the famous and elegant hotel is one reason Jack Dragna took active

Sacred Heart Church, Los Angeles, Niotta-Dragna wedding, June 20, 1948. *Courtesy of Frannie LaRussa.*

control of the guest list. Aside for a few little ones the family snuck in as pages, no one younger than Georgie and Bing was invited. Georgie, the younger of the two, was now fourteen. But the choice in venue wasn't the only issue.

Approaching his daughter, Jack asked, "How about if you have Tommy Lucchese's daughter as your maid of honor?" Years later, Tommy's daughter Frances would marry Carlo Gambino's son Tom, bringing together two influential and powerful New York families. Hearing his suggestion and thinking it a swell idea, Anna accepted. Although a coast-to-coast distance separated Anna from her longtime friend Frances—or "Cucchi," as friends and family warmly called her—they'd shared a close bond since the mid-'30s. Their parents met back in New York but kept in touch after the Dragnas and Rizzottos settled in Los Angeles. Years later, a relationship between their young ones would start. This began when the Luccheses came to stay at the Dragna household on vacation. From then on, the families took turns riding the train between New York and LA, staying at one another's homes during their visit. With so many miles between them, Anna and Cucchi weren't able to see each other as often as they would have liked, but when they spoke on the phone, the pair gabbed

Jack Dragna (*center*) and Tommy Lucchese (*right*) circa 1948. *Courtesy of Frannie LaRussa.*

Bride Anna Dragna and maid of honor Frances "Cucchi" Lucchese, 1948. *Courtesy of Frannie LaRussa.*

for hours. The same sort of special relationship exists today between their two daughters.

News of Anna's selection did not sit well with Big George's oldest. Ever since his estrangement over the affair, Celie's husband, John Cacioppo, had served as the unofficial patriarch of the Niotta family. Likely for this reason, Celie took a very active interest in her siblings' affairs. Learning Frances Lucchese had been chosen as Anna Dragna's maid of honor instead of

her Lolly, she spoke up. Lolly, after all, had introduced the couple, and in her eyes, the girls appeared inseparable. Though merely a suggestion, and certainly not forced, there may have been more to Jack's advice. Italian tradition bound the maid of honor or best man as godparents to the bride and groom's first child. And this in fact did come to pass. As Frannie confessed, "It was very intentional that Frances was my mother's maid of honor." For Jack, facilitating this move strengthened and ensured the longevity of an existing bond.

Despite a few hiccups over the details, on the day of the event, everything went off spectacularly. The younger George remembered, "It was such a big wedding that it was held in the largest of the rooms," the hotel's three-tiered Biltmore Bowl. The menu was another thing George would never forget; it offered squab and filet mignon. "Everybody went crazy when they cut the cake!" Apparently, a pair of "white doves flew out with hundred dollar bills tied to their legs." People climbed the drapes to get at them. As entertainment, family friend "Jimmy Durante played a guest piano set." Anthony Amador adds, "Durante performed with Eddie Jackson" that night. The duo had shared another bill two years earlier—the opening of the Flamingo Hotel in

From left to right: Frankie Matranga, Cookie, "Bing," Lucy Niotta-Amador, Helen Niotta and Anthony Amador, Niotta-Dragna reception, Biltmore Hotel, Biltmore Bowl, 1948. *Courtesy of Anthony Amador.*

The Los Angeles Sugar Ring

Rose and Michael Niotta (*standing*), Anna and Stevie Niotta (*seated*), Frances "Cucchi" Lucchese (*seated*), Biltmore Hotel, Biltmore Bowl, 1948. *Courtesy of Frannie LaRussa.*

nearby Las Vegas. Although Anthony admitted to having a little too much to drink to remember any birds coming out of the cake, he swears he saw the lovely Myrna Loy. Several plainclothes "Special Agents of the FBI" were also in attendance. They'd come to photograph the guests and to keep tabs on "known hoodlums" John Roselli and Jack Dragna.

Regarding the events that followed, Anna Dragna-Niotta indicated, "We left for our honeymoon trip to New York City on the Super Chief" and "had hotel reservations at the Waldorf Astoria." The couple stayed "on the lucky thirteenth floor." Although housed in elegant surroundings, the newlyweds did manage to pry themselves from the hotel long enough to take in the sights. "Numerous family friends entertained us with visits to the Copacabana, the Latin Quarter, the Riviera, the Gay Nineties and Coney Island." At the Copa, they caught a hot duo that had really been pulling them in: Dean Martin and Jerry Lewis. Following the haze of a movie-quality wedding and a spectacular and happening honeymoon, the

pair returned to California. They settled into a house in LA's South Gate, not far from where the Martello brothers had opened the first El Rey Club a decade earlier. But Stevie and Anna weren't slated to remain Angelenos. After a failed stab at running a car wash in the early '50s with Anna's older brother Frank, they left for San Diego.

There, Jack Dragna set his son-in-law Stevie up in another business, securing him as secretary and treasurer for a vending endeavor similar to the one he'd run for Big George before the war. "Grandpa Jack knew Leo Dia," Frannie relayed, saying Dia and Charlie Gelardi owned Maestro Music and that Jack bought in as a partner then relinquished his share to Stevie. This maneuver also proved strategic. When Jack passed a few years later, the IRS seized everything, leaving not a drop of inheritance. Expecting this, Jack held his son-in-law to a very important promise. From his earnings at Maestro, Stevie would provide a monthly payment to Jack's only son, Frank Paul. For the same reason he'd put the business in Stevie's name, he'd kept Frankie's off it. Back then, the government could seek restitution from a son, but they couldn't squeeze it from a daughter.

12
A DELI TO BRING THEM TOGETHER

All these years everybody thought it was his fault—the separation.
—*Celie Niotta-Cacioppo*

Big George and Phyllis spent the bulk of the 1940s apart—she, alone, and he with his mistress. But their children never gave up on restoring the marriage. When the '50s rolled in, they took action, overstepping their boundaries with a plot to bring them back together. "Lucy's mom and dad got back together while they were living out in Encino," recalled Anthony Amador, "when they opened up the Italian Deli." A high schooler at the time, the younger George recalls his aunts' efforts. Celie, Lucy and Marion "raised some money and bought this deli to let grandpa run." They even "bought them a house in Encino, in the little village."

In July 1951, Michael Niotta filed paperwork for the American-Italian Delicatessen. The storefront at 17038 Ventura Boulevard rested less than a mile from Michael's home, and to make the job of keeping tabs on their folks easier, the house they purchased was no doubt nearby as well. The biggest flaw in the plan they'd cooked up was that their father was still living with Jenny Musso. As awkward as moving back in with Phyllis after all those years apart must have sounded, Big George would have done just about anything to get back into the good graces of his children. Given the circumstances, though, the arrangement was bound to fail.

"They worked there for a while," explained Anthony, before pausing to dish out the caveat. Then "he took off," leaving the kids to fix the mess all

Back, from left to right: Frances Dragna, Anna Costa and Kitty Lucchese with (*front*) Frances and Bobby Lucchese, early 1930s, New York. *Courtesy of Frannie LaRussa.*

over. Anthony and Lucy stuck around awhile to console Phyllis through the difficult time. To keep the business afloat, Lucy even worked in the deli, bringing her two-year-old daughter, Toni, to the store each morning. But this arrangement also proved short-lived. "We had to get back," Anthony confessed. The long commute to work out in Glendale had begun to take its toll. "I don't know how long the store was open. It wasn't open too long." Thinking back on the deli plot, the younger George admits it wasn't the best idea, saying it must have been tough "to settle down like that," especially considering "he had this other woman that he lived with."

Once again, Big George's actions alienated him from the family. And like before, years would pass before any of his children viewed the situation from another perspective. Unfortunately, by then George had already passed. While in her nineties and living under the care of her nephew George, Celie came to a sad conclusion. "All these years everybody thought it was his fault—the separation." At last she understood that her mother shared in the blame. Phyllis "would never go out to dinner in all those fancy places—blacktie or dress up. He'd buy her the gown, and she wouldn't go. 'No, I don't feel like going,' she'd say. 'You go.'" What Celie finally came to see is that her mother "didn't want to ride this rocket ship" that Big George

Big George, circa 1930.
Courtesy of George Niotta.

"was on." Thinking over the realization his Aunt Celie had conveyed, and of his grandparents' failed marriage, the younger George sighed deeply. "They got back together...that was during that deli time."

Late in 1954, as if sensing the end, Big George took out a life insurance policy. Less than a year later, he succumbed to stomach cancer. Giorgio Mercurio Niotta—"Big George"—left this place on September 29, 1955. Estranged at the time of his passing, little fanfare accompanied his exit. Five months after Stevie Niotta lost a father he hadn't spoken more than a few words to in years, his wife, Anna, suffered a loss of her own. Jack Ignatius Dragna died alone in a Sunset Boulevard hotel on February 23, 1956. His children learned of his death over the radio.

> Los Angeles Times, *February 24, 1956*
> *JACK DRAGNA FOUND DEAD IN SUNSET BLVD. HOTEL*
> *REPUTED RULER OF MAFIA IN LOS ANGELES APPARENTLY*
> *HAD HEART ATTACK WHILE ASLEEP*

Inside the World of Old Money, Bootleggers & Gambling Barons

Resting place of Mercurio "Mike" Neoto, his daughter Celie Neoto-Cacioppo, son "Big" George Niotta and daughter-in-law Phyllis Niotta. Calvary Cemetery, Los Angeles, 2017.
Photograph by author.

Jack Dragna, 65, long reputed to be the ruler of the Los Angeles Mafia, was found dead in his bed in a Sunset Blvd. hotel yesterday, Hollywood police reported, apparently having suffered a heart attack while sleeping.

In the 1960s, Frannie Niotta remembers it being a "big deal to go to the cemetery." "My grandmother and dad would go" to Los Angeles "to see everyone" at Calvary. "The Niottas were in one section and the Dragnas another. They were all there. And I can remember going and seeing Mercurio." It had all begun with him, with Big George's father, Mercurio, and so this is where it ends. "He had a large tombstone" and on it was his picture. Frannie always found humor in the hat and mustache. As a child it made her think Grandpa "Mercurio was a cowboy."

BIBLIOGRAPHY

Albuquerque Journal. "Indict 13 in Lottery Racket; California Police Chief Charged by U.S." January 13, 1938, 1.

Alcohol and Tobacco Tax and Trade Bureau. "Penalties for Illegal Distilling." U.S. Department of the Treasury. http://www.ttb.gov/spirits/home-distilling.shtml.

Andrews, Evan. "10 Things You Should Know about Prohibition." *History* (January 16, 2015). http://www.history.com/news/10-things-you-should-know-about-prohibition.

Amerine, Maynard. Introduction to *California Wine Industry Oral History Project*, by the Regents of the University of California, 1975.

Arizona Republic. "Race Lottery Scheme Barred." November 7, 1936, 2.

———. "Three Are Held in Race Lottery." November 20, 1936, 3.

Ashforth, David. *Ringers & Rascals: The True Story of Racing's Greatest Con Artists.* Lexington, KY: Eclipse Press, 2004.

"Attorney Asks Brewery Fee." Unknown publication, circa 1935. Article clipping found in family scrapbook of Celie Cacioppo.

Bachelder, W.K., "The Suppression of Bookie Gambling by a Denial of Telephone and Telegraph Facilities," *Journal of Criminal Law and Criminology* 40, no. 2 (1949). http://scholarlycommons.law.northwestern.edu/cgi/viewcontent.cgi?article=3673&context=jclc.

Bakersfield Californian. "Crosby Opens Del Mar Race Track for 40 Days." July 11, 1945.

———. "Ex-U.S. Agent Is Held For Inquiry." November 28, 1936.

———. "Former Grocer of Kern Faces Charge." September 10, 1934.

———. "High Court Denies L.A. Man Review." October 15, 1935.
———. "Kern Man's Case in Supreme Court." September 10, 1935.
———. "L.A. Citizenry and Papers Interested in Vice Charges." February 19, 1938.
———. "Notice No. 710." December 21, 1933, 14.
———. "Santa Ana Police Chief Is Freed on Lottery Charges." December 3, 1938.
———. "Tax Claims Abated." July 27, 1937.
Beer Can History. "The ABC's of Cans." http://www.beercanhistory.com/abcs2.htm.
Belle Plaine News. "The Mafia." March 20, 1891.
Berkeley Daily Gazette. "Alleged Gamblers to be Subpoenaed." July 31, 1937.
Blytheville Courier News. "Movie Stars Run for Cover When Club Is Raided." December 31, 1937.
Borgia v. United States. Circuit Court of Appeals, Ninth Circuit, July 9, 1935. http://www.ravellaw.com/opinions/5dd9da6f5d9c389b61a22ed8095f4c48.
Bukowski, Charles. *Post Office.* San Francisco, CA: Black Sparrow Press, 1971.
California Historical Society. "California Vintage: Wine and Spirits in the Golden State." December 5, 2016. http://www.californiahistoricalsociety.blogspot.com/2016/12/california-vintage-wine-and-spirits-in.html.
Chap. 0239. An Act Dissolving Certain Corporations. State Library of Massachusetts, Boston. April 29, 1937. http://www.archives.lib.state.ma.us/bitstream/handle/2452/61320/1937acts0239.txt?seq.
Chicago Packer. "Geo. Musante Brewery President." October 5, 1935.
———. "To Brew Old-Time Ale." November 6, 1937. http://www.idnc.library.illinois.edu.
Clifford E. Clinton Papers, 1934–1969. Online Archive of California. UCLA Library Special Collections.
Comte, Julien. "Let the Federal Men Raid; Bootlegging and Prohibition Enforcement in Pittsburgh." *Pennsylvania History: A Journal of Mid-Atlantic Studies* 77, no. 2 (2010).
Corona Daily Independent. "Eight Injured in Head-On Collision." October 30, 1937.
Crowley, Kent. "From Black Hand to Mafia. The Mystery of Iron Man," *The Foothills Reader. Los Angeles Times*, February 23, 2014, http://www.npaper2.com/foothill/2014/02/23/#?article=630261.
———. "The Real L.A. Mafia from Corleone to Cucamonga," *The Foothills Reader. Los Angeles Times.* January 27, 2013.

BIBLIOGRAPHY

Daily Picayune. "Administering Popular Justice." March 15, 1891, 4.
———. "Assassinated: Superintendent of Police David C. Hennessy Victim of the Vendetta." October 16, 1890, 1.
———. "None Guilty!" March 14, 1891, 1.
———. "The Vendetta." July 16, 1881, 8.
———. "When the Ministers of the Law Fail." March 15, 1891, 4.
Dan Morean's Breweriana. "Eagle Beer Cone Top." http://www.breweriana.com/beer-cans-cone-tops/eagle-beer-cone-top-12668.
Demaris, Ovid. *The Last Mafioso: The Treacherous World of Jimmy Fratianno*. New York: Times Books, 1981.
DiStasi, Lawrence. *Una Storia Segreta: The Secret History of Italian American Evacuation and Internment During World War II*. Berkeley, CA: Heyday Books, 2001.
Drug Trade Weekly, "Activities in California," 3 (November 27, 1920): 13.
Eighteenth Amendment. U.S. Constitution. Cornell University Law School. http://www.law.cornell.edu/constitution/amendmentxviii.
"El Rey Team Seeks Sixth Victory in Stadium League." Unknown publication, January 12, 1935. Article clipping found in family scrapbook of Celie Cacioppo.
Encyclopedia Britannica. "Fascio Siciliano: Italian Political Organization." July 20, 1998. http://www.britannica.com/topic/fascio-siciliano.
Fisher, Lawrence. "Alfred Fromm, 93, Early Leader in the California Wine Industry." *New York Times*, July 9, 1998.
Fowler, Kari, Heather Goers, and Christine Lazzaretto. "The Quonset Hut, 1941–1965." Survey LA: Los Angeles Historic Resources Survey. Office of Historic Resources. http://www.preservation.lacity.org/sites/default/files/The%20Quonset%20Hut,%201920-1965.pdf.
Fox, Stephen. *UnCivil Liberties: Italian Americans Under Siege During World War II*. Boca Raton, FL: Universal Publishers, 2010.
Fresno Bee. "Court Clears Status of Small Beer Bottles." March 3, 1942, 5B.
———. "Face New Indictment." October 20, 1934, 2A.
———. "L.A. Grocer Gets Prison Term and Fine of $8,000." November 1, 1934, 10A.
———. "Los Angeles Grocer Is Found Guilty of Still Conspiracy." October 31, 1934.
———. "Muroc Still Case Soon to Go to Jury." October 30, 1934.
———. "Officers Suspected in L.A. Sweepstakes Plan." November 24, 1936.
———. "Police Fear Foul Play in Case of Missing LA Man." December 26, 1951. 1.

Gallup Independent. "Agua Caliente Track Becomes Center of West Coast Racing Sport Events." January 20, 1942.

Gambino, Megan. "During Prohibition, Your Doctor Could Write You a Prescription for Booze: Take Two Shots of Whiskey and Call Me in the Morning." *Smithsonian* (October 7, 2013).

Gatto, Mariann. *Los Angeles's Little Italy: Images of America*. Charleston, SC: Arcadia Publishing, 2009.

Glass, Andrew. "Congress Overrides Prohibition Veto, Oct. 28, 1919." *Politico*, October 28, 2009. http://www.politico.com/story/2009/10/congress-overrides-prohibition-veto-oct-28-1919-028790.

Goldstein, Alan. "ITT-Gilfillan Homes in on Radar Systems and Profit." *Los Angeles Times*, September 2, 1986.

Granucci v. Claasen. Supreme Court of California, 1928. http://www.casetext.com/case/granucci-v-claasen.

Great Falls Tribune. "California Resident Visitor." August 17, 1936.

———. "Mrs. Fred Woehner Returns from Stay in California City." July 7, 1937.

Hanson, David. "Prohibition in Maryland Caused Serious Problems." Alcohol Problems and Solutions. http://www.alcoholproblemsandsolutions.org/prohibition-in-maryland.

Hardman, Melissa. "Beer & Wine: The Science of Fermentation." *Vine Daily*, July 17, 2015. http://www.winebags.com/Beer-Wine-the-Science-of-Fermentation-s/1853.htm.

Henstell, Bruce. *Sunshine & Wealth: Los Angeles in the Twenties and Thirties*. San Francisco, CA: Chronicle Books, 1984.

Hull, Warren, and Michael Druxman. *Family Secret*. Tucson, AZ: Hats Off Books, 2004.

Jack Crono v. United States. Circuit Court of Appeals. Ninth Circuit, May 31, 1932. http://www.leagle.com/decision/193239859F2d339_1301/CRONO%20v.%20UNITED%20STATES.

Jewish Museum of the American West. "Simon Levi, Pioneer Wholesale Grocer of San Diego, California." February 15, 2014. http://www.jmaw.org/simon-levi-jewish-san-diego.

Kelly, Dick. "Spotlight on Sports." *Daily Mail*, August 3, 1954, 10.

King, Helen. "Wine's in Picture Again," *Los Angeles Times Farm and Garden Magazine* (February 18, 1934): 3–6.

Legal Information Institute. "Registry of Stills and Distilling Apparatus." Cornell University Law School. http://www.law.cornell.edu/cfr/text/27/29.55.

Bibliography

Literary Digest. "Wilson and Wine." May 31, 1919. http://www.oldmagazinearticles.com/Prohibition_Law_and_Woodrow_Wilson#.WDNr9ja7p7h.

Long Beach Independent. "Owner and Trainer Suspended." November 25, 1949, 18.

Los Angeles Herald. "Fruit Peddler Shoots Another." June 3, 1906.

———. "Police Trail the Murderer." September 26, 1906.

Los Angeles Sunday Times. "Extra Dry, Forecast for State When Wright Act's Effective." May 29, 1921, 1.

Los Angeles Times. "Agents to Keep After Wet Spots." March 10, 1933.

———. "Census to Include Films." May 21, 1922, 11.

———. "Corn Sugars Deals Bring Dry Charge." November 22, 1931.

———. "Court Denies Pleas in Raid." February 9, 1932.

———. "Court Dismisses Borgia Charge." July 25, 1933.

———. "Eight Men Go to Trial on Lottery Plot Charges." November 30, 1938, 21.

———. "Ex-Officials Face Arrest in Sweepstakes Lottery." November 26, 1936, 3.

———. "Federal Raiders Seize Five." November 21, 1931.

———. "Gang Suspect Wins Bail Cut." September 28, 1933.

———. "Grape Men Are Riled by Wright Act." May 5, 1921.

———. "Grape Men Kept Busy with Cash." March 12, 1921.

———. "Grocer Denies Knowing of Huge Still." October 30, 1934.

———. "Illegal Sugar Selling Denied." January 12, 1932.

———. "Incendiary Device Is Discovered." January 22, 1922.

———. "Irish Sweepstakes Loses Ticket Race to Lotteries, Calls It Quits." February 28, 1987.

———. "Italians of City Charge Dry Abuse." March 7, 1926.

———. "Italians Unite for Repeal of State Dry Act." January 10, 1926.

———. "It's a Pleasure Barge." October 14, 1928.

———. "Jack Dragna Found Dead in Sunset Blvd. Hotel." February 24, 1956.

———. "Lotteries Urged to Pay Dole." December 27, 1938, 5.

———. "More Sweepstakes Tickets Seized in Handicap Lottery." November 21, 1936.

———. "Pair Surrender on Indictment in Liquor Case." September 25, 1932.

———. "Permit Asked for Two New Residence Jobs." May 28, 1933, 14.

———. "Phone-Tapping Admitted." February 6, 1932.

———. "Rum Death Uncorked: Twenty-Nine Die of Poisoning." October 9, 1928.
———. "Seized Liquor's Return Ordered." March 28, 1933.
———. "Six Bookmakers Get Jail Terms: Money Seized in Raid at West Riverside to Go to County." August 4, 1939, 11.
———. "Suspects Freed in Lottery Case: Jury Acquits All Eight Defendants in Federal Court." December 3, 1938, 9.
———. "Three Arrested Here in Rack Track Betting Ring Scheme." November 20, 1936, 3.
———. "Three Barns Burned." December 29, 1918.
———. "Wants to Make Wine: Letters to *The Times*." December 28, 1928.
———. "Weddings." June 27, 1948, 7.
———. "Winery Found in Haystacks." October 24, 1931.
Manitowoc Herald-Times. "Steam Beer Will Return." March 18, 1933, 9.
Manitowoc Tavern History. "Automatic Hostess." http://www.manitowoctavernhistory.org/tag/manitowoc-wired-music-studio.
Martello, Andy. *The King of Casinos: Willie Martello and The El Rey Club.* Las Vegas, NV: Just A Martello Books, 2014.
"May 22, 1934." Unknown source, article clipping found in family scrapbook of Celie Cacioppo.
Meeks, Eric. *Palm Springs True Crime.* Horatio Limburger Oglethorpe, 2016.
Modesto News-Herald. "34 Indicted in Bay City Rum Scandal by U.S. Jury." May 23, 1929.
Moitoret, Anthony. "Candidacy of Rolph Is Seen in Dry Repeal," *Oakland Tribune*, January 8, 1930.
New Orleans Times-Democrat. "Details of the Awful Tragedy." July 22, 1899.
Niotta, J. Michael. *Dragna: Beneath the Hollywood Mafia Mask.* Unfinished manuscript.
———. *The Fight Abroad and the Fear Back Home: America's Italians during WWII.* Unpublished manuscript.
Oakland Tribune. "Addition to Brewery." August 22, 1933, 30E.
———. "Albion Brewing in Bankruptcy." January 22, 1941.
———. "Axe Squad to Smash L.A. Gaming Ship." December 12, 1928.
———. "Bootlegs Work for Referendum, Says Dry Head." May 6, 1921.
———. "Booze Trial Will Go to Jury Today." July 19, 1929, 2.
———. "Brewery Is Offered for Use As School." March 7, 1919.
———. "Gambling, Leading Racket in America: An Interview with U.S. Attorney-General William D. Mitchell," August 23, 1931.
———. "Grape Men Vote to Indorse Bell." October 7, 1918.

———. "S.F. Brewery Sold." October 20, 1933, 35B.
———. "State Joins in Killing Probe." August 22, 1948, A13.
———. Untitled article. August 22, 1931, 44.
———. "Witnesses Flee Death as 50 Are Indicted in Eastbay Booze Probe." May 23, 1929.
Old Breweries. "El Rey Brewing Co. Inc." http://www.oldbreweries.com/breweries-by-state/california/san-francisco-ca-83-breweries/el-rey-brewing-co-inc-ca-308d.
Oxnard Daily Courier. "Johanna Smith Now in Competition with 2nd Gambling Ship at LA." July 25, 1929.
Passarello, Giuseppe. "Cuccia, the Bloodthirsty Used and Put in Jail," *La Repubblica*, February 16, 2003.
"Piana degli Albanese." http://www.contessaentellina.net/piana/piana.htm.
Reid, Edgar, and Ovid Demaris. *The Green Felt Jungle*. New York: Trident Press, 1963.
Reno Evening Gazette. "Brewing Company Team to Play in Reno." August 3, 1935, 9.
Richardson, Jiles. "White Lightning." Glad Music Company, 1959.
Roselli, John. File LA 92-113. Federal Bureau of Investigation.
San Bernardino County Sun. "Furnishings of Bookie Are Sold." August 14, 1939.
———. "Grape Producers Seek Quick Word as to This County if Measure Repealed." May 31, 1919.
———. "Officers Raid Track Betting Pool Offices." January 4, 1935, 6.
———. "Riverside Bookie Operators Jailed." August 4, 1939.
———. "Riverside Raid Closes Bookie." July 31, 1939.
———. "Vital Records: Notices of Intention to Wed." August 4, 1938, 23.
San Bernardino Daily Sun. "Big Reason Behind Los Angeles Recall." September 20, 1938.
———. "County Drops Proposal for Legal Bookies." December 24, 1937.
———. "Gaming Mogul Makes Nevada Headquarters." June 2, 1939.
———. "Legislators Find Gambling Is Fertile Field for Bills." February 8, 1937.
———. "Jury Deliberating Tax Fraud Charges." October 13, 1935.
———. "Whisky Still Near Country Club Raided." May 9, 1930.
Sandbrook, Dominic. "How Prohibition Backfired and Gave America an Era of Gangsters and Speakeasies." *Guardian*, August 25, 2012.
San Francisco Call. "Baron Fava Recalled." April 1, 1891.
———. "Lager's Vogue Takes Steam Out of Brewery." August 6, 1911, 38.

San Francisco Chronicle. "Watchman Mysteriously Shot in Brewery Yard." November 2, 1912.
Santa Ana Daily Register. "Seeks to Make Gambling Legal." June 27, 1939.
———. "Two Truckloads of Groceries Stolen." July 21, 1925, 10.
———. "Uncovered Cases of Alleged Bonded Goods Bring Fine of $1,000 in Wake." December 8, 1924.
———. "U.S. Speeds Drive to Block Sale of Sweepstake Tickets." April 1, 1939.
Santa Ana Register. "Four Men Held on Lottery Charges." November 21, 1936.
———. "Hayes Expected to Be Witness in Lottery Case." January 25, 1938.
———. "Howard Trial Witness Reals Lottery Plan." November 30, 1938.
———. "Lottery Case Hearing Set." January 14, 1938.
———. "Police Chief, Other Santa Anan's Indicted by Federal Grand Jury: County Men Involved in Million Dollar L.A. Sweepstakes Lottery." January 12, 1938, 1.
Santa Anita Park. "The History of Santa Anita Park." http://www.santaanita.com/discover/history.
Santa Cruz Sentinel. "S.F. Mission District Is Hit by Big Blast." November 2, 1933.
———. "Steam Beer on Way Back at One Nickel a Pound." April 14, 1933, 1.
Santa Monica Evening Outlook. "Burglars Remove Sugar and Foods." July 20, 1925, 1.
Scherck, George. "Doping Case at Tanforan." *Oakland Tribune*, November 25, 1949, 38.
Sixty-Eighth Congress. 1924 Immigration Act. US Immigration Legislation. http://www.library.uwb.edu/Static/USimmigration/1924_immigration_act.html.
Springfield Leader. "Film Magnate Is Badly Hurt in Auto Crash." July 17, 1929, 1.
St. Louis Post-Dispatch. "All-Out Drive by U.S. Against Gambling, Crime Is Up." February 14, 1950.
Stoll, Horatio. "Crop Is Saved by Home Brew." *Los Angeles Times*, October 10, 1921.
Stout, David. "Morey Amsterdam, Comedian and Joke Encyclopedia Dies." *New York* Times, October 29, 1996. http://www.nytimes.com/1996/10/29/arts/morey-amsterdam-comedian-and-joke-encyclopedia-dies.html.

BIBLIOGRAPHY

Sugar, Bert, and Cornell Richardson. *Horse Sense: An Inside Look at the Sport of Kings.* Hoboken, NJ: John Wiley & Sons, 2003.

Thornton, Mark. "Alcohol Prohibition Was a Failure." CATO Institute. July 17, 1991. http://www.cato.org/publications/policy-analysis/alcohol-prohibition-was-failure.

Time. "Mortal Moonshine." 2008. http://www.content.time.com/time/specials/packages/article/0,28804,1864521_1864524_1864626,00.html.

———. "Where Everybody Knows Your Name (Except the Coppers)." 2008. http://www.content.time.com/time/specials/packages/article/0,28804,1864521_1864524_1864614,00.html.

Tucson Daily Citizen. "Race Horse Owner Draws Suspension." November 26, 1949, 3.

Tyrrell, Ian. "Alcohol Prohibition in the USA." http://www.iantyrrell.wordpress.com/alcohol-prohibition-in-the-usa.

Ukiah Daily Journal. "Grape Ass'n. Starts Fight on Amendment." February 28, 1919.

"Understanding the 18th Amendment." Laws. http://www.constitution.laws.com/american-history/constitution/constitutional-amendments/18th-amendment.

Van Nuys News. "Certificate of Business. Fictitious Firm Name." July 23, 1951, 9B.

Verne, Jules. "Sandorf's Revenge." *Coffeyville Weekly Journal,* June 26, 1886, 4.

Vinton, Kate. "How Breweries Like Coors, Yuengling and Anheuser-Busch Survived Prohibition," *Forbes,* November 23, 2015. http://www.forbes.com/sites/katevinton/2015/11/04/how-breweries-like-coors-yuengling-and-anheuser-busch-survived-prohibition/#a503e9467b9e.

Wilmington (DE) Morning News. "California Hunts Mobster Dragna Gangster Termed Capone of Los Angeles." February 15, 1950, 4B.

Yenne, Bill. *Great American Beers: Twelve Brands That Became Icons.* Voyager Press, 2004.

———. *San Francisco Beer: A History of Brewing by the Bay.* Charleston, SC: Arcadia Publishing, 2017.

INDEX

A

Agua Caliente Racetrack 116, 126, 129, 138
Albion Brewing Company 94
Amsterdam, Morey 117
Anti-Saloon League 38
Ardizzone, Joe 24, 25, 26, 27, 40, 49, 50, 70
arson 77

B

Bohemian Distributing Company 24, 73
bookmaking 12, 27, 46, 96, 97, 98, 99, 101, 114, 120, 123, 125
bootlegging 18, 40, 44, 45, 51, 56, 59, 74, 78, 85, 90
Borgia, Frank 29, 47, 48, 50, 51, 53, 56, 57, 58, 59, 60, 61, 82, 92, 104, 110
Bowron, Fletcher 119, 120
Boyle Heights 28, 31, 47, 71, 75, 76, 133, 138, 144

C

California Grape Protective Association 36, 38, 40

Christian Brothers 15
Claasen, John 84, 86
Clinton, Clifford 118, 119
Cohen, Mickey 28, 102
Cornero, Tony "the Hat" 45, 120
Crawford, Charles 25, 27
Cuccia, Francesco 62, 63, 70

D

Del Mar Racetrack 125, 150
Dragna, Jack 7, 11, 21, 24, 25, 26, 27, 28, 29, 40, 42, 44, 48, 49, 50, 62, 79, 80, 82, 110, 115, 118, 120, 138, 151, 152, 153, 155, 157, 160, 161
Durante, Jimmy 31, 117, 155

E

Eagle Brewing Company 82, 84, 86, 92
enemy alien 133, 134, 135

F

Fischetti family 50
Fitts, Buron 26, 27, 117, 118, 119, 120
Fox, William 30
Fromm & Sichel 15, 16

INDEX

G

gambling 12, 18, 21, 25, 26, 27, 28, 45, 46, 92, 96, 98, 100, 108, 115, 117, 118, 120, 122, 123, 124
Gilfillan Radio 137, 138, 148

H

Hells Angels Motorcycle Club 121

I

Italian Welfare League 25, 26, 40, 41, 50

L

L.K. Small Company 73
Lucchese, Tom 50, 153
lynching 65, 67

M

Mafia 28, 49, 64, 160, 161
Matranga family 49, 52, 53, 64, 65, 70
McAfee, Guy 118, 120
Monfalcone 26, 27

O

Olympic Games 32

P

Parker, William H. 28
Piana dei Greci, Sicily 48, 62, 66, 70, 71, 75
Preston, Edward J. 86, 87, 89, 92, 94
prohibition 11, 12, 17, 18, 20, 25, 26, 35, 36, 37, 38, 39, 40, 42, 43, 44, 45, 46, 47, 51, 54, 55, 58, 80, 84, 85, 87, 89, 92, 98, 120, 171

R

racing wire 96, 97, 98, 114, 115, 116
Rayburn, Carl 121, 122
Raymond, Harry 118, 119
ringer horses 127, 129
Roosevelt, President Franklin 87, 133
Roselli, John 7, 118

S

Santa Anita Park 99, 100, 101, 102, 116, 125, 129
Shaw, Franklin 7, 27, 119
Siegel, Benjamin "Bugsy" 28, 97, 115, 118
Simon Levi Company 15, 16
Simpson, Wallis 32
Stensland, Norris 102, 103, 104, 105, 107

T

Tanforan Racetrack 104, 125, 127, 129
Tavaglione family 109, 113, 122, 124
Tornberg, Carl A. 82, 85, 88, 90

V

Verne, Jules 64

W

Warren, Earl 28, 118, 120, 121
wartime restrictions 134, 135
Wilson, President Woodrow 35, 36, 37

ABOUT THE AUTHOR

J. Michael and the Borgia statue, 2017. *Belgium Lion Photography*.

Italian American J. Michael Niotta is a San Diego native who hates the sun and never learned to surf. He writes about the California you won't find in the palm-tree-infested brochures. As the eldest great-grandson of Jack Dragna, one of the most mysterious players to ever operate in the City of Angels, delving into SoCal's sordid past has become a near obsession. Years of research and interviews spill heavily into his work as an author, journalist, artist and fiction writer. Although Niotta holds a business doctorate and a master's in human behavior, his time behind the desk has not severed him from his blue collar. The son of a teamster and a beautician, his long list of jobs includes plumber, draftsman, diesel mechanic, line crew firefighter, furniture mover and bouncer. As such, it's no

About the Author

wonder a working-class mindset and dialect feeds so directly into his prose. Bleak yet witty, Niotta's narrative displays a cynically funny way of looking at life and at recapping history.

Niotta gained notoriety as an editor in chief and columnist for SoCal custom culture magazines and as an upright and electric bass player touring California, the Southwest and Europe. The Iraqi Freedom veteran has over fifteen years of military service and is among the first cohort of the Rosie Network's (NPO) Service2CEO entrepreneurial program. He also maintains affiliations with the Order of Sons of Italy in America (OSIA) and is a longtime member of the Conquistadors Car Club of San Diego.